The Adoring Audience

FAN CULTURE
AND POPULAR MEDIA

edited by

LISA A. LEWIS

London and New York

To the memory of
Delbert E. Lewis,
my greatest fan

First published in 1992
by Routledge
11 New Fetter Lane, London EC4P 4EE

Simultaneously published in the USA and Canada
by Routledge
a division of Routledge, Chapman and Hall, Inc.
29 West 35th Street, New York, NY 10001

Reprinted 2001

Routledge is an imprint of the Taylor & Francis Group

© 1992 Lisa A. Lewis

Typeset in Palatino by
Falcon Typographic Art Ltd, Edinburgh & London

Transferred to digital printing 2003
Printed and bound by Antony Rowe Ltd. Eastbourne

British Library Cataloguing-in-Publication Data
Lewis, Lisa A.
The adoring audience: fan culture and popular media.
I. Title
302.2308

Library of Congress Cataloging-in-Publication Data
The Adoring audience: fan culture and popular media /
edited by Lisa A. Lewis.
p. cm.
Includes bibliographical references and index.
1. Fans (Persons) – United States – Psychology. 2. Television
viewers – United States – Psychology. 3. Groupies – United States –
Psychology. 4. United States – Popular culture. I. Lewis, Lisa A.
HM291.A343 1992
302.23 – dc20 91–37332

ISBN 0–415–07820–2
ISBN 0–4515–07821–0 pbk

Grossberg, Steve Hinerman, Henry Jenkins, Joli Jensen, Lisa A. Lewis, Robert Sabal, Fred and Judy Vermorel.

Contents

PART III *Fans and Industry*

PART IV *Production by Fans*

Notes on Contributors

Sue Brower completed her doctorate in Radio–Tele vision–Film at the University of Texas at Austin. Her work has focused on the relationships among promotion, television fiction, and viewer practices. She has written about tabloids, 'Dallas' viewers, promotional strategies of 'Cagney & Lacey,' star biography in 'Moonlighting' and seriality in television of the 1980s.

Cheryl Cline writes for *Bitch: The Women's Rock Newsletter with Bite* and is at work on an encyclopedia of rock musicians.

Barbara Ehrenreich is the author of the book, *The Hearts of Men*. Her articles have appeared in many publications, including the *New York Times, Vogue, The Atlantic,* and the *Wall Street Journal.*

John Fiske teaches in the Department of Communication Arts at the University of Wisconsin–Madison and has held appointments in the UK and Australia. He is author or co-author of *Reading Television, Introduction to Communication Studies, Key Concepts in Communication, Myths of Oz,* and *Television Culture.*

Lawrence Grossberg is a Professor of Speech Communication and Communications Research at the University of Illinois at Urbana. His newest book, *We Gotta Get Out of This Place: Rock Politics and Postmodernity* is a study of relationships between popular culture and the new conservativism. He is co-editor of *Marxism and the Interpretation of Culture, Rethinking Communication,* and *Cultural Studies: Now and In the Future.*

Elizabeth Hess is a free-lance writer who has written for the *Washington Post*, the *Village Voice*, *Art in America*, and *Ms.*, among other publications.

Stephen Hinerman is a Lecturer in the Departments of Communication Studies and Humanities at San Jose State University. He wrote extensively on popular music as a rock critic at the *Colorado Daily* and Denver's *Westword* between 1979 and 1984. In addition, he has written academically about both mass culture and rhetoric, presenting a number of papers discussing the political dimensions of popular culture. He is working to produce his play about Elvis fans entitled *Burnin' Love*.

Gloria Jacobs has served as an editor at *Ms.* and written for publications such as *Mother Jones*, *Women's World*, and *Daily News*.

Henry Jenkins is an Assistant Professor of Literature at MIT. He has published a number of journal articles on media audiences and is the author of the forthcoming book entitled *Textual Poachers: Television Fans and Participatory Culture,* to be published by Routledge.

Joli Jensen is interested in twentieth-century culture and society. She has published articles on country music production, and on the typewriter as a communication technology. Her recent book, *Redeeming Modernity: Contradictions in Media Criticism,* analyzes media criticism as displaced social criticism. She is an Associate Professor in the Faculty of Communication at the University of Tulsa.

Lisa A. Lewis has published widely on the subject of female musicians, music video, and female fans culminating in *Gender Politics and MTV: Voicing the Difference* (Temple University Press, 1990). She holds a PhD and graduated from the American Film Institute's Center for Advanced Film and Television Studies. She works as a video and film producer in Tucson, Arizona.

Robert Sabal teaches film-making in the Department of Media Arts at the University of Arizona. He has written, produced and directed the feature film, *Indian Summer.*

Fred and Judy Vermorel are conducting research with fans in the USA and Britain for an updated version of their previously published book, *Starlust: The Secret Fantasies of Fans*, which is now out of print.

Acknowledgements

I wish to acknowledge the enthusiasm and commitment of the authors who participated in the collection. Their collegiality in critical discussions and efforts at revisions made the book better and a true joy to edit. I am grateful to Lisa Freeman who recognized the importance of a book about fans and fandom from the onset. Special thanks go to Joli Jensen for her encouragement at the early stage of the book's conception, and to Jeremy Butler for introducing me to fanzines.

Introduction

We all know who the fans are. They're the ones who wear the colors of their favorite team, the ones who record their soap operas on VCRs to watch after the work day is over, the ones who tell you every detail about a movie star's life and work, the ones who sit in line for hours for front row tickets to rock concerts. Fans are, in fact, the most visible and identifiable of audiences. How is it, then, that they have been overlooked or not taken seriously as research subjects by critics and scholars? And why are they maligned and sensationalized by the popular press, mistrusted by the public?

For the academy, the answer may reside in its historical propensity to treat media audiences as passive and controlled, its tendency to privilege aesthetic superiority in programming, its reluctance to support consumerism, its belief in media industry manipulation. The popular press, as well, has stigmatized fandom by emphasizing danger, abnormality, and silliness. And the public deny their own fandom, carry on secret lives as fans or risk the stigma that comes from being a fan.

Perhaps only a fan can appreciate the depth of feeling, the gratifications, the importance for coping with everyday life that fandom represents. Yet we are all fans of something. We respect, admire, desire. We distinguish and form commitments. By endeavoring to understand the fan impulse, we ultimately move towards a greater understanding of ourselves.

The authors represented in this collection are aware of their own fandom and many proclaim it proudly. They have all courageously defied the stigma of fandom in the interest of investigating and analyzing what makes fans tick and the forces that fuel the popular consensus about fandom. As researchers and writers, they are separated by academic disciplines, by the division between academic scholarship and popular criticism,

1

and by national boundaries. The breadth of their assembled work is an indication of its collective strength. The authors consider a range of relationships between fans, stars, media texts, and media industries. They cross over popular media boundaries that typically segregate analyses of music, television, and cinema. Together, their essays argue for fandom as a coherent and important subject for critical inquiry.

I have chosen to begin the book with the more general and theoretically-minded essays, those that approach most pointedly the question, 'What is a fan?' Fandom has been so delegitimized as an area of study that it seems fitting to assess the core definitional issues and problems first. If we approach fandom as a serious and complicated arena right from the beginning, perhaps we will be less inclined to trivialize the fan behaviors described in later sections. Readers are, therefore, advised that the most difficult essays may be the first ones they encounter.

The first part of the book, Defining Fandom, features the writing of three scholars. Joli Jensen surveys the social scientist's view of fandom as pathological and deviant. She draws a parallel between the fan's obsession with popular media figures and the scholar's devotion to a specific research interest in order to demonstrate a system of bias which debases fans and elevates scholars even though they engage in virtually the same kinds of activities. Jensen counters the preoccupation of the academy and the press with the 'dangerous fan' by approaching fans as ordinary people immersed in everyday life, and reveals the deep dilemmas about modern life that generate such negative characterizations.

John Fiske defines fandom as the register of a subordinate system of cultural taste. Applying Bourdieu's concept of 'cultural economy,' he describes how the cultural criteria of fans differ from (and, at times, appropriate) official standards. In contrast to official culture, which relies on aesthetic evaluations of texts and the elevation of individual artistry, popular culture proponents tend to formulate personal (social) connections with texts and to participate in textual production. All audiences, Fiske declares, engage in production, not mere reception, but fans execute a broader range of producerly activity. Fans concentrate on popular culture, he suggests,

because industrially-produced texts encourage identification and participation by audience members.

Lawrence Grossberg approaches fandom as a distinct 'sensibility,' a special relationship between audience and culture in which the pleasure of consumption is superseded by an investment in difference. In fandom, moods and feelings become organized and particular objects or personas take on significance. By participating in fandom, fans construct coherent identities for themselves. In the process, they enter a domain of cultural activity of their own making which is, potentially, a source of empowerment in struggles against oppressive ideologies and the unsatisfactory circumstances of everyday life.

The three authors who tackle the difficult preliminary work efining fans attempt to distinguish fans from aficionados, umers, and general audience members. Each points to the etween fandom and popular culture, although they differ hether the relationship is a necessary one. All highlight as a product of a hierarchical social system in which e and value are accorded to only the few.

h this last observation keenly in mind, the second part, dom and Gender, looks at the social category of gender and, to an extent, age) as it relates to fan practice and fan representation. The section, which includes essays by a fan writer, a team of popular journalists, and two scholars, focuses primarily on the condition of female fans. The implicit question for readers to ponder is whether women have a special or distinct stake in fandom. Clearly, males are involved in fan activity as well, especially through sports culture. I suspect that there are many fans of color who can be similarly analyzed. The abundance of writing on female fans should not, in other words, be construed necessarily as an indication of an actual parameter of fandom.

Cheryl Cline, in two essays written for a fan magazine, explores how female fans of rock music are classified as 'groupies' by the music press and by popular male opinion. Cline makes the point that female sexual fantasies should not always be interpreted literally as a desire for sex with the star. She tears at the soft underbelly of gender discrimination by revealing how the patterned characterizations of female fans are designed to deride women as a group.

Barbara Ehrenreich, Elizabeth Hess and Gloria Jacobs travel back in time to 1964 and rediscover the meaning of girls' hysterical adoration of the Beatles. After investigating the social expectations placed on female adolescents of the period, they explain how sexual repression and narrow sex-roles gave rise to Beatles fandom. They raise a number of important issues about the nature of fan–star relationships including the point that female fans often choose stars that represent subversive versions of heterosexuality. The authors are led to the conclusion that the mass organization of girls around the Beatles constituted a significant advance towards the political movements of the late 1960s and early 1970s.

Steve Hinerman delves into female fantasies and paranormal episodes involving the figure of Elvis Presley. Using Freud and Lacan as points of embarkation, he reviews psychosexual development in order to explain the role of fantasy in human lives. He analyzes specific Elvis fans who claim to have had extraordinary encounters with the star and shows how fantasy episodes facilitate their expression of repressed desires and help fans cope with real-life traumas.

In my essay, Hollywood representations of fans in movies stand in for actual fan subjects. Despite their celluloid existence, the fans exhibit many of the tendencies and complexities identified by the authors in this collection. The popular consensus of fandom as pathological and deviant is an undercurrent in the films, yet the treatment is tempered by perceptive illustrations of fans' relation to subordination, empowerment, identity conflicts, sexuality, trauma, the heterosexual norm, and textual production. Perhaps the greatest insight demonstrated by the films as a group is their vision of fandom as a contradictory site of love and hate.

Part Three, Fans and Industry, looks closely at the antagonisms and correlations between the industries that create and distribute textual narratives and performers, and the fans that popularize them.

Sue Brower's essay examines instances of alignment between fans and producers against the dictates of US television networks. Schooled in the 'bottom line' of television by interested producers and aware of the stigma of fandom, the fan group 'Viewers for Quality Television' developed clout with

the networks by emphasizing their membership's affluent demographic profile and articulating their demands within the 'quality discourse,' a valued system of cultural criteria in the television industry. These strategies, according to Brower, elevated fans to the category of 'tastemakers' thereby creating an acceptable and effective basis from which to challenge network cancellations of adored programs.

This essay is followed by a transcript which reproduces statements made by US television executives about the role of fans in network decision-making practices. The transcript is provided by Robert Sabal, who, as a participant in the Academy of Television Arts and Sciences' first Faculty Seminar, directed discussion towards the subject of fan letters to the networks. Representatives of three major networks confirm that fans can and do have an impact on television programming.

Whereas Part Three considers the ways fans intervene in industrially-produced television products, contributing to their content in the mode of producers, Part Four, Production by Fans, looks at fan production of texts which are uniquely their own.

Researchers Fred and Judy Vermorel, whose book *Starlust* is cited by many of the authors in this anthology, present a collage of fan letters for readers to contemplate. The fans' statements of love, madness, lust, despair and hope can be analyzed in terms of the points made in previous essays. Some of the letters are designed for the private eyes of stars, while others are intended as correspondences with fellow fans. They demonstrate the social nature of fandom, a point developed by Henry Jenkins in his essay on science fiction fans.

Jenkins provides a critique of fan-produced fiction and music (or 'filk') bringing readers full circle to the definitional issues encountered at the start of the book and illustrated or applied in later essays. He distinguishes fans from general audience members by pointing out the distinctive interpretations, evaluative criteria and alternative identities made manifest in the texts that fans themselves produce. What emerges in the work of fan artists, Jenkins shows, is a propensity to appropriate and rework industrial texts according to self-proclaimed priorities, and this includes poking fun at the negative fan characterizations circulated by the academy, the press and the public.

The collection of essays as a whole is designed to give fans the recognition and respect they deserve as cultural producers and creative respondents to the social milieu. This is not to say that all fans are worthy of praise, for many do pursue destructive avenues of expression or use fandom to resolve problems that might be better addressed through other forms of action. But overall, the book's authors argue, fans must be given credit for responding with energy, creativity and optimism to difficult, and often unjust, social conditions.

PART I

Defining Fandom

Fandom as Pathology: The Consequences of Characterization

JOLI JENSON

The literature on fandom is haunted by images of deviance. The fan is consistently characterized (referencing the term's origins) as a potential fanatic. This means that fandom is seen as excessive, bordering on deranged, behavior. This essay explores how and why the concept of fan involves images of social and psychological pathology.

In the following pages I describe two fan types – the obsessed individual and the hysterical crowd. I show how these types appear in popular as well as scholarly accounts of fans and fandom. I consider why these two particular characterizations predominate – what explains this tendency to define fans as, at least potentially, obsessed and/or hysterical fanatics?

I suggest here that these two images of fans are based in an implicit critique of modern life. Fandom is seen as a psychological symptom of a presumed social dysfunction; the two fan types are based in an unacknowledged critique of modernity. Once fans are characterized as deviant, they can be treated as disreputable, even dangerous 'others.'

Fans, when insistently characterized as 'them,' can be distinguished from 'people like us' (students, professors and social critics) as well as from (the more reputable) patrons or aficionados or collectors. But these respectable social types could also be defined as 'fans,' in that they display interest,

affection and attachment, especially for figures in, or aspects of, their chosen field.

But the habits and practices of, say, scholars and critics are not deemed fandom, and are not considered to be potentially deviant or dangerous. Why? My conclusion claims that the characterization of fandom as pathology is based in, supports, and justifies elitist and disrespectful beliefs about our common life.

Characterizing the Fan

The literature on fandom as a social and cultural phenomenon is relatively sparse. What has been written is usually in relationship to discussions of celebrity or fame. The fan is understood to be, at least implicitly, a result of celebrity – the fan is defined as a *response* to the star system. This means that passivity is ascribed to the fan – he or she is seen as being brought into (enthralled) existence by the modern celebrity system, via the mass media.

This linking of fandom, celebrity and the mass media is an unexamined constant in commentary on fandom. In a *People Weekly* article on the killing of TV actress Rebecca Schaeffer by an obsessive fan, a psychologist is quoted as saying:

> The cult of celebrity provides archetypes and icons with which alienated souls can identify. On top of that, this country has been embarking for a long time on a field experiment in the use of violence on TV. It is commonplace to watch people getting blown away. We've given the losers in life or sex a rare chance to express their dominance.[1]

In one brief statement, cults, alienation, violence, TV, losers and domination (themes that consistently recur in the fandom literature) are invoked. A security guard, also quoted in the article, blames media influence for fan obsessions: 'It's because of the emphasis on the personal lives of media figures, especially on television. And this has blurred the line between appropriate and inappropriate behavior.'[2]

In newspaper accounts, mental health experts offer descriptions of psychic dysfunctions like 'erotomania' and 'Othello's Syndrome,' and suggest that the increase in fan attacks on celebrities may be due to 'an increasingly narcissistic society or maybe the fantasy life we see on television.'[3]

This same blending of fandom, celebrity and presumed media influence in relation to pathological behavior can be found in more scholarly accounts. Caughey describes how, in a media addicted age, celebrities function as role models for fans who engage in 'artificial social relations' with them. He discusses fans who pattern their lives after fantasy celebrity figures, and describes at some length an adolescent girl, 'A,' who in 1947 shot Chicago Cubs first baseman Eddie Waitkus. He argues that her behavior cannot simply be dismissed as pathological, because up to a point her fan activity resembled that of other passionate fans. The model of fandom Caughey develops is one in which pathological fandom is simply a more intense, developed version of more common, less dangerous, fan passion.[4]

This is also Schickel's explicit claim. He ends his book on the culture of celebrity by comparing deranged fans and serial killers to 'us.' He concludes that we 'dare not turn too quickly away' from 'these creatures' who lead 'mad existences' because 'the forces that move them also move within ourselves in some much milder measure.'[5] These academically-oriented accounts develop an image of the pathological fan who is a deranged version of 'us.'

One model of the pathological fan is that of the obsessed loner, who (under the influence of the media) has entered into an intense fantasy relationship with a celebrity figure. These individuals achieve public notoriety by stalking or threatening or killing the celebrity. Former 'crazed' acts are referenced in current news stories of 'obsessive' fans: Mark David Chapman's killing of ex-Beatle John Lennon, and John Hinckley's attempted assassination of President Ronald Reagan (to gain and keep the attention of actress Jodie Foster) are frequently brought up as iconic examples of the obsessed loner type.

This loner characterization can be contrasted with another version of fan pathology: the image of a frenzied or hysterical member of a crowd. This is the screaming, weeping teen at the

11

airport glimpsing a rock star, or the roaring, maniacal sports fan rioting at a soccer game. This image of the frenzied fan predominates in discussions of music fans and sports fans.

Since the 1950s, images of teens, rock 'n' roll and out-of-control crowds have been intertwined. In press coverage, the dangers of violence, drink, drugs, sexual and racial mingling are connected to music popular with young people. Of particular concern are the influences of the music's supposedly licentious lyrics and barbaric rhythms. Crowds of teen music fans have been depicted as animalistic and depraved, under the spell of their chosen musical form. Heavy Metal is the most recent genre of youth music to evoke this frightening description of seductive power: Metal fans are characterized, especially by concerned parents, as vulnerable youngsters who have become 'twisted' in response to the brutal and Satanic influence of the music.[6]

The press coverage of rock concerts almost automatically engages these images of a crazed and frantic mob, of surging crowds that stampede out of control in an animalistic frenzy. When 11 teenagers were crushed to death in Cincinnati's Riverfront Coliseum (before a 1979 concert by The Who) press coverage was instantly condemnatory of the ruthless behaviour of the frenzied mob. In his Chicago-based syndicated column, Mike Royko vilified the participants as 'barbarians' who 'stomped 11 persons to death [after] having numbed their brains on weeds, chemicals and Southern Comfort.'[7]

Yet, after investigation, the cause of the tragic incident was ascribed not to a panic or a stampede of selfish, drug-crazed fans, but instead to structural inadequacies of the site, in combination with inadequate communication between police, building workers and ticket-takers. Apparently, most crowd members were unsuccessfully (but often heroically) trying to help each other escape from the crush, a crush caused by too few doors into the arena being opened to accommodate a surge of people pressing forward, unaware of the fatal consequences at the front of the crowd.

In other words, the immediately circulated image of mass fan pathology (a crazed and depraved crowd climbing over dead bodies to get close to their idols) was absolutely untrue. As Johnson concludes, 'the evidence . . . is more than sufficient

12

to discount popular interpretations of "The Who Concert Stampede" which focus on the hedonistic attributes of young people and the hypnotic effects of rock music.'[8] Nonetheless, the 'hedonistic and hypnotic' interpretation was widely made, an interpretation consistent with the iconic fans-in-a-frenzy image historically developed in connection with musical performances.

Concern over fan violence in crowds also appears in relation to sports. There is an academic literature, for example, on football hooliganism.[9] This literature explores the reasons for violence at (mostly) soccer games, where 'hard-core hooligans' engage in violent and destructive acts, often against the opposing teams' fans. These incidents have become cause for social concern, and have been researched in some depth, especially in Britain. Even though, obviously, not all soccer fans engage in spectator violence, the association between fandom and violent, irrational mob behaviour is assumed. In this literature, fans are characterized as easily roused into violent and destructive behavior, once assembled into a crowd and attending competitive sports events.[10]

To summarize, there is very little literature that explores fandom as a normal, everyday cultural or social phenomenon. Instead, the fan is characterized as (at least potentially) an obsessed loner, suffering from a disease of isolation, or a frenzied crowd member, suffering from a disease of contagion. In either case, the fan is seen as being irrational, out of control, and prey to a number of external forces. The influence of the media, a narcissistic society, hypnotic rock music, and crowd contagion are invoked to explain how fans become victims of their fandom, and so act in deviant and destructive ways.

Fans as Socially Symptomatic

What explains these two iconic images? One possibility is that they genuinely embody two different aspects of the fan/celebrity interaction – individual obsessions, privately elaborated, and public hysteria, mobilized by crowd contagion. But *do* these models accurately or adequately describe the ways in which fandom is manifested in contemporary life? *Are* they

appropriate representations of fandom? Do fans *really* risk becoming obsessed assassins or hysterical mobs? Do they (we) too easily 'cross the line' into pathological behavior, as Schickel suggests, because 'we suffer to some degree from the same confusion of realms that brings them, finally, to tragedy?'[11]

I suspect not, and the crux of my argument here is that these particular pathological portrayals exist in relation to different, unacknowledged issues and concerns. I believe that these two images tell us more about what we want to believe about modern society, and our connection to it, than they do about actual fan–celebrity relations.[12]

What is assumed to be true of fans – that they are potentially deviant, as loners or as members of a mob – can be connected with deeper, and more diffuse, assumptions about modern life. Each fan type mobilizes related assumptions about modern individuals: the obsessed loner invokes the image of the alienated, atomized 'mass man'; the frenzied crowd member invokes the image of the vulnerable, irrational victim of mass persuasion. These assumptions – about alienation, atomization, vulnerability and irrationality – are central aspects of twentieth-century beliefs about modernity.

Scholars as well as everyday people characterize modern life as fundamentally different from pre-modern life. Basically, the present is seen as being materially advanced but spiritually threatened. Modernity has brought technological progress but social, cultural and moral decay. The modernity critique is both nostalgic and romantic, because it locates lost virtues in the past, and believes in the possibility of their return.

In the early twentieth century, mass society terms (like alienation and atomization) took on added resonance in the urbanizing and industrializing United States, where the inevitable beneficence of progress (celebrated by technocrats and industrialists) was being increasingly questioned by intellectuals and social critics. Two aspects were of particular concern to American critics – the decline of community, and the increasing power of the mass media.

These concerns are related. Communities are envisioned as supportive and protective, they are believed to offer identity and connection in relation to traditional bonds, including race,

14

religion and ethnicity. As these communal bonds are loosened, or discarded, the individual is perceived as vulnerable – he or she is 'unstuck from the cake of custom' and has no solid, reliable orientation in the world.

The absence of stable identity and connection is seen as leaving the individual open to irrational appeals. With the refinement of advertising and public relations campaigns in the early twentieth century, along with the success of wartime propaganda, and the dramatic rise in the popularity of film and radio, fears of the immense and inescapable powers of propaganda techniques grew. It seemed that 'mass man' could all too easily become a victim of 'mass persuasion.' And under the spell of propaganda, emotions could be whipped into frenzies, publics could become crowds and crowds could become mobs.

This conceptual heritage, which defines modernity as a fragmented, disjointed mass society, is mobilized in the two images of the pathological fan. The obsessed loner is the image of the isolated, alienated 'mass man.' He or she is cut off from family, friends and community. His or her life becomes increasingly dominated by an irrational fixation on a celebrity figure, a perverse attachment that dominates his or her otherwise unrewarding existence. The vulnerable, lonely modern man or woman, seduced by the mass media into fantasy communion with celebrities, eventually crosses the line into pathology, and threatens, maims or kills the object of his or her desire.

The frenzied fan in a crowd is also perceived to be vulnerable, but this time to irrational loyalties sparked by sports teams or celebrity figures. As a member of a crowd, the fan becomes irrational, and thus easily influenced. If she is female, the image includes sobbing and screaming and fainting, and assumes that an uncontrollable erotic energy is sparked by the chance to see or touch a male idol. If he is male, the image is of drunken destructiveness, a rampage of uncontrollable masculine passion that is unleashed in response to a sports victory or defeat.

Dark assumptions underlie the two images of fan pathology, and they haunt the literature on fans and fandom. They are referenced but not acknowledged in the relentless retelling of

particular examples of violent or deranged fan behavior. Fans are seen as displaying symptoms of a wider social dysfunction – modernity – that threatens all of 'us.'

Fandom as Psychological Compensation

The modernity critique, with its associated imagery of the atomized individual and the faceless crowd, is mostly social theory – it does not directly develop assumptions about individual psychology. Nonetheless, it implies a connection between social and psychological conditions – a fragmented and incomplete modern society yields a fragmented and incomplete modern self. What we find, in the literature of fan–celebrity relationships, is a psychologized version of the mass society critique. Fandom, especially 'excessive' fandom, is defined as a form of psychological compensation, an attempt to make up for all that modern life lacks.

In 1956, Horton and Wohl characterized the media–audience relationship as a form of 'para-social interaction.'[13] They see fandom as a surrogate relationship, one that inadequately imitates normal relationships. They characterize the media mode of address as a 'simulacrum of conversation' and demonstrate how it tries to replicate the virtues of face-to-face interaction.

They also examine the structure and strategies of celebrity public relations, noting how they function to create what they call the celebrity 'persona.' They suggest that 'given the prolonged intimacy of para-social relations . . . it is not surprising that many members of the audience become dissatisfied and attempt to establish actual contact One would suppose that contact with, and recognition by, the persona transfers some of his prestige and influence to the active fan.' This implies that the fan, unable to consummate his desired social relations 'normally,' seeks celebrity contact in the hope of gaining the prestige and influence he or she psychologically needs, but cannot achieve in anonymous, fragmented modern society.

This statement is followed by commentary on a letter written to Ann Landers by a female fan (another 'Miss A.'), who says she has 'fallen head over heels in love with a local television star'

and now can't sleep, finds other men to be 'childish,' and is bored by her modeling job. Miss A. is said to reveal in this letter 'how narrow the line often is between the more ordinary forms of social interaction and those which characterize relations with the persona.' Even worse, 'persona' relations are deemed to have 'invaded' Miss A.'s life, 'so much so that, without control, it will warp or destroy her relations with the opposite sex' (p. 206).

Horton and Wohl suggest, however, that 'it is only when the para-social relationship becomes a substitute for autonomous social participation, when it proceeds in absolute defiance of objective reality, that it can be regarded as pathological' (p. 200). These extreme forms of fandom, they claim, are mostly characteristic of the socially isolated, the socially inept, the aged and invalid, the timid and rejected. For these and similarly deprived groups, para-social interaction is an attempt by the socially excluded (and thus psychologically needy) to compensate for the absence of 'authentic' relationships in their lives.

Schickel suggests that celebrities act to fulfill our own dreams of autonomy (the famous appear to have no permanent allegiances) and dreams of intimacy (the famous appear to belong to a celebrity community). The psychopathic fan-turned-assassin, he implies, similarly uses mediated celebrities to form an identity, although he kills in order to share their power and fame. To be a fan, Schickel and others imply, is to attempt to live vicariously, through the perceived lives of the famous. Fandom is conceived of as a chronic attempt to compensate for a perceived personal lack of autonomy, absence of community, incomplete identity, lack of power and lack of recognition.

These vague claims, bolstered by various strains of social and psychological research, parallel, strikingly, the claims made about the reasons for fanaticism. Milgram defines a fanatic as 'someone who goes to extremes in beliefs, feelings and actions.'[14] He suggests that fanatics use belief systems as a 'therapeutic crutch . . . staving off a collapse of self worth.' Any challenge to the fanatic's belief system is seen as a 'threat to his self-esteem,' and thus to his 'ego-defensive system.'

Interestingly, deviants are also seen by researchers as lacking in self-worth, or as having weak 'ego-boundaries.'[15] This

17

characteristic may even be linked to 'role engulfment,' where the identity of deviance becomes a way to organize a 'concept of self.'[16] Thus in all three concepts (fan, fanatic and deviant) a psychological portrait of fundamental inadequacy, and attempted compensation, is developed.

The inadequate fan is defined as someone who is making up for some inherent lack. He or she seeks identity, connection and meaning via celebrities and team loyalties. Like the fanatic and the deviant, the fan has fragile self-esteem, weak or non-existent social alliances, a dull and monotonous 'real' existence. The mass media provide (the argument goes) ways for these inadequate people to bolster, organize and enliven their unsatisfying lives.

Fandom, however, is seen as a risky, even dangerous, compensatory mechanism. The fan-as-pathology model implies that there is a thin line between 'normal' and excessive fandom. This line is crossed if and when the distinctions between reality and fantasy break down. These are the two realms that must remain separated, if the fan is to remain safe and normal.[17]

The literature implies that 'normal' fans are constantly in danger of becoming 'obsessive loners' or 'frenzied crowd members.' Ann Lander's curt response to Miss A. ('you are flunking the course of common sense') is figuratively given to all fans – as long as the fan shows 'good common sense,' remains 'rational' and 'in control', then he or she will be spared. But if the fan ceases to distinguish the real from the imaginary, and lets emotion overwhelm reason and somehow gets 'out of control,' then there are terrible consequences. These consequences are referenced in the cautionary tales of fans who go 'over the edge' into fanaticism, and thus pathology.

Aficionados as Fans

The literature on fandom, celebrity and media influence tells us that: Fans suffer from psychological inadequacy, and are particularly vulnerable to media influence and crowd contagion. They seek contact with famous people in order to compensate

for their own inadequate lives. Because modern life is alienated and atomized, fans develop loyalties to celebrities and sports teams to bask in reflected glory, and attend rock concerts and sports events to feel an illusory sense of community.

But what happens if we change the objects of this description from fans to, say, professors? What if we describe the loyalties that scholars feel to academic disciplines rather than to team sports, and attendance at scholarly conferences, rather than Who concerts and soccer matches? What if we describe opera buffs and operas? Antique collectors and auctions? Trout fisherman and angling contests? Gardeners and horticulture shows? Do the assumptions about inadequacy, deviance and danger still apply?

I think not. The paragraph makes sense only if it is believed to describe recognizable but nebulous 'others' who live in some world different from our own. Fandom, it seems, is not readily conceptualized as a general or shared trait, as a form of loyalty or attachment, as a mode of 'enacted affinity.' Fandom, instead, is what 'they' do; 'we,' on the other hand, have tastes and preferences, and select worthy people, beliefs and activities for our admiration and esteem. Furthermore, what 'they' do is deviant, and therefore dangerous, while what 'we' do is normal, and therefore safe.

What is the basis for these differences between fans like 'them' and aficionados like 'us'? There appear to be two crucial aspects – the objects of desire, and the modes of enactment. The objects of an aficionado's desire are usually deemed high culture: Eliot (George or T.S.) not Elvis; paintings not posters; the *New York Review of Books* not the *National Enquirer*. Apparently, if the object of desire is popular with the lower or middle class, relatively inexpensive and widely available, it is fandom (or a harmless hobby); if it is popular with the wealthy and well educated, expensive and rare, it is preference, interest or expertise.

Am I suggesting, then, that a Barry Manilow fan be compared with, for example, a Joyce scholar? The mind may reel at the comparison, but why? The Manilow fan knows intimately every recording (and every version) of Barry's songs; the Joyce scholar knows intimately every volume (and every version) of Joyce's *oeuvre*. The relationship between Manilow's real life

and his music is explored in detail in star biographies and fan magazines; the relationship between Dublin, Bloomsday and Joyce's actual experiences are explored in detail in biographies and scholarly monographs.

Yes, you may say, there are indeed these surface similarities. But what about the fans who are obsessed with Barry, who organize their life around him?[18] Surely no Joyce scholar would become equally obsessive? But the uproar over the definitive edition of *Ulysses*[19] suggests that the participant Joyceans are fully obsessed, and have indeed organized their life (even their 'identity' and 'community') around Joyce.

But is a scholar, collector, aficionado 'in love' with the object of his or her desire? Is it the existence of passion that defines the distinction between fan and aficionado, between dangerous and benign, between deviance and normalcy?

So far we have established that one aspect of the distinction between 'them' and 'us' involves a cultural hierarchy. At least one key difference, then, is that it is normal and therefore safe to be attached to elite, prestige-conferring objects (aficionado-hood), but it can be abnormal, and therefore dangerous to be attached to popular, mass-mediated objects (fandom).

But there is another key distinction being made between the fan and the aficionado. Fans are believed to be obsessed with their objects, in love with celebrity figures, willing to die for their team. Fandom involves an ascription of excess, and emotional display – hysterics at rock concerts, hooliganism at soccer matches, autograph seeking at celebrity sites. Affinity, on the other hand, is deemed to involve rational evaluation, and is displayed in more measured ways – applause and a few polite 'Bravos!' after concerts; crowd murmurs at polo matches; attendance of 'big-name' sessions at academic conferences.

This valuation of the genteel over the rowdy is based in status (and thus class) distinctions. It has been described in nineteenth-century parades,[20] public cultural performances,[21] and turn of the century newspaper styles.[22] Unemotional, detached, 'cool' behavior is seen as more worthy and admirable than emotional, passionate, 'hot' behavior. 'Good' parades are orderly and sequential and serious (not rowdy, chaotic or lighthearted); 'good' audiences are passive and quiet and respectful (not active, vocal or critical); 'good' newspapers

are neutral, objective and gray (not passionate, subjective and colorful). Congruently, then, 'good' affinities are expressed in a subdued, undisruptive manner, while 'bad' affinities (fandom) are expressed in dramatic and disruptive ways.

The division between worthy and unworthy is based in an assumed dichotomy between reason and emotion. The reason–emotion dichotomy has many aspects. It describes a presumed difference between the educated and uneducated, as well as between the upper and lower classes. It is a deeply rooted opposition, one that the ascription of intrinsic differences between high and low culture automatically obscures.

Apparently, the real dividing line between aficionado and fan involves issues of status and class, as they inform vernacular cultural and social theory. Furthermore, the Joyce scholar and the Barry Manilow fan, the antique collector and the beer can collector, the opera buff and the Heavy Metal fan are differentiated not only on the basis of the status of their desired object, but also on the supposed nature of their attachment. The obsession of a fan is deemed emotional (low class, uneducated), and therefore dangerous, while the obsession of the aficionado is rational (high class, educated) and therefore benign, even worthy.

These culturally-loaded categories engage Enlightenment-originated ideas based on rationality. Reason is associated with the objective apprehending of reality, while emotion is associated with the subjective, the imaginative, and the irrational. Emotions, by this logic, lead to a dangerous blurring of the line between fantasy and reality, while rational obsession, apparently, does not. But does this reason–emotion dichotomy, complete with dividing line, hold up? Let me give you some examples from my own life, to suggest that the line is inevitably and constantly crossed, without pathological consequences, by respectable professorial types like me.

Anyone in academia, especially those who have written theses or dissertations, can attest to the emotional components of supposedly rational activity. A figure or topic can become the focal point of one's life; anything even remotely connected to one's research interests can have tremendous impact and obsessive appeal. For example, while I was writing my dissertation (on the commercialization of country music in the 1950s),

21

the chance to touch Patsy Cline's mascara wand, retrieved from the site of her 1963 plane crash, gave me chills.

Similarly, (but far more respectably) the handling of a coffee cup made by William Morris was deeply moving. I have also envied a colleague who once owned a desk that had been used by John Dewey, and I display a framed copy of a drawing of William James in my office. I would be thrilled if I could own any memorabilia associated with Lewis Mumford, to whom I regret not having written a letter of appreciation before he died.

Am I, then, a fan of Patsy Cline, William Morris, William James, John Dewey and Lewis Mumford? Or of country music, the pre-Raphaelites, the pragmatists and iconoclastic social critics? Yes, of course I am, if fandom is defined as an interest in, and an attachment to, a particular figure or form. Would I write a fan letter to these figures? Yes, if fan letter includes (as it does, in academic circles) review essays or appreciative quotation. Would I read a fanzine? Again yes, but in the scholarly versions – heavily footnoted biographies and eloquent critical appreciations. Would I seek autographs? Yes, if I could do so without losing face, via auctions or books or scholarly correspondence. Would I collect memorabilia? Well, I confess here to having at least one version of all 100 of Patsy Cline's recordings; calendars and a piece of cloth designed by Morris; and as many books as I can afford to purchase by James, Dewey and Mumford, along with miscellaneous biographies, reviews and commentaries.[23]

Would I defend my 'team,' the pragmatists, against the attacks on them by, say, Hegelians, neo-Marxists and/or post-structuralists? You bet. Would I do so in a rowdy, rambunctious or violent way? Of course not. I would respond instead with respectable rowdiness (acerbic asides in scholarly articles) and acceptable violence (the controlled, intellectual aggression often witnessed in conference presentations).

Would I claim to be 'in love' with any of these individuals, would I offer to die for any of these preferences? Not likely, and certainly not in public. I would lose the respect of my peers. Instead, I will say that I 'admire' William James, I 'read with interest' Lewis Mumford, I 'enjoy' pre-Raphaelite design and 'am drawn to' aspects of pragmatism. In short, I will

display aficionado-hood, with a vengeance. But, as I hope my confessions have made obvious, my aficionado-hood is really disguised, and thereby legitimated, fandom.

The pejorative connotations of fans and fandom prevent me from employing those terms to describe and explore my attachments. While my particular affinities may be somewhat idiosyncratic, everyone I've ever met has comparable ones. Most of us seem to have deep, and personal, interests, and we enact our affinities by investing time, money and 'ourselves' in them. I have even been fortunate enough to make a living in relation to my interests. Does that mean I am truly 'obsessed' by them? Am I, perhaps, even more dysfunctional than most because I force others (like students) to listen, even temporarily to participate, in my predilections?

Were I to call myself a fan, I would imply that I am emotionally engaged with unworthy cultural figures and forms, and that I was risking obsession, with dangerous consequences. I would imply that I was a psychologically incomplete person, trying to compensate for my inadequate life through the reflected glory of these figures and forms. My unstable and fragile identity needs them, they are a 'therapeutic crutch,' a form of 'para-social relations,' functioning as 'personas' in my life. I must have these relationships because my lonely, marginal existence requires that I prop myself up with these fantasy attachments to famous dead people, and these alliances with abstract, imaginary communities.

Obviously, I find these ascriptions of dysfunction, based on my affinities, to be misguided and muddleheaded, as well as extraordinarily insulting. I assume that others would, too, whether they call themselves aficionados or fans. The pejorative association of fandom with pathology is stunningly disrespectful, when it is applied to 'us' rather than 'them.'

The Consequences of Circumscription

There are consequences to defining fans as abnormal 'others,' irrationally obsessed with particular figures or cultural forms, capable of violent and destructive behavior. To consider these consequences, we need first to discuss why this kind of

stigmatizing definition have been developed, and why it continues to dominate the literature. What purposes does such a conceptualization serve?

Stigmatization of a persona or group can be seen as a way of relieving anxiety[24] by a display of hostility or aggression. It is a form of displacement, a blaming, a scapegoating that allows explanation in ambivalent or contradictory circumstances.

By conceiving of fans as members of a lunatic fringe which cracks under the pressure of modernity, as the canaries in the coal mines whose collapse indicates a poisonous atmosphere, we tell ourselves a reassuring story – yes, modernity is dangerous, and some people become victims of it by succumbing to media influence or mob psychology, *but we do not*. 'We' are not these unstable, fragile and therefore vulnerable people. We are psychologically stable and solid ('normal') and we will not crack. We recognize and maintain an equilibrium. Unlike obsessed and frenzied fans, we are in touch with reality. We have not crossed that line between what is real and what is imaginary.

To summarize, one outcome of the conceptualization of the fan as deviant is reassurance – 'we' are safe, because 'we' are not as abnormal as 'they' are, and the world is safe, because there is a clear demarcation between what is actual and what is imagined, what is given and what is up for grabs.

Defining disorderly and emotional fan display as excessive allows the celebration of all that is orderly and unemotional. Self-control is a key aspect of appropriate display. Those who exhibit charged and passionate response are believed to be out of control; those who exhibit subdued and unimpassioned reaction are deemed to be superior types. Thus the 'we' who write about, and read about, 'them,' the fans, get to be allied with the safe and superior and worthy types. 'We' get to be thoughtful, educated and discriminating, if we assume that 'they' are obsessed, uneducated and indiscriminate. Not only do 'we' get to be safe, in spite of the perceived dangers of modernity, but we also get to be better than this group of inferior types – fans.

Defining fandom as a deviant activity allows (individually) a reassuring, self-aggrandizing stance to be adopted. It also supports the celebration of particular values – the rational over

the emotional, the educated over the uneducated, the subdued over the passionate, the elite over the popular, the mainstream over the margin, the status quo over the alternative. The beliefs evidenced in the stigmatization of fans are inherently conservative, and they serve to privilege the attributes of the wealthy, educated and powerful. If these are indeed the attributes and values that the critic or researcher seeks to celebrate, then they should be disentangled from their moorings in objective research or critical inquiry, and directly addressed.

Treating people as 'others' in social and psychological analysis risks denigrating them in ways that are insulting and absurd. The literature on deviance, fanaticism and fandom has a thinly veiled subtext – how are 'we' not 'them'? The 'others' become interesting cases, that tell us about life on the margin, or in the wild, under duress, or on the edge. Like primitive tribes to be saved by missionaries, or explained by anthropologists, we too easily use social and psychological inquiry to develop and defend a self-serving moral landscape. That terrain cultivates in us a dishonorable moral stance of superiority, because it makes others into examples of extrinsic forces, while implying that we somehow remain pure, autonomous, and unafflicted.

Much social analysis gets conducted from this savannah of smug superiority, particularly research on media effects. Whether researchers are concerned with the media uses and gratifications, or the circulation of ideology, or the reasons for fandom, 'they' (viewers, consumers and fans) are seen as victims of forces that somehow can not and will not influence 'us.' The commentator on fandom is protected by reason or education or critical insight: thanks to these special traits, 'we' don't succumb to whatever it is we believe applies to 'them.'

This is not only a dishonorable stance, individually, but it is a severely truncated basis for inquiry. It means that the perceived-to-be deviant, exotic and dramatic, is studied with zeal, while the normal, everyday, and accepted is ignored. Little is known, for example, about the variety of ways people make meaning in everyday ways. We know far too little about the nature – and possibilities – of varieties of affection, attachment, sentiment and interest, *as they are manifested in people's lives*. How and why do we invest meaning and value in things, lives, ideals? Does our selection of particular figures

and forms connect with other aspects of ourselves? How does sentiment work? How and why do things mean? These are not trivial or uninteresting questions, but so far they have barely been studied, except perhaps in the humanities as 'aesthetics,' and in the social sciences as functions of other (economic or psychological or demographic) forces.

I am arguing here that social inquiry and criticism can and should proceed very differently. They should not define people as collections of preferences to be analyzed and controlled, any more than they should define them as unwitting victims of ideology or advertising or media or mob mentalities or ego-fragmentation. Social inquiry can and should be a form of respectful engagement. It can and should illuminate the experiences of others *in their own terms*, because these 'others' are us, and human experiences intrinsically and inherently matter. Constantly to reduce what other people do to dysfunction or class position or psychic needs or socio-economic status is to reduce others to uninteresting pawns in a game of outside forces and to glorify ourselves as somehow off the playing field, observing and describing what is really going on.

If we instead associate ourselves with those 'others,' assume that there are important commonalties as well as differences between all individuals, communities and social groups, and believe that we are constantly engaged in a collective enterprise of reality creation, maintenance and repair, then we are less likely to succumb to the elitism and reductionism that so far has characterized the research and literature on fans and fandom. What I am suggesting is that we respect and value other people as if they were us, because they always are. I ask that we avoid, assiduously, the seduction of separateness that underlies the description of fans as pathological.

The moral iconography of the deviant other fosters a belief that modernity hurts 'them' and (for now) spares us, that the habits and practices of the wealthy and educated are to be valued and emulated, and that 'we' are inevitably separate from, and superior to, 'them.' To the extent that we stigmatize fandom as deviant, we cut ourselves off from understanding how value and meaning are enacted and shared in contemporary life. If we continue to subscribe to the dominant perspective on fandom – pathology – inquiry on fandom cannot help us

understand how we engage with the world. Instead, we will continue to conceptualize the fan as desperate and dysfunctional, so that he or she can be explained, protected against, and restored to 'normalcy.'

I believe what it means to be a fan should be explored in relation to the larger question of what it means to desire, cherish, seek, long, admire, envy, celebrate, protect, ally with others. Fandom is an aspect of how we make sense of the world, in relation to mass media, and in relation to our historical, social, cultural location. Thinking well about fans and fandom can help us think more fully and respectfully about what it means today to be alive and to be human.

Notes

1 Marilyn Robinette Marx, quoted in Axthelm (1989).
2 Gavin de Becker is described in Axthelm (1989, p. 66) as 'an L.A. security expert who helps stars ward off unwanted attentions.'
3 Jack Pott, Assistant Clinical Director of Psychiatry for Maricopa County Health Services, quoted in Rosenblum (1989), an *Arizona Daily Star* article kindly provided to me by Lisa Lewis.
4 Caughey (1978a). See also Caughey (1978b).
5 Schickel (1985). See especially the final pages.
6 See Miller (1988).
7 Quoted in Johnson (1987).
8 Johnson, ibid.
9 See, for example: Ingham (1978); Lee (1985); and Marsh *et al.* (1978).
10 See Dunning, Murphy and Williams (1986, p. 221), where they say that many fans are 'drawn into hooligan incidents – fans who did not set out for the match with disruptive intent . . . [by contact with] hard-core hooligans.'
11 Schickel (1985, p. 285).
12 The argument in this essay draws on my belief that vernacular social theory is accessible through the analysis of the narrative strategies of popular and scholarly accounts. I develop this belief, as well as the associated notion of the displacement of ambivalence, or scapegoating, in Jensen (1990).
13 Horton and Wohl (1956). Subsequently reprinted in Gumpert and Cathcart (eds) (1982).
14 Milgram (1977).
15 See, for example, the model developed by S. Giora Shoham (1976).

16 See the brief summary of this and other claims in Schur (1971).
17 The mass media, in conjunction with modern society, are believed somehow to blur this necessary distinction. The media are defined as dangerous precisely because they are believed to disrupt people's ability consistently and reliably to separate fantasy from reality. This account of media influence is pervasive, but fails to recognize the historical presence of narrativity in cultures, and that the insistence on distinctions between 'objective' fact and 'subjective' fiction is an historically recent development.
18 Vermorel (1985).
19 Probably best recorded in the *New York Review of Books* letters, in 1988 and 1989.
20 See Davis (1986).
21 Levine (1988).
22 Schudson (1978).
23 In the case of William James, my fandom extends to an interest in his parents and siblings, and I wish I knew something about his descendants. I have considered taking a vacation that would include visits to places he lived and worked. I disagree with some of the interpretations of some of his biographers, and am infuriated by Leon Edel's 'unfair' portrayal of William in his biography of Henry James.
24 See, for example, the conclusion of Shoham (1976).

References

Axthelm, Pete. 1989. An Innocent Life, A Heartbreaking Death. *People Weekly* 32 (5): 60–66.
Caughey, John L. 1978a. Artificial Social Relations in Modern America. *American Quarterly* 30(1).
———1978b. Media Mentors. *Psychology Today* 12(4): 44–49.
Davis, Susan. 1986. *Parades and Power: Street Theatre in Nineteenth-Century Philadelphia*. Philadelphia: Temple University Press.
Dunning, Eric, Patrick Murphy, and John Williams. 1986. Spectator Violence at Football Matches: Towards a Sociological Explanation. *The British Journal of Sociology* 37(2).
Gumpert, Gary and Robert Cathcart. 1982. *Inter/Media: Interpersonal Communication in a Media World*, 2nd edn. New York: Oxford University Press.
Horton, David and R. Richard Wohl. 1956. Mass Communication and Parasocial Interaction: Observation on Intimacy at a Distance. *Psychiatry* 19(3): 188–211.
Ingham, Roger (ed.). 1978. *Football Hooliganism: The Wider Context*. London: Inter-Action.
Jensen, Joli. 1990. *Redeeming Modernity: Contradictions in Media Criticism*. Beverly Hills: Sage Publications.

Johnson, Norris R. 1987. Panic at 'The Who Stampede': An Empirical Assessment. *Social Problems* 34(4): 362.

Lee, Martin J. 1985. From Rivalry to Hostility Among Sports Fans. *Quest* 37(1): 38–49.

Levine, Lawrence W. 1988. *Highbrow/Lowbrow: The Emergence of Cultural Hierarchy in America.* Boston: Harvard University Press.

Marsh, Peter, Elizabeth Rosser, and Rom Harre. 1978. *The Rules of Disorder.* London: Routledge & Kegan Paul.

Milgram, Stanley. 1977. The Social Meaning of Fanaticism. *Et Cetera* 34(1): 58–61.

Miller, Dale. 1988. Youth, Popular Music and Cultural Controversy: The Case of Heavy Metal. PhD thesis, University of Texas at Austin.

Rosenblum, Keith. 1989. Psychiatrists Analyze Fantasies, Fixations that Lead to Crimes Against Celebrities. *Arizona Daily Star* July 21, Section A: p. 2.

Schickel, Richard. 1985. Coherent Strangers. In *Intimate Strangers: The Culture of Celebrity.* Garden City, New York: Doubleday.

Schudson, Michael. 1978. *Discovering the News: A Social History of American Newspapers.* New York: Basic Books.

Schur, Edwin M. 1971. New York: Harper & Row.

Shoham, S. Giora. 1976. *Social Deviance.* New York: Gardner Press.

Vermorel, Fred and Judy. 1985. *Starlust: The Secret Fantasies of Fans.* London: W. H. Allen.

The Cultural Economy of Fandom

JOHN FISKE

Fandom is a common feature of popular culture in industrial societies. It selects from the repertoire of mass-produced and mass-distributed entertainment certain performers, narratives or genres and takes them into the culture of a self-selected fraction of the people. They are then reworked into an intensely pleasurable, intensely signifying popular culture that is both similar to, yet significantly different from, the culture of more 'normal' popular audiences. Fandom is typically associated with cultural forms that the dominant value system denigrates – pop music, romance novels, comics, Hollywood mass-appeal stars (sport, probably because of its appeal to masculinity, is an exception). It is thus associated with the cultural tastes of subordinated formations of the people, particularly with those disempowered by any combination of gender, age, class and race.

All popular audiences engage in varying degrees of semiotic productivity, producing meanings and pleasures that pertain to their social situation out of the products of the culture industries. But fans often turn this semiotic productivity into some form of textual production that can circulate among – and thus help to define – the fan community. Fans create a fan culture with its own systems of production and distribution that forms what I shall call a 'shadow cultural economy' that lies outside that of the cultural industries yet shares features with them which more normal popular culture lacks.

In this essay I wish to use and develop Bourdieu's metaphor of describing culture as an economy in which people invest

and accumulate capital. The cultural system works like the economic system to distribute its resources unequally and thus to distinguish between the privileged and the deprived. This cultural system promotes and privileges certain cultural tastes and competences, particularly through the educational system, but also through other institutions such as art galleries, concert halls, museums, and state subsidies to the arts, which taken together constitute a 'high' culture (ranging from the traditional to the avant-garde). This culture is socially and institutionally legitimated, and I shall refer to it as official culture, in distinction from popular culture which receives no social legitimation or institutional support. Official culture, like money, distinguishes between those who possess it, and those who do not. 'Investing' in education, in acquiring certain cultural tastes and competences, will produce a social 'return' in terms of better job prospects, of enhanced social prestige and thus of a higher socio-economic position. Cultural capital thus works hand in hand with economic capital to produce social privilege and distinction.

Bourdieu (1984) has analyzed in detail how accurately cultural tastes can be mapped onto economic status within the social space. He models our society first as a two-dimensional map in which the vertical, or north–south, axis records the amount of capital (economic *and* cultural) possessed, and the horizontal, or east–west, records the type of capital (economic *or* cultural). Those on the west, or left, are higher in cultural capital than economic capital (e.g. academics, artists, etc.), whereas those on the east or right possess more economic than cultural (business people, manufacturers). In the top center of the map reside those rich in both forms of capital – the professions such as architects, doctors, lawyers and so on, the educated, 'tasteful' capitalists! The south, or bottom, of the diagram is occupied by those deprived of both, whom Bourdieu calls 'the proletariat.'

Both forms of capital are complicated further by whether they have been inherited or acquired. The difference between old and new money is a crucial distinction for the 'northerners' though ludicrous to the poor; similarly the distinction between acquired and inherited cultural capital becomes more important as we move northwards in the social space. Briefly,

31

acquired cultural capital is that produced by the educational system and consists of the knowledge and critical appreciation of a particular set of texts, 'the canon,' in literature, art, music and now, increasingly, film. Inherited cultural capital is manifest in lifestyle rather than in textual preference – in fashion, furnishings, manners, in choice of restaurant or club, in sport or vacation preferences.

This is a productive model, but it has two main weaknesses. The first is its emphasis on economics and class as the major (if not the only) dimension of social discrimination. We need to add to Bourdieu's model gender, race and age as axes of discrimination, and thus to read his account of how culture works to underwrite class differences as symptomatic of its function in other axes of social difference. In this essay I wish to focus on class, gender and age as axes of subordination. I regret being unable to devote the attention to race which it deserves, but I have not found studies of non-white fandom. Most of the studies so far undertaken highlight class, gender and age as the key axes of discrimination.

Bourdieu's other weakness, for my particular purposes, is his failure to accord the culture of the subordinate the same sophisticated analysis as that of the dominant. He subdivides dominant culture into a number of competing categories, each characteristic of socially distinguished groups within the bourgeoisie. But he leaves proletarian culture and the proletariat as an undistinguished homogeneity. This leads him seriously to underestimate the creativity of popular culture and its role in distinguishing between different social formations within the subordinated. He does not allow that there are forms of popular cultural capital produced outside and often against official cultural capital.

These two weaknesses can be compensated for, and should not blind us to the value of his work. A concept of his which I find particularly useful is that of the *habitus*. The habitus includes the notion of a habitat, the habitants and the processes of inhabiting it, and the habituated ways of thinking that go with it. It encompasses our position within the social space, the ways of living that go with it and what Bourdieu calls the associated 'dispositions' of mind, cultural tastes and ways of thinking and feeling. The habitus refuses the

traditional distinction between the social and the individual, and it reformulates the relationship between domination and subjectivity.

One final point to make about Bourdieu's model is that the idea of a map includes that of movement. Social space is that through which both class or social groups and individuals move through time. Acquiring or losing capital of either sort changes one's position on the map and thus one's habitus. In this essay I shall base my argument upon Bourdieu's model, modified to take account of gender and age as axes of subordination, and extended to include forms of 'popular cultural capital' produced by subordinate social formations (Fiske 1989a), which can serve, in the subordinate, similar functions to those of official cultural capital in the dominant context. Fans, in particular, are active producers and users of such cultural capital and, at the level of fan organization, begin to reproduce equivalents of the formal institutions of official culture. By the conclusion of this essay I hope to have shown that fan culture is a form of popular culture that echoes many of the institutions of official culture, although in popular form and under popular control. It may be thought of as a sort of 'moonlighting' in the cultural rather than the economic sphere, a form of cultural labor to fill the gaps left by legitimate culture. Fandom offers ways of filling cultural lack and provides the social prestige and self-esteem that go with cultural capital. As with economic capital, lack cannot be measured by objective means alone, for lack arises when the amount of capital possessed falls short of that which is desired or felt to be merited. Thus a low achiever at school will lack official cultural capital and the social, and therefore self-esteem that it brings. Some may well become fans, often of a musician or sports star, and through fan knowledge and appreciation acquire an unofficial cultural capital that is a major source of self-esteem among the peer group. While fandom may be typical of the socially and culturally deprived, it is not confined to them. Many young fans are successful at school and are steadily accumulating official cultural capital, but wish still to differentiate themselves, along the axis of age at least, from the social values and cultural tastes (or habitus) of those who currently possess the cultural and economic capital they

are still working to acquire. Such social distinction, defined by age rather than class or gender, is often expressed by their fandom and by accumulation of unofficial or popular cultural capital whose politics lie in its opposition to the official, dominant one.

Such popular cultural capital, unlike official cultural capital, is not typically convertible into economic capital, though, as will be argued below, there are exceptions. Acquiring it will not enhance one's career, nor will it produce upward class mobility as its investment payoffs. Its dividends lie in the pleasures and esteem of one's peers in a community of taste rather than those of one's social betters. Fans, then, are a good example of Bourdieu's 'autodidacts' – the self-taught who often use their self-acquired knowledge and taste to compensate for the perceived gap between their actual (or official) cultural capital, as expressed in educational qualifications and the socio-economic rewards they bring, and what they feel are their true desserts.

Fandom, then, is a peculiar mix of cultural determinations. On the one hand it is an intensification of popular culture which is formed outside and often against official culture, on the other it expropriates and reworks certain values and characteristics of that official culture to which it is opposed.

I propose to discuss the main characteristics of fandom under three headings: Discrimination and Distinction, Productivity and Participation, and Capital Accumulation. These are characteristics of fandom in general rather than of any one fan or group of fans in particular. No one fan or fan community will exhibit all of them equally, but will differ considerably among themselves in emphasis.

Discrimination and Distinction

Fans discriminate fiercely: the boundaries between what falls within their fandom and what does not are sharply drawn. And this discrimination in the cultural sphere is mapped into distinctions in the social – the boundaries between the community of fans and the rest of the world are just as strongly

marked and patrolled. Both sides of the boundary invest in the difference; mundane viewers often wish to avoid what they see as the taint of fandom – 'I'm not really a fan, of course, but . . .' On the other side of the line, fans may argue about what characteristics allow someone to cross it and become a true fan, but they are clearly agreed on the existence of the line. Textual and social discrimination are part and parcel of the same cultural activity.

Fan discrimination has affinities to both the socially relevant discrimination of popular culture and the aesthetic discrimination of the dominant (Fiske 1989a). Bourdieu argues that one of the key differences between the culture of the subordinate and that of the dominant is that subordinate culture is functional, it must be *for* something. D'Acci's (1988) study of 'Cagney & Lacey' fans shows how they used the show and its stars to enhance their self-esteem which in turn enabled them to perform more powerfully in their social world. Fans reported that the show gave them the confidence to stand up for themselves better in a variety of social situations – a school girl said that her fandom had made her realize that she could perform as well as boys at school, and an adult woman attributed her decision to risk starting her own business directly to the self-confidence she generated from watching the show. Elsewhere (Fiske 1989b), I have shown how some teenage girl fans of Madonna make use of the self-empowerment their fandom gives them to take control of the meanings of their own sexuality, and to walk more assertively through the streets. Similarly, Radway (1984) tells of the woman romance fan whose reading enables her better to assert her own rights within the structure of a patriarchal marriage. This 'popular' discrimination involves the selection of texts or stars that offer fans opportunities to make meanings of their social identities and social experiences that are self-interested and functional. Those may at times be translated into empowered social behavior, as discussed above, but at other times may remain at the level of a compensatory fantasy that actually precludes any social action.

Other forms of fan discrimination approach the aesthetic discrimination of official culture. Kiste's (1989) study of comic book fans shows how acutely they can discriminate between

various artists and storyliners, and how important it is to be able to rank them in a hierarchy – particularly to 'canonize' some and exclude others. Tulloch and Alvarado (1983) recount how some 'Dr Who' fans canonize the early series and specifically exclude the more widely popular later series in which Tom Baker played the lead. Their criteria were essentially ones of authenticity and as such were not dissimilar to those of the literary scholars who try to uncover what Shakespeare really wrote in preference to that which has been widely performed. Authenticity, particularly when validated as the production of an artistic individual (writer, painter, performer), is a criterion of discrimination normally used to accumulate official cultural capital but which is readily appropriated by fans in their moonlighting cultural economy.

Many of the fans studied by Kiste and by Tulloch and Alvarado were aware that their object of fandom was devalued by the criteria of official culture and went to great pains to argue against this misevaluation. They frequently used official cultural criteria such as 'complexity' or 'subtlety' to argue that their preferred texts were as 'good' as the canonized ones, and constantly evoked legitimate culture – novels, plays, art films – as points of comparison.

In the comparatively few studies of fans available to us, it is possible to trace social factors within the modes of discrimination. They show a slight but regular tendency for the more official or aesthetic criteria to be used by older, male fans rather than by younger, female ones. If further studies reveal this tendency to be structural (as I suspect it is), the explanation may well lie in differential relationships to the structures of power. Those who are subordinated (by gender, age or class) are more likely to have developed a habitus typical of proletarian culture (that is, one without economic or cultural capital): the less a fan suffers from these structures of domination and subordination, the more likely he or she is to have developed a habitus that accords in some respects with that developed by the official culture, and which will therefore incline to use official criteria on its unofficial texts. It would not be surprising in such a case to find that older fans, male fans, and more highly educated fans tend to use official criteria, whereas younger, female and the less educated ones

tend towards popular criteria. Cultural tastes and practices are produced by social rather than by individual differences, and so textual discrimination and social distinction are part of the same cultural process within and between fans just as much as between fans and other popular audiences.

Productivity and Participation

Popular culture is produced by the people out of the products of the cultural industries: it must be understood, therefore, in terms of productivity, not of reception. Fans are particularly productive, and I wish to categorize their productions into three areas, while recognizing that any example of fan productivity may well span all categories and refuse any clear distinctions among them. Categories are produced by the analyst for analytical purposes and do not exist in the world being analyzed but they do have analytical value. The ones I propose to use may be called semiotic productivity, enunciative productivity, and textual productivity. All such productivity occurs at the interface between the industrially-produced cultural commodity (narrative, music, star, etc.) and the everyday life of the fan.

Semiotic productivity is characteristic of popular culture as a whole rather than of fan culture specifically. It consists of the making of meanings of social identity and of social experience from the semiotic resources of the cultural commodity. The Madonna fans who made their own meanings of their sexuality rather than patriarchal ones (Fiske 1989b) or the romance fans who legitimated their own feminine values against patriarchal ones (Radway 1984) were engaging in semiotic productivity. Recent ethnographies of audiences have produced numerous examples of this form of productivity, and we need not spend any longer on it here. (See, for example, Cho and Cho 1990, Dawson 1990, Jones 1990, Leal 1990, Lipsitz 1989).

Semiotic productivity, then, is essentially interior; when the meanings made are spoken and are shared within a face-to-face or oral culture they take a public form that may be called *enunciative productivity*. An enunciation is the use of a semiotic

system (typically, but not exclusively, verbal language) which is specific to its speaker and its social and temporal context. Fan talk is the generation and circulation of certain meanings of the object of fandom within a local community. The talk of women soap-opera fans has been widely studied (see for example, Brown 1987, Hobson 1989 and 1990, Seiter *et al.* 1989) to show how the meanings and evaluations of characters and their behaviour in the soap opera are related more or less directly to the everyday lives of the fans. Indeed, much of the pleasure of fandom lies in the fan talk that it produces, and many fans report that their choice of their object of fandom was determined at least as much by the oral community they wished to join as by any of its inherent characteristics. If colleagues at work or at school are constantly talking about a particular program, band, team or performer, many people become drawn into fandom as a means of joining that particular social group. This is not to suggest that the acquired taste is in any way unauthentic, but rather to point again to the close interrelations between textual and social preferences.

But, important though talk is, it is not the only means of enunciation available. The styling of hair or make-up, the choice of clothes or accessories are ways of constructing a social identity and therefore of asserting one's membership of a particular fan community. The Madonna fans who, on MTV, claimed that dressing like Madonna made people take more notice of them as they walked down the street were not only constructing for themselves more empowered identities than those normally available to young adolescent girls but were putting those meanings into social circulation. Similarly British soccer fans, many of whom are socially and economically disempowered males, can, when wearing their colors and when in their own community of fans, exhibit empowered behavior that may, at times, become violent and lethal but which more typically confines itself to assertiveness. Such assertiveness is often socially offensive and deliberately challenges more normal social values and the discipline they exert; in this, girl Madonna fans and boy soccer fans are identical and both call forth considerable adult disapproval. Indeed, such disapproval is an integral part of this sort of fan pleasure, for its arousal is part of the intention, albeit unstated and possibly unadmitted, of the enunciation.

Enunciation can occur only within immediate social relationships – it exists only for its moment of speaking, and the popular cultural capital it generates is thus limited to a restricted circulation, a very localized economy. But within such a local or fan community the pay-offs from the investment are continuous and imn.ediate.

There is, however, another category of fan productivity that approximates much more closely the artistic productions validated by the official culture, that of *textual productivity*. Fans produce and circulate among themselves texts which are often crafted with production values as high as any in the official culture. The key differences between the two are economic rather than ones of competence, for fans do not write or produce their texts for money; indeed, their productivity typically costs them money. Economics, too, limits the equipment to which fans have access for the production of their texts, which may therefore often lack the technical smoothness of professionally-produced ones. There is also a difference in circulation; because fan texts are not produced for profit, they do not need to be mass-marketed, so unlike official culture, fan culture makes no attempt to circulate its texts outside its own community. They are 'narrowcast,' not broadcast, texts.

A rare exception to this was provided by MTV. In association with Madonna they ran a competition for fans to produce their own videos for her song 'True Blue' and devoted 24 hours to playing a selection of those that poured in, almost swamping the studio. While one might argue that one would have to be the most fervent fan imaginable to endure 24 hours of the same song, nonetheless the means of distribution made the videos available to a wider audience than that of Madonna fans alone.

More typical are the 'Star Trek' fans (Jenkins 1989, Penley 1990) who write full-length novels filling in the syntagmatic gaps in the original narrative, and circulate these novels, and other writings, among themselves through an extensive distribution network. So, too, Bacon-Smith (1988) has shown the productivity of other TV science fiction fans who produce their own music videos by editing shots from their favorite episodes onto the soundtrack of a popular song. While these

fan-artists gain considerable prestige within the fan com-
munity, with few exceptions they earn no money for their
labor. Indeed, as Henry Jenkins has pointed out to me in
correspondence, there is a strong distrust of making a profit in
fandom, and those who attempt to do so are typically classed as
hucksters rather than fans. The one major exception appears to
be fan-artists whose paintings and sketches may occasionally
sell for hundreds of dollars at fan auctions. Such figures are, of
course, well below those of the dominant art world; but they do
indicate a difference between more mundane popular cultural
capital, which is never convertible to economic capital, and
fan cultural capital which, under certain conditions, may be.

Fan productivity is not limited to the production of new
texts: it also participates in the construction of the original
text and thus turns the commercial narrative or performance
into popular culture. Fans are very participatory. Sports crowds
wearing their teams' colors or rock audiences dressing and
behaving like the bands become part of the performance. This
melding of the team or performer and the fan into a productive
community minimizes differences between artist and audience
and turns the text into an event, not an art object. This is, again,
consistent with Bourdieu's characterization of the subordinate
habitus as opposed to the dominant one. The subordinate, or
proletarian habitus refuses to distance the text and artist from
the audience as it refuses to distance it from everyday life. The
reverence, even adoration, fans feel for their object of fandom
sits surprisingly easily with the contradictory feeling that they
also 'possess' that object, it is *their* popular cultural capital. So
Hobson's (1982) fans felt that 'Crossroads' was *their* show, and
its leading character, Meg, belonged to them rather than to the
producers.

Fan magazines often play up to and encourage this sense of
possession, the idea that stars are constructed by their fans
and owe their stardom entirely to them. Fandom typically
lacks the deference to the artist and text that characterizes
the bourgeois habitus: so soap opera fans often feel that they
could write better storylines than the scriptwriters and know
the characters better (Fiske 1987) and sports fans are frequently
at odds with the owner's policies for their teams. The industry
takes seriously letters from fans who try to participate in and

thus influence the production of the text (Tulloch and Moran 1986) or its distribution (D'Acci 1989).

When this industrial text meets its fans, their participation reunites and reworks it, so that its moment of reception becomes the moment of production in fan culture. Sports fans who cheer their team on are not just encouraging them to greater effort but are participating in that effort and the reward, if any, that it brings. Cheerleaders symbolically link the fans' cheering to the spectacle on the field of play and 'the wave' in US sports grounds (like the more individualized instances of streaking in European ones) evidences fans' desires to participate in the spectacle on display of which their teams' performance is only a part. The official barriers that separate fans from the field of play – police and security guards, fences, walls, and in extreme cases, moats and barbed wire – are evidences not only of the fans' desire to participate (however disruptively) but also of the dominant culture's need to maintain the disciplinary distance between text and reader: a function that in the academic arena is performed by the critic who polices the meanings of a text and its relationship to its readers in a way that differs from the disciplinary apparatus on sports grounds only by being intellectual rather than physical.

More traditional texts, such as films, can also be participated in communally and publicly by their fans. This makes public and visible the widespread but more private involvement of, for instance, soap opera fans in 'sharing' the lives of their favorite characters by writing and rewriting their narratives in talk and imagination. Cult films such as *The Blues Brothers* or *The Rocky Horror Picture Show* have regular fan screenings (typically at midnight on weekends) that are carnivals of fan participation. Not only do fans take part in and *with* the original industrial text (by dressing like its characters, joining in favourite lines of dialogue, throwing rice during wedding scenes or shooting water pistols in thunderstorms) but they exceed and rework it by inserting fan-written lines of dialogue that change the meaning of the original. When, for instance the straight-faced narrator in *The Rocky Horror Picture Show* describes the storm clouds as 'heavy, black and pendulous,' the pause before his line is filled by the audience shouting

'describe your testicles' (Hoberman and Rosenbaum 1981). As Heffernan (1989) argues, such rewriting can, for a particular fan group, change much of the film's heterosexual cliches into more subversive homoerotic meanings.

Fan texts, then, have to be 'producerly' (Fiske 1987, 1989a), in that they have to be open, to contain gaps, irresolutions, contradictions, which both allow and invite fan productivity. They are insufficient texts that are inadequate to their cultural function of circulating meanings and pleasure until they are worked upon and activated by their fans, who by such activity produce their own popular cultural capital.

Capital Accumulation

There is a complex, often contradictory relationship of similarities and differences between fan and official cultural capital: at times fans wish to distance themselves from the official culture, at other times, to align themselves with it. Fan cultural capital, like the official, lies in the appreciation and knowledge of texts, performers and events, yet the fan's objects of fandom are, by definition, excluded from official cultural capital and its convertibility, via education and career opportunity, into economic capital. In this section I wish to trace some of the more significant of these similarities and differences.

In fandom as in the official culture, the accumulation of knowledge is fundamental to the accumulation of cultural capital. The cultural industries have, of course, recognized this and produce an enormous range of material designed to give the fan access to information about the object of fandom. These vary from the statistics that fill the sports pages of our newspapers to gossipy speculations about the private lives of stars. This commercially produced and distributed information is supported, and sometimes subverted, by that produced by and circulated among the fans themselves. The gay community, for instance, circulates the knowledge of which apparently straight stars are actually gay, and thus knew, long before the general public, for instance, that Rock Hudson was gay and Marilyn Monroe was bisexual. Such fan

knowledge helps to distinguish a particular fan community (those who possess it) from others (those who do not): like the official culture, its work is finally one of social distinction. It also serves to distinguish within the fan community. The experts – those who have accumulated the most knowledge – gain prestige within the group and act as opinion leaders. Knowledge, like money, is always a source of power.

But fan cultural knowledge differs from official cultural knowledge in that it is used to enhance the fan's power over, and participation in, the original, industrial text. The *Rocky Horror* fans who know every line of dialogue in the film use that knowledge to participate in and even rewrite the text in a way that is quite different from the way the Shakespeare buff, for instance, might use his or her intimate knowledge of the text. This dominant habitus would enable the buff not to participate in the performance, but to discriminate critically between it and other performances or between it and the 'ideal' performance in the buff's own mind. Textual knowledge is used for discrimination in the dominant habitus but for participation in the popular.

In the same way, the dominant habitus uses information about the artist to enhance or enrich the appreciation of the work, whereas in the popular habitus such knowledge increases the power of the fan to 'see through' to the production processes normally hidden by the text and thus inaccessible to the non-fan ('he had to be sent to South America on business because they couldn't agree on the terms to renew his contract'). This knowledge diminishes the distance between text and everyday life ('I know that she's not just "acting" here, she "really" knows what it's like to have a marriage collapse around her'), or between star and fan ('If he can come from a black depressed neighbourhood and win a gold medal and a fortune so can I'). The popular habitus makes such knowledge functional and potentially empowering in the everyday life of the fan.

The accumulation of both popular and official cultural capital is signalled materially by collections of objects – artworks, books, records, memorabilia, ephemera. Fans, like buffs, are often avid collectors, and the cultural collection is a point where cultural and economic capital come together.

The 'northerners' in Bourdieu's social space – those high in both economic and cultural capital – will often conflate the aesthetic and economic value of, for instance, a collection of paintings, of first editions or of antique furniture, so that the role of the insurance assessor becomes indistinguishable from that of the critic. The 'north-westerners,' however, who have greater cultural than economic capital are more likely to collect cheaper lithographs or prints rather than original paintings, and to have a library of 'ordinary' books rather than first editions, because such collections allow them to invest culturally rather than economically.

Collecting is also important in fan culture, but it tends to be inclusive rather than exclusive: the emphasis is not so much upon acquiring a few good (and thus expensive) objects as upon accumulating as many as possible. The individual objects are therefore often cheap, devalued by the official culture, and mass-produced. The distinctiveness lies in the extent of the collection rather than in their uniqueness or authenticity as cultural objects. There are, of course, exceptions to this: fans with high economic capital will often use it, in a non-aesthetic parallel of the official cultural capitalist, to accumulate unique and authentic objects – a guitar, an autographed piece of sporting equipment, an article of clothing 'genuinely' worn by the star, or an object once possessed by him or her.

But even the everyday fans, with their collections of cheap, mass-produced fan objects, will often ape official culture in describing their collections in terms of their economic as well as their cultural capital. So Kiste's (1989) comic book fans were eager to comment upon both the economic values of their collections, and their investment potential: how much they expected them to increase, or how much the value of a particular issue had increased over the price they paid for it. Particularly valuable issues were, in another shadowing of the official cultural economy, the first issues of comics or story lines – the popular equivalent of first editions whose scarcity and age become markers of authenticity, originality, and rarity, which give them a high cultural capital which is, in its turn, readily convertible into high economic capital. The conventions at which comic fans gather are as much market places for buying and selling 'collectibles' as they are cultural

fora for the exchange and circulation of knowledge and the building of a cultural community.

Capitalist societies are built upon accumulation and investment, and this is as true of their cultural as well as financial economies. The shadow economy of fan culture in many ways parallels the workings of the official culture, but it adapts them to the habitus of the subordinate. A habitus involves not only the cultural dimension of taste, discrimination, and attitude towards the cultural objects or events, but also the social dimension of economics (and education) upon which those tastes are mapped: a habitus is thus both a mental disposition and a 'geographical' disposition in the social space. So the differences between fan collections and art collections are socio-economic. Fan collections tend to be of cheap, mass-produced objects, and stress quantity and all-inclusiveness over quality or exclusivity. Some fans, whose economic status allows them to discriminate between the authentic and the mass-produced, the original and the reproduction, approximate much more closely to the official cultural capitalist, and their collections can be more readily turned into economic capital.

While fan and official culture are similar in at least some respects in their material versions of accumulated cultural capital and its convertibility to the economic, they differ widely in the convertibility of their non-material capital. The knowledge and discrimination that comprise official cultural capital are institutionalized in the educational system, and thus can be readily converted into career opportunities and earning power. In Bourdieu's map of the social space education plays a key role, for it is related both to class on the vertical axis and to cultural and economic capital on the horizontal. It is the exclusion of popular or fan cultural capital from the educational system that excludes it from the official and disconnects it from the economic. This, of course, makes it an appropriate culture for those in subordinated formations of the people who feel themselves to be unfairly excluded from the socio-economic or status-enhancing rewards that the official culture can offer because of its direct interconnections, via the educational system, with the social order.

Fans and Commercial (Popular) Culture

Fans make their culture out of the commercial commodities (texts, stars, performances) of the cultural industries. Fandom thus has dual relationships to what is often, if wrongly, called mass culture, and by way of conclusion I would like to raise some of the central issues within them.

First there is the relationship of fandom to popular culture generally, of the fan to the more 'normal' audience member. Elsewhere (Fiske 1989a) I have argued that fandom is a heightened form of popular culture in industrial societies and that the fan is an 'excessive reader' who differs from the 'ordinary' one in degree rather than kind. The romantic and pornographic novels written by 'Star Trek' fans to fill the gaps in the original text would therefore be understood as elaborated and public versions of the interior, semiotic productions of more normal viewers, many of whom might imagine for themselves similar 'extra-textual' relationships among the crew of the SS Enterprise. So, too, we would understand the videos produced by Madonna fans as textualizations of the interior fantasies of others who either lacked access to video equipment or the desire (or talent) to turn their fantasies into texts. The commonly recurring features of these fan videos can then be understood as typical of semiotic, and thus invisible, productivity that is characteristic of popular culture generally. And a textual analysis of the videos does indeed reveal features that accord well with ethnographic investigations into the way that people make popular culture out of mass-cultural products, and that support theorizations of this process. The videos consistently exhibited the characteristics of relevance (Madonna's words, music, movements and appearance were inserted meaningfully into the everyday lives and surroundings of the fans), empowerment (Madonna was shown giving her fans power over boys, parents, teachers and even politicians), and participation (the fans 'became' Madonna in a way that denied any distance between performer and audience; they participated in constructing and circulating the 'meanings of Madonnaness' in their own culture).

Fan culture is also related to the commercial interests of the

culture industries. For the industries fans are an additional market that not only buys 'spin-off' products, often in huge quantities, but also provides valuable free feedback on market trends and preferences. There are thus contradictory functions performed by cultural commodities which on the one hand serve the economic interests of the industry and on the other the cultural interests of the fans. There is a constant struggle between fans and the industry, in which the industry attempts to incorporate the tastes of the fans, and the fans to 'excorporate' the products of the industry.

Official culture likes to see its texts (or commodities) as the creations of special individuals or artists: such a reverence for the artist and, therefore, the text necessarily places its readers in a subordinate relationship to them. Popular culture, however, is well aware that its commodities are industrially produced and thus do not have the status of a uniquely crafted art-object. They are thus open to the productive reworking, rewriting, completing and to participation in the way that a completed art-object is not. It is not surprising then that the dominant habitus, with its taste for official culture, denigrates and misunderstands both the production and reception of popular culture. It fails to realize that many industrially-produced texts have producerly characteristics that stimulate popular productivity in a way that official art-works cannot. It fails to realize, too, that such popular productivity works better on industrial texts with their contradictions, inadequacies and superficialities, because it is these very qualities that make the text open and provocative rather than completed and satisfying. Because the industrial text is not an art-object to be preserved, its ephemerality is not an issue; indeed its disposability and constant, anxious search for that which is new, stimulating and yet acceptable to the people are among its most valuable characteristics.

It may be ironic or regrettable that the economic imperative has brought capitalist industries closer to the culture of the people than the purer motives of those within official culture. But it should not surprise us. Official cultural capital, like economic capital, is systematically denied to the people and their lack then functions to distinguish them from those that possess it. In capitalist societies popular culture is necessarily

47

produced from the products of capitalism, for that is all the
people have to work with. The relationship of popular culture
to the culture industries is therefore complex and fascinating,
sometimes conflictive, sometimes complicitous or co-operative,
but the people are never at the mercy of the industries – they
choose to make some of their commodities into popular culture,
but reject many more than they adopt. Fans are among the most
discriminating and selective of all formations of the people and
the cultural capital they produce is the most highly developed
and visible of all.

Author's note: I would like to thank Lynn Spigel and Henry
Jenkins for their helpful comments on early drafts of this
essay.

References

Bacon-Smith, C. 1988. Acquisition and Transformation of Popular
 Culture: The International Video Circuit and the Fanzine Com-
 munity. Paper presented at The International Communication
 Association Conference, New Orleans, 1988.
Bourdieu, P. 1984. *Distinction; a Social Critique of the Judgement of Taste.*
 Cambridge: Harvard University Press.
Brown, M. E. 1987. The Politics of Soaps: Pleasure and Feminine
 Empowerment. *Australian Journal of Cultural Studies* 4(2): 1–25.
Cho, M. and C. Cho. 1990. Women Watching Together: an Ethno-
 graphic Study of Korean Soap Opera Fans in the U.S. *Cultural
 Studies* 4(1): 30–44.
D'Acci, J. 1989. *Women, 'Woman' and Television: The Case of Cagney
 and Lacey.* Dissertation, University of Wisconsin–Madison.
Dawson, R. 1990. Culture and Deprivation: Ethnography and Everyday
 Life. Paper presented at the International Communication Associa-
 tion Conference, Dublin 1990.
Fiske, J. 1987. *Television Culture.* London and New York: Routledge.
———1989a. *Understanding Popular Culture.* Boston: Unwin Hyman.
———1989b *Reading the Popular.* Boston: Unwin Hyman.
Heffernan, K. 1989. Heterotextuality. Unpublished paper, University
 of Wisconsin–Madison.
Hoberman, J. and J. Rosenbaum. 1981. *Midnight Movies.* New York:
 Harper & Row.
Hobson, D. 1982. *Crossroads: the Drama of a Soap Opera.* London:
 Methuen.
———1989. Soap Operas at Work. In Ellen Seiter (ed.) *Remote Control:*

Television. Audiences and Cultural Power (1989). London: Routledge, pp. 150–67.

———1990. Women Audiences and the Workplace. In Mary Ellen Brown (ed.) *Television and Women's Culture: The Politics of the Popular* (1990), London: Sage, pp. 61–71.

Jenkins, H. 1989. *Star Trek*: Rerun, Reread, Rewritten: Fan Writing as Textual Poaching. *Critical Studies in Mass Communication* 5(2): 85–107.

Jones, S. 1990. Black Music and Young People in Birmingham. In F. Rogilds (ed.) *Every Cloud Has a Silver Lining* (1990). Copenhagen: Akademisk Forlag, pp. 126–35.

Kiste, A. 1989. Comic Books: Practices of Reading and Strategies of Legitimation. Unpublished paper, University of Wisconsin–Madison.

Leal, O. 1990. Popular Taste and Erudite Repertoire: The Place and Space of Television in Brazil. *Cultural Studies* 4(1): 19–29.

Leal, O. and R. Oliver. 1988. Class Interpretations of a Soap Opera Narrative: The Case of the Brazilian *Novella* 'Summer Sun.' *Theory Culture and Society* 5, 81–99.

Lipsitz, G. 1990. *Time Passages: Collective Memory and American Popular Culture*. Minneapolis: University of Minnesota Press.

Penley, C. 1990. Feminism, Psychoanalysis and Popular Culture. Paper presented at conference on 'Cultural Studies Now and in the Future,' University of Illinois, April 1990.

Radway, J. 1984. *Reading the Romance: Feminism and the Representation of Women in Popular Culture*. Chapel Hill: University of North Carolina Press.

Seiter, E. *et al.* 1989. 'Don't Treat Us Like We're So Stupid and Naive': Toward an Ethnography of Soap Opera Viewers. In Ellen Seiter *et al.* (eds) *Remote Control* (1989). London: Routledge.

Tulloch, J. and M. Alvarado. 1983. *Dr Who: The Unfolding Text*. London: Macmillan.

Tulloch, J. and A. Moran. 1986. *A Country Practice: 'Quality Soap.'* Sydney: Currency Press.

Is there a Fan in the House?: The Affective Sensibility of Fandom

LAWRENCE GROSSBERG

There is something odd about 'fans.' I remember when I began teaching university classes on rock-and-roll. A number of colleagues tried to sabotage them, by arguing that such forms of culture did not belong in the university curriculum. When this argument was defeated, they took a different strategy: they argued that, as a fan of rock, I was not the appropriate person to teach the class. While I disagreed with their implicit assumption that fans could not have any critical distance, I was fascinated by their insight that, somehow, being a fan entails a very different relationship to culture, a relationship which seems only to exist in the realm of popular culture. For example, while we can consume or appreciate various forms of 'high culture' or art, it makes little sense to describe someone as a fan of art. How, then, do we understand what it means to be a fan? The easiest answer, one that I reject, is that it is all a matter of what forms of and relationships to culture are legitimated within the existing relations of power. This assumes that it is all a matter of status and that there are no real distinctions that mark the 'fan.'

How then do we look for those distinctions? One way would be to consider what differences if any define the sorts of texts that fans are fans of. Or in other words, we can try to understand what makes popular culture popular? The question seems innocent enough but, as soon as we begin to look for an answer, we are confronted only by ambiguity

and uncertainty. What is it, after all, that we are attempting to explain? Is it a matter of aesthetic or moral criteria which define the differences between popular texts and other forms of cultural texts (for example, high culture, mass culture, folk culture)? But history has shown us that texts move in and out of these categories (for example, what was popular can become high art), and that a text can exist, simultaneously, in different categories. There are no necessary correspondences between the formal characteristics of any text and its popularity, and the standards for aesthetic legitimacy are constantly changing. Is it then a matter of where the text comes from, of how and by whom it is produced? But again, there are too many exceptions to this assumed correlation. The mode by which a text is produced, or the motivations behind it, do not guarantee how it is placed into the larger cultural context nor how it is received by different audiences. So perhaps the answer to our question is the most obvious one: what makes something popular is its popularity; it is, in other words, a matter of taste. This formulation begins to point us away from the texts, and toward the audiences of popular cultures. But, in the end, it does not help us very much, for the same questions remain, albeit in different forms: how much popularity? whose tastes? and what do different tastes signify?

A second approach attempts to begin by characterizing the particular sorts of people who become fans, and the basis on which their relationship to popular culture is constructed. In this model, it is often assumed that popular culture appeals to the lowest and least critical segments of the population. These audiences are thought to be easily manipulated and distracted (not only from 'serious' culture but also from real social concerns), mobilized solely to make a profit. The various forms of popular culture appeal to the audience's most debased needs and desires, making them even more passive, more ignorant and noncritical than they apparently already are. Fans are simply incapable of recognizing that the culture they enjoy is actually being used to dupe and exploit them. A second, related view of fans assumes that they are always juveniles, waiting to grow up, and still enjoying the irresponsibility of their fandom.

For many years, the only alternative to this image of fans

as cultural dopes came from various arguments that divided the audience for popular culture into two groups: the larger segment is still assumed to be cultural dopes who passively consume the texts of popular culture. But there is another segment, much smaller and more dispersed, who actively appropriate the texts of specific popular cultures, and give them new and original significance. For example, one small part of the audience for comic books or popular music might approach such forms as art; or another group might take them to be the expression of their own lived experience. And still others may use them to resist the pressures of their social position and to construct new identities for themselves. According to this 'subcultural' model, any of these groups would be considered fans; fans constitute an elite fraction of the larger audience of passive consumers. Within this model, the fan is able to discriminate between those forms of popular culture which are 'authentic' (that is, which really are art, which really do represent their experience, etc.) and those which are the result of the efforts of the commercial mainstream to appropriate these forms and produce tainted versions for the larger audience. Thus, the fan is always in constant conflict, not only with the various structures of power, but also with the vast audience of media consumers. But such an elitist view of fandom does little to illuminate the complex relations that exist between forms of popular culture and their audiences. While we may all agree that there is a difference between the fan and the consumer, we are unlikely to understand the difference if we simply celebrate the former category and dismiss the latter one.

We have to acknowledge that, for the most part, the relationship between the audience and popular texts is an active and productive one. The meaning of a text is not given in some independently available set of codes which we can consult at our own convenience. A text does not carry its own meaning or politics already inside of itself; no text is able to guarantee what its effects will be. People are constantly struggling, not merely to figure out what a text means, but to make it mean something that connects to their own lives, experiences, needs and desires. The same text will mean different things to different people, depending on how it is interpreted. And different

people have different interpretive resources, just as they have different needs. A text can only mean something in the context of the experience and situation of its particular audience. Equally important, texts do not define ahead of time how they are to be used or what functions they can serve. They can have different uses for different people in different contexts. The same text can be a source of narrative romance, sexual fantasy, aesthetic pleasure, language acquisition, identity or familial rebellion. Given contemporary recording technology (whether audio or video), a text can be remade and even remixed to conform to the audience's expectations and desires. How a specific text is used, how it is interpreted, how it functions for its audience – all of these are inseparably connected through the audience's constant struggle to make sense of itself and its world, even more, to make a slightly better place for itself in the world.

Audiences are constantly making their own cultural environment from the cultural resources that are available to them. Thus, audiences are not made up of cultural dopes; people are often quite aware of their own implication in structures of power and domination, and of the ways in which cultural messages (can) manipulate them. Furthermore, the audience of popular culture cannot be conceived of as a singular homogeneous entity; we have to take seriously the differences within and between the different fractions of the popular audience.

This view of an active audience only makes it more difficult for us to understand the nature of fandom, for if all consumers are active, then there is nothing against which to measure the fan. Such views cannot explain the significance of the fact that some people pay attention to particular texts, in ways that demand particular sorts of interpretations, or that some texts are granted an importance and perhaps even a power denied to others. We need a different approach, then, to the question of fandom and popular culture. If we cannot locate a viable response in either the nature of the cultural forms or the audience, then perhaps it is necessary to look at the relations that exist between them. But we have to consider the relationship without falling back into theories which privilege either the text or the audience by giving one the power to determine the relationship. For even if it is true that

audiences are always active, it does not follow that they are ever in control.

The relations between culture and audiences cannot be understood simply as the process by which people appropriate already existing texts into the already constituted context of their social position, their experience or their needs. Nor can it be described in terms which suggest that the audience is simply passively acceding to the predetermined nature of the text. In fact, both audiences and texts are continuously remade – their identity and effectiveness reconstructed – by relocating their place within different contexts. The audience is always caught up in the continuous reconstruction of cultural contexts which enable them to consume, interpret and use texts in specific ways. It is these 'specific ways' that concern us here.

Audiences never deal with single cultural texts, or even with single genres or media. Culture 'communicates' only in particular contexts in which a range of texts, practices and languages are brought together. The same text can and often will be located in a number of different contexts; in each, it will function as a different text and it will likely have different relations to and effects on its audience. For example, a typical context of rock-and-roll – and there are many of them at a single moment – brings together musical texts and practices, economic and race relations, images of performers and fans, social relations (for instance, of gender, of friendship), aesthetic conventions, styles of language, movement, appearance and dance, media practices, ideological commitments and, sometimes, media representations of rock-and-roll itself. It is within such contexts that the relations between audience members and cultural forms are defined.

We can call the particular relationship that holds any context together, that binds cultural forms and audiences, a 'sensibility.' A sensibility is a particular form of engagement or mode of operation. It identifies the specific sorts of effects that the elements within a context can produce; it defines the possible relationships between texts and audiences located within its spaces. The sensibility of a particular cultural context (an 'apparatus') defines how specific texts and practices can be taken up and experienced, how they are able to effect the

audience's place in the world, and what sort of texts can be incorporated into the apparatus. Different apparatuses produce and foreground different sensibilities. This assumes that human life is multidimensional, and texts may, in various contexts, connect into certain dimensions more powerfully than others. There is, in fact, more to the organization of people's lives than just the distribution or structure of meaning, money and power.

I want now to describe the dominant sensibilities of contemporary popular culture in order to identify the sensibility within which fandom is located. Just as the same text can exist in different contexts and thus, different sensibilities, so too can different audience members. The different sensibilities are not mutually exclusive; people always exist in different sensibilities, and their relations to a particular set of cultural practices (for instance, rock-and-roll) may be defined by an overlapping set of sensibilities. Nevertheless, it may be useful to make some basic distinctions here.

The sensibility of the consumer operates by producing structures of pleasure. Of course, pleasure is itself a complex phenomenon, and there are many different relations operating in this notion of consumption: there is the satisfaction of doing what others would have you do, the enjoyment of doing what you want, the fun of breaking the rules, the fulfillment – however temporary and artificial – of desires, the release of catharsis, the comfort of escaping from negative situations, the reinforcement of identifying with a character, and the thrill of sharing another's emotional life, and so on. All of these are involved in the 'normal' and common relationship to popular culture and the mass media. We are engaged with forms of popular culture because, in some way and form, they are entertaining; they provide us with a certain measure of enjoyment and pleasure.

I am suggesting that our most common relationship to popular culture is determined by the cultural production of pleasures. But again, this consumerist sensibility rarely operates in total isolation. It is quite usual, for example, to find that such pleasures depend upon the production of other sorts of effects. The culture of the mass media often depends upon the production of meanings and, more specifically, of ideological

representations. Ideology refers to the structures of meaning within which we locate ourselves. That is, ideologies are the maps of meaning which we take for granted as the obviously true pictures of the way the world is. By defining what is natural and commonsensical, ideologies construct the ways we experience the world. A consumerist sensibility might, in specific instances, be connected to ideological sensibilities, either by making certain experiences pleasurable, or through the pleasures of ideological reinforcement. Nevertheless, I still believe that the real source of the popularity of the culture of the mass media lies, not in its ideological effects, but in its location within a consumerist sensibility emphasizing the production of pleasure. We can find some evidence for this claim in the existence of a variant of the consumer relation, one that we might call the 'hyperconsumerist' sensibility. This describes the seemingly compulsive consumption of mass media, regardless of whether any actual single text provides pleasure. That is, hyperconsumerism describes the situation in which the very activity of consuming becomes more important, more pleasurable, more active as the site of the cultural relationship, than the object of consumption itself (for instance, 'couch potatoes,' collectors, and so on).

The category of the fan, however, can only be understood in relation to a different sensibility. The fan's relation to cultural texts operates in the domain of affect or mood. Affect is perhaps the most difficult plane of our lives to define, not merely because it is even less necessarily tied to meaning than pleasure, but also because it is, in some sense, the most mundane aspect of everyday life. Affect is not the same as either emotions or desires. Affect is closely tied to what we often describe as the feeling of life. You can understand another person's life: you can share the same meanings and pleasures, but you cannot know how it feels. But feeling, as it functions here, is not a subjective experience. It is a socially constructed domain of cultural effects. Some things feel different from others, some matter more, or in different ways, than others. The same experience will change drastically as our mood or feeling changes. The same object, with the same meaning, giving the same pleasure, is very different as our affective relationship to it changes. Or perhaps it is more accurate

to say that different affective relations inflect meanings and pleasures in very different ways. Affect is what gives 'color,' 'tone' or 'texture' to our experiences.

Perhaps this can be made clearer if we distinguish two aspects of affect: quantity and quality. Affect always defines the quantitatively variable level of energy (activation, enervation) or volition (will); it determines how invigorated we feel in particular moments of our lives. It defines the strength of our investment in particular experiences, practices, identities, meanings, and pleasures. In other words, affect privileges volition over meaning. For example, as one ad campaign continuously declares, 'Where there's a will there's an "A".' But affect is also defined qualitatively, by the inflection of the particular investment, by the nature of the concern (caring, passion) in the investment, by the way in which the specific event is made to matter to us.

Within an affective sensibility, texts serve as 'billboards' of an investment, but we cannot know what the investment is apart from the context in which it is made (that is the apparatus). While critics generally recognize that meanings, and even desires, are organized into particular structures or maps, they tend to think of mood as formless and disorganized. But affect is also organized; it operates within and, at the same time, produces maps which direct our investments in and into the world; these maps tell us where and how we can become absorbed – not into the self but into the world – as potential locations for our self-identifications, and with what intensities. This 'absorption' or investment constructs the places and events which are, or can become, significant to us. They are the places at which we can construct our own identity as something to be invested in, as something that matters.

These mattering maps are like investment portfolios: there are not only different and changing investments, but different forms, as well as different intensities or degrees of investment. There are not only different places marked out (practices, pleasures, meanings, fantasies, desires, relations, and so on) but different purposes which these investments can play, and different moods in which they can operate. Mattering maps define different forms, quantities and places of energy. They tell us how to use and how to generate energy, how to navigate our

way into and through various moods, and how to live within emotional and ideological histories. This is not to claim that all affective investments are equal or even equivalent; there are, at the very least, qualitative and quantitative differences among them.

The importance of affect derives, not from its content, but from its power over difference, its power to invest difference. Affect plays a crucial role in organizing social life because affect is constantly constructing, not only the possibility of difference, but the ways specific differences come to matter. Both ideology and pleasure depend on defining and privileging particular terms within various relations of difference. But it is affect which enables some differences (for instance, race, and gender) to matter as markers of identity rather than others (foot length, angle of ears, eye color) in certain contexts and power relations. While we might notice these latter sorts of things on certain occasions, we would think it ridiculous to imagine a world in which they mattered. Those differences which do matter can become the site of ideological struggle, and to the extent that they become common-sense social investments, they are landmarks in the political history of our mattering maps.

Through such investments in specific differences, fans divide the cultural world into Us and Them, but the investment in – and authority of – any identity may vary within and across apparatuses. In fact, as individuals and as members of various social groups, there are many axes along which we register our difference from others – some are physical categories, some are sociological, some are ideological and some are affective. We are women, black, short, middle-class, educated, and so on. Any particular difference, including that marked out by being a rock fan, is always augmented and reshaped by other differences. At different points and places in our lives, we reorder the hierarchical relations among these differences. We redefine our own identity out of the relations among our differences; we reorder their importance, we invest ourselves more in some than in others. For some, being a particular sort of rock fan can take on an enormous importance and thus come to constitute a dominant part of the fan's identity (this is how we often think of subcultures). For others, it remains a powerful

but submerged difference that colors, but does not define, their dominant social identities.

The most obvious and frightening thing about contemporary popular culture is that it matters so much to its fans. The source of its power, whatever it may seem to say, or whatever pleasures one may derive from it, seems to be its place on people's mattering maps, and its ability to place other practices on those maps. For the fan, certain forms of popular culture become taken for granted, even necessary investments. The result is that, for the fan, specific cultural contexts become saturated with affect. The relations within the context are all defined affectively, producing a structure of 'affective alliances.' And the apparatus, as an affective alliance, itself, functions as a mattering map within which all sorts of activities, practices and identities can be located. It is in their affective lives that fans constantly struggle to care about something, and to find the energy to survive, to find the passion necessary to imagine and enact their own projects and possibilities. Particular apparatuses may also provide the space within which dominant relations of power can be challenged, resisted, evaded or ignored.

Consequently, for the fan, popular culture becomes a crucial ground on which he or she can construct mattering maps. Within these mattering maps, investments are enabled which empower individuals in a variety of ways. They may construct relatively stable moments of identity, or they may identify places which, because they matter, take on an authority of their own. Fans actively constitute places and forms of authority (both for themselves and for others) through the mobilization and organization of affective investments. By making certain things or practices matter, the fan 'authorizes' them to speak for him or her, not only as a spokesperson but also as surrogate voices (as when we sing along to popular songs). The fan gives authority to that which he or she invests in, letting the object of such investments speak for and as him or her self. Fans let them organize their emotional and narrative lives and identities. In this way, they use the sites of their investments as so many languages which construct their identities. In so far as a fan's investments are dispersed, his or her identity is similarly dispersed. But in so far as fandom organizes these

investments – both structurally (as a mattering) and intensively (as different quantities) – so it establishes different moments of relative authority, moments which are connected affectively to each other (for example, the investment in rock may make an investment in certain ideological positions more likely although it can never guarantee them). The fan need not – and usually does not – have blind faith in any specific investment site, but he or she cannot give up the possibility of investment as that which makes possible a map of his or her own everyday life and self.

The image of mattering maps points to the constant attempt, whether or not it is ever successful, to organize moments of stable identity, sites at which we can, at least temporarily, find ourselves 'at home' with what we care about. The very notion of a fan assumes the close relationship between identity and caring; it assumes that identity matters and that what matters – what has authority – is the appropriate ground of stable identity. But mattering maps also involve the lines that connect the different sites of investment; they define the possibilities for moving from one investment to another, of linking the various fragments of our identity together. They define not only what sites (practices, pleasures, and so on) matter, but how they matter. And they construct a lived coherence for the fan.

Moreover, the affective investment in certain places (texts, identities, pleasures) and differences demands a very specific ideological response, for affect can never define, by itself, why things should matter. That is, unlike ideology and pleasure, it can never provide its own justification, however illusory such justifications may in fact be. The result is that affect always demands that ideology legitimate the fact that these differences and not others matter, and that within any difference, one term matters more than the other. This is accomplished by linking specific mattering maps to an ideological principle of excessiveness. Because something matters, it must have an excess which explains the investment in it, an excess which ex post facto not only legitimates but demands the investment. Whatever we invest ourselves into must be given an excess which outweighs any other consideration. The more powerful the affective investment in difference is, the more powerfully must that difference be ideologically and

experientially legitimated, and the greater the excess which differentiates it. This excess, while ideologically constructed, is always beyond ideological challenge, because it is called into existence affectively. The investment guarantees the excess.

For example, what defines rock's difference – what makes it an acceptable and, for its fans, absolutely necessary investment – is simply the fact that it matters. It offers a kind of salvation which depends only on our obsession with it. It constructs a circular relation between the music and the fan: the fact that it matters makes it different; it gives rock an excess which can never be experienced or understood by those outside of the rock culture. And this excess in turn justifies the fan's investment in it. Rock refers, in this sense, to the excess which is granted the music by virtue of our investment in it. By virtue of the fact that rock matters, rock is granted the excess which justifies its place on our mattering maps, and its power to restructure those maps. Thus it is not so much that rock has a 'real' difference but, rather, the fact that it matters calls its difference into existence. Consequently, the ideology and even the pleasure of rock are always secondary to, or at least dependent upon, the fan's assumption of rock's excess, an excess produced by the ways rock is placed in the fan's everyday life. The place of rock defines possible mattering maps, maps which specify the different forms, sites and intensities of what can matter, maps which chart out affective alliances. Rock positions not only the elements of rock culture, but other aspects of everyday life. It can determine how other things matter. Thus, for example, within rock's mattering maps, entertainment matters but in a very different way from rock, as something to be consumed and to produce pleasure. Rock works by offering the fan places where he or she can locate some sense of his or her own identity and power, where he or she can invest his or her self in specific ways.

But how are we to understand rock's excess? Rock, like any other culture of fandom, is organized around a particular ideology of excess, an ideology which distinguishes certain kinds of musical–cultural practices and certain kinds of 'fans' (although the two dimensions do not always correspond). This ideology not only draws an absolute distinction between

rock and 'mere' entertainment, it says that it is the excess of the difference – its authenticity – that enables rock to matter. Every fan – of whatever forms of popular culture – exists within a comparable ideology of authenticity, although the difference need not operate in just the same way, and the ideological grounds of authenticity may vary considerably. This ideological difference has taken many forms, which are not necessarily the same: the center vs the margin, rock vs pop, the mainstream vs the periphery, commercial vs independent, coopted vs resistant. Moreover, the same distinction can be applied in very different ways to describe the same musics. In different rock apparatuses, the difference can be explained in different ways; for example, the line can be justified aesthetically or ideologically, or in terms of the social position of the audiences, or by the economics of its production, or through the measure of its popularity, or the statement of its politics. In all of these cases, the line serves, for the fan, 'properly' to distribute rock cultures. On the one side, entertainment, on the other, something more – an excess by virtue of which even mere fun can become a significant social statement. The excess links the social position and experience of musicians and fans with rock's ability to redefine the lines of social identity and difference. That is, the excess marks the rock fan's difference. Rock fans have always constructed a difference between authentic and coopted rock. And it is this which is often interpreted as rock's inextricable tie to resistance, refusal, alienation, marginality, and so on.

However, we must be careful, for sometimes 'authenticity' is used to refer to a single definition of authenticity. But there are many forms of authenticity, even within rock culture. One need only compare the various contemporary performers who might qualify as authentic rockers: Springsteen, U2, REM, Tracy Chapman, Sting, Prince, Public Enemy, Talking Heads and even the Pet Shop Boys. In general, it is possible to isolate three versions of this ideological distinction. The first, and most common, is usually linked to hard rock and folk rock. It assumes that authentic rock depends on its ability to articulate private but common desires, feelings and experiences into a shared public language. The consumption of rock constructs or expresses a 'community.' This romantic ideology displaces

62

sexuality and makes desire matter by fantasizing a community predicated on images of urban mobility, delinquency, bohemianism and artistry. The second, often linked with dance and black music, locates authenticity in the construction of a rhythmic and sexual body. Often identifying sexual mobility and romance, it constructs a fantasy of the tortured individual struggling to transcend the conditions of their inadequacy. The third, often linked with the self-consciousness of pop and art rock, is built on the explicit recognition of and acknowledgment that the difference that rock constructs (and which in turn is assigned back to rock) is always artificially constructed. That is, the difference does not exist outside of the consumption of rock itself. Such music, which is increasingly seen as 'avant garde' or 'postmodern,' celebrates style over music, or at least it equates the two. But despite its self-conscious negation of both romantic transcendence and transcendental sexuality, it still produces real and significant differences for its fans.

I do not mean to suggest that the category of the 'fan' exists in the same way in every historical situation. The fan can only be understood historically, as located in a set of different possible relations to culture. In fact, everyone is constantly a fan of various sorts of things, for one cannot exist in a world where nothing matters (including the fact that nothing matters). In fact, I think that what we today describe as a 'fan' is the contemporary articulation of a necessary relationship which has historically constituted the popular, involving relationships to such diverse things as labor, religion, morality and politics. Thus, there is no necessary reason why the fan relationship is located primarily on the terrain of commercial popular culture. But it is certainly the case that for the vast majority of people in advanced capitalist societies, this is increasingly the only space where the fan relationship can take shape. It is in consumer culture that the transition from consumer to fan is accomplished. It is here, increasingly, that we seek actively to construct our own identities, partly because there seems to be no other space available, no other terrain on which we can construct and anchor our mattering maps. The consumer industries increasingly appeal to the possibilities of investing in popular images, pleasures, fantasies and desires. The fact

that we relate to these appeals, as either consumers or fans, does not guarantee our subjugation to the interests or practices of the commercial sector. One can struggle to rearticulate effective popular appeals but I think it is also true that the consumer, however active, cannot remake the conditions of their subordination through their act of consumption.

The fan, however, is a different matter altogether. For the fan speaks from an actively constructed and changing place within popular culture. Moreover, because the fan speaks for and to the question of authority, and from within an ideology of excess (which constructs a certain critical distance), the politics of the fan never entails merely the celebration of every investment or every mattering map. The fan's relation to culture in fact opens up a range of political possibilities and it is often on the field of affective relations that political struggles intersect with popular concerns. In fact, the affective is a crucial dimension of the organization of political struggle. No democratic political struggle can be effectively organized without the power of the popular. It is in this sense that I want to say that the relationship of fandom is a potentially enabling or empowering one, for it makes it possible to move both within and beyond one's mattering maps.

Empowerment is an abstract possibility; it refers to a range of effects operating at the affective level. It is not synonymous with pleasure (for pleasure can be disempowering and dis-pleasure can be empowering); nor does it guarantee any form of resistance to or evasion of existing structures of power, although it is a condition of the possibility of resistance. Empowerment refers to the reciprocal nature of affective investment: that is, because something matters (as it does when one invests energy in it), other investments are made possible. Empowerment refers to the generation of energy and passion, to the construction of possibility. Unlike the consumer, the fan's investment of energy into certain practices always returns some interest on the investment through a variety of empowering relations: in the form of the further production of energy (for example, rock dancing, while exhausting, continu-ously generates its own energy, if only to continue dancing); by placing the fan in a position from which he or she feels a certain control over his or her life (as a recent ad proclaimed, 'shopping

puts me on top of the world'); or by making fans feel that they are still alive (as Tracy Chapman sings, 'I had a feeling I could be someone').

In all of these cases, fans are empowered in the sense that they are now capable of going on, of continuing to struggle to make a difference. Fans' investment in certain practices and texts provides them with strategies which enable them to gain a certain amount of control over their affective life, which further enables them to invest in new forms of meaning, pleasure and identity in order to cope with new forms of pain, pessimism, frustration, alienation, terror and boredom. Such empowerment is increasingly important in a world in which pessimism has become common sense, in which people increasingly feel incapable of making a difference, and in which differences increasingly seem not to matter, not to make any difference themselves. Fandom is, at least potentially, the site of the optimism, invigoration and passion which are necessary conditions for any struggle to change the conditions of one's life. At this level, culture offers the resources which may or may not be mobilized into forms of popular struggle, resistance and opposition. The organization of struggles around particular popular languages depends upon their articulation within different affective economies, that is, upon the different investments by which they are empowered and within which they empower their fans. While there is no guarantee that even the most highly charged moments will become either passive sites of evasion or active sites of resistance, without the affective investments of popular culture the very possibility of such struggles is likely to be drowned in the sea of historical pessimism.

PART II

Fandom and Gender

Essays from Bitch: The Women's Rock Newsletter with Bite

CHERYL CLINE

I David Lee Roth: Threat or Menace? (March '86)

You might have noticed, if you hang around the magazine racks of 7–11 stores, that between March, 1985 and August, 1985, David Lee Roth was cover-boy for no less than seven slick rock magazines. I noticed. I also noticed that his old band Van Halen was featured on the covers of four more. I saved the pink section of the Sunday *San Francisco Chronicle* for 10 February, 1985, because it contained an interview with David Lee Roth. My roommate Bruce swiped a copy of *People* from work for me (what a pal) with David Lee Roth in the sub-celebrity spot. I sat on the floors of two separate used bookstores looking through piles of old copies of *Rolling Stone* and came away with three issues with articles on Van Halen (14 June, '79; 4 September, '80; and 21 June, '84). I bought a Van Halen poster and a Van Halen calendar. I bought an unauthorized paperback biography (*Van Halen*) a picture book (*Van Halen*) and *The Van Halen Scrapbook*. I even bought two Van Halen albums.

I have, as the song says, got it bad.

Lynn is appalled. We've been married longer than most people keep their cars, so he thought he knew me pretty well. Now he's not so sure. He made a few feeble attempts to reason with me. 'How'd you feel,' he asked me, 'if I put up a Madonna poster in the living room?' 'Oh,' I said, with no

shame at all, 'Then can I put up a poster of David Lee Roth in the living room?' 'No!' he roared. I was unrepentant.

In our house, I have an office. It's my office and I can do anything I want there. Already I have posters of Dave Edmunds and Elvis Costello hanging on the walls. 'Van Halen Memorial Day 1983' will fit in quite nicely with 'Elvis Costello Armed Forces' – don't you think that's an artistic touch?

Bruce says, 'She's just *losing her mind.*'

If you want to test the theory that men and women are brought up differently, just mention to a few male friends that you have a crush on a rock star. Any rock star will do. Prince, David Byrne, Daryl Hall . . . you could even admit to having a crush on Jeff Beck all these years. Just do it, and in less time than it takes to say 'Bay City Rollers,' you'll feel like giving those friends of yours a good poke in the snoot.

On the other hand, if you confide in a woman friend, after the initial, 'Oh *no*, not *David Lee Roth!*' she'll most likely be sympathetic. She knows. She's been there. Buy her a few drinks and she'll probably confess to an intense crush on Billy Idol.

But for an adult woman to admit, in mixed company, to a crush on a rock star is to overstep the bounds of proper feminine behaviour, akin to your Victorian grandmother slipping and saying 'legs' when she meant to say 'limbs.' To so much as mention Bruce Springsteen's biceps is to leave yourself open to charges of immaturity, bad taste, politically incorrect thinking and general mush-mindedness.

A lot of junk has been written about the teenage crush, and almost as much junk on the middle-aged matron crush, but between these two periods of hormonal lunacy (adolescence and menopause), women are supposed to give up their crushes on famous people – especially rock stars. It's a sign of maturity to pack up all the posters, photos, magazines, scrapbooks, and unauthorized biographies you so lovingly collected and shove them in the back of the closet. If you're a rock fan, you're careful to discuss bands in terms of their artistic merits, and if you privately think Elvis Costello is better looking than Graham Parker, you keep this opinion strictly to yourself. If you should slip and unwittingly voice such an opinion, you pass it off with a small deprecating laugh. You decorate your walls with tasteful prints instead of Beatles posters and you read *Musician* instead

of *Creem*. And so on and so on, until you reach the age when everybody thinks you're crazy anyway, so why not admit to an intense hankering to run your fingers through Willie Nelson's whiskers?

If you're under thirteen, you're *supposed* to have crushes on rock stars, it's *normal*, so it might be a good idea to babble on about Duran Duran, even if personally, you think diurnal lepidoptera are much more interesting. But after you hit, say, eighteen, it's best not to say out loud, 'Gee, don't you think the way Tom Petty smiles kind of crooked is real cute?' Especially don't say this to a man you are living with. It's much easier for a man to be indulgent about the crushes of teenage girls than it is for him to be fair-minded about the sexual fantasies of the woman he loves when they're about someone else. And the same guy who'll leave *Penthouse* in the bathroom will yell, 'No woman of mine is gonna hang a poster of Prince naked to the waist on the inside of the closet of the spare room where no one will see it!'

If you should confess to a crush on a member of some tasteless band like Motley Crue or Ratt, bands that obviously exist just to sucker witless females into thinking Vince Neil or Steve Pearcy is so hot they gotta go out and buy all their albums, then you are a dupe.

If you admit to lusting after Bono or David Byrne, that's still no good, because U2 and Talking Heads are *serious* bands, and women who happen to notice that David Byrne is an anatomically correct male are misguided at best. Not wanting to be on the wrong end of the pointing finger of scorn, we keep our lips buttoned and lust in silence.

This sad state of affairs is due, as I said, to differences in upbringing. It's partly a matter of being taught to choose different sets of sexual stimuli: men learn to jerk off over anonymous tits-and-ass from the local liquor store newsstands; women to get hot over a sharp-dressed man with a low-slung guitar. It's partly that, and partly plain old male ignorance. They just don't know shit about what goes on in women's minds, even (or maybe especially) when we get that peculiar slack-jawed expression (dubbed 'dreamy' when it occurs in women) which means we're thinking about sex. Until recently, women weren't believed to *have* sexual fantasies. Even now, after years of steady

exposure to educational material like *The Hite Report* and *My Secret Garden*, many men still flunk. If your men friends make pious pronouncements like 'Feminists don't like guys in heavy metal bands,' send them to the bottom of the class. They can be so damned ignorant! HOW MANY TIMES HAVE YOU HEARD THIS ONE?

'Girls who have crushes on rock stars want to be groupies.'

Or the more psychological approach:

'Grown women who have crushes on rock stars still want to sleep with their fathers.'

You can see what I mean about the poke in the snoot. However, it'd be better if you merely put your hand on your friend's shoulder and said in a firm but friendly voice, 'No, Tom, Dick, or Harry, all women do not want to be groupies.'

True groupiedom is a tough business and not everyone is cut out for it. For one thing, not everyone looks like Britt Eckland. For another, to do it properly takes a big chunk out of your day, and many women, though the crush they've got is something severe, would rather pursue their careers as brain surgeons. Thought doesn't necessarily lead to action anyway – if it did, we'd all be roller derby stars. Even girls who indulge in the hardest core fantasies about a rock star and who occasionally (say, four or five times a day) fantasize about being his groupie, do not, in real life, want to *be* groupies. In one of the few sympathetic articles on teenage girl rock fans, 'Devils or Angels? The Female Teenage Audience Examined,' (*Trouser Press*, April, '81), Twersky dispenses with the groupie question with a blunt observation men everywhere should take to heart: 'A desire for sex shouldn't be confused with a desire to get fucked.'

Write that down.

According to Twersky, 'Teenage girl's daydreams about sex rarely involve anonymous quickies with people who don't care for them . . . Many girls who would willingly humiliate themselves for an affair with a rock star would die before trying a one night stand with him.' Many girls would die before *willingly humiliating* themselves for an affair. Many women would just as soon keep the whole thing strictly hypothetical. As Cynthia Heimel says in *Sex Tips For Girls*, 'A crush is a passionate love affair, without risk . . . No muss, no fuss.' And no irate boyfriend.

On the other hand, my friend Candi is convinced that most women would sleep with that *Him* with a capital 'H' if given the chance. 'Everybody,' she insisted to me, 'Has someone in mind they'd break the rules for.' By which she doesn't mean she'd follow some guy to Detroit, stand in backstage lineups, strip for strangers, or give head to roadies, just so she *might* get to spend the night with her favorite rock star and five other girls (a la rock video) or with five other guys (rock porn reverses the ratio). She's talking about telling Matt she's just going to a thrift store with Lucy Huntzinger, when she's really sneaking off to meet Billy Idol, that sort of thing. Or breaking rules like 'Don't go out with men with IQ's of less than half of yours.' 'Stay clear of men who've had the insides of their noses rebuilt,' or 'Never sleep with a man who's wearing women's clothes.'

The idea that women rock fans want to be groupies of the most craven sort is a strictly masculine daydream – *Them* as the rock stars surrounded by *Us*, the groupies. If you watch too much MTV, you can see this fantasy acted out many times an hour in a scenario I'll call 'The Number One Fan.' You can see her in videos like Mick Jagger's 'Just Another Night,' Bruce Springsteen's 'Dancing in The Dark,' and Dave Edmunds' 'High School Nights.' She's the girl who's picked out of the mass of common humanity by the god-like rock star and given the privilege of 'dancing' with him. She's full of awe and admiration and gratitude, she swoons, she breathes funny. There is no way to tell her apart from a groupie. Outside of TV land, in porno and in sleazier rock journalism, she's so grateful she'll perform any grovelling, humiliating, masochistic sexual act the rock star is capable of dreaming up (and they're capable of dreaming up some amazing stuff, the infamous Led Zeppelin 'fish fuck' being a prime example).

Women's fantasies are different. Consider the following paragraph from *Rolling Stone*, September 4, '80:

'After the concert, the party spirit extends backstage. As ZZ Top's "I'm Bad, I'm Nation-wide" pours out of Roth's portable stereo, two young women climb up on the banquet table and cheerfully strip down to their boots and panties, to the rowdy delight of the men and the silence of the other women. Eddie Van Halen is hanging out at the rear of the room, wearily

watching it all with unconcern. Brother Alex, however, and Michael Anthony move up close.'

The boy Van Halen fan, reading this paragraph, no doubt thinks 'Awwwright! I wanna be a rock'n'roll star! The girl fan, on the other hand, isn't favorably struck by the idea that the one sure way to get the attention of Michael and Alex is to jump up on a table and strip. Most likely, she identifies, not with the women on the table, but with the silent, other women. The girl reader gleans material for *her* fantasy by zeroing in on *Eddie* ('He's not like the others, he might even be nice.') The best way to get Eddie's attention, as everyone knows, is to go up and say something like, 'I found this old Fender Stratocaster in a junk shop in Vallejo, do you think I could fix it up?' Bingo.

In the classic female sex rock fantasy, the heroine is a musician, a journalist, a photographer – not a groupie. As Twersky describes the logic of the fantasy', . . . If I were one of these, creeps couldn't say to me, "No head, no backstage". I'd have a legitimate reason for being backstage and could be part of the action without being treated as if I were wearing a sign saying, "fuck me . . ." Young girls conclude the fantasy with '. . . One day my hero will see my act/ photos of him/ poems and say, "Here is the soul mate I've been searching for . . ." I suspect many older women drop the 'one day' stuff and head straight for second base. A romantic fantasy, sure, but not nearly as masochistic as The Number One Fan.

Women who have crushes – or 'passing fancies' as Allyson Dyer prefers to call them – don't worry overmuch when their chosen crush object shows signs of arrested juvenile delinquency. You're not going to take him home to meet Mom, so why worry about his penchant for attacking public property with fire extinguishers or the pentagram carved in his forehead? He believes the earth is flat? Who cares? You can afford to be magnanimous about his foibles. He lives in Beverly Hills, you live in Idaho Falls.

Twersky writes, '. . . Women don't automatically condone the morals, drug intake, or male chauvinism of the rock star they worship . . .' Just because a rock star is known to go through women as fast as he goes through cocaine, or to pay his roadies a $50 bonus for bringing him the prettiest groupies,

or to have said in print, 'I use women like I use toilet paper,' (Stiv Bators), doesn't mean that women who hang his picture over the night-light in the bathroom want to mug for roadies or to be used like toilet paper. Twersky says,' . . . A traditional woman's fantasy is, he's a wild, bad boy but a woman's true love, understanding will reform him . . .' As far as rock sex fantasies go, I think, 'He's a wild, bad boy, but I'll bring him to his knees by God, he'll beg for it, he'll be such a quivering mass of desire he won't be able to see straight (a little to the left, please), etc,' is just as popular.

If we don't automatically approve of our favorite's morals, neither do we automatically approve of his lack of intellectual capacities. 'I can't see myself having intellectual conversations with Billy Idol,' says Candi. 'He's just . . . attractive.' Just as girls who like tough music aren't necessarily tough chicks who put out (as Twersky points out), women who find themselves attracted to punks and clowns don't suddenly feel their IQs drop or their brains dribble out their ears. Men have for some years enjoyed the luxury of getting all gaga over 'dumb blondes,' so why can't women? I mean, women shouldn't, in the interest of equality, do every idiot thing men do, but really, this seems harmless enough.

It's strange – the more cynical among us would say 'typical' – that women should have to apologize for being attracted to men who wear clothes that show off chest, biceps and ass to good advantage, who do a credible bump & grind, and who sing things like, 'I wanna be your lover, lover, loverboy.' Really now, it seems to me the blame is severely misplaced. No one, after all, blames *men* for getting all hot over (choose one) Madonna, Stevie Nicks, or Chrissie Hynde.

Rock stars are sexy. Surely this is not a novel idea? Men can mumble in their beards about the 'goddamn Tom Jones syndrome' all they want, but I ask you: Isn't there a *hell* of a lot of good material for sex fantasies in rock'n'roll? Say yeah! *Playgirl* pales by comparison. I mean, it just cuts and fades. *Playgirl* peddles a narrow assortment of universally handsome, clean-cut, well-formed male model types. Nothing as weird as Ozzy Osbourne, or as sinister as Billy Idol, or as fat as Meatloaf, or as misshapen as Ian Dury, or even as, ahem, old as Mick Jagger. Quoting Twersky again, 'Many rock star crazed girls

have a wide variety of desires. It's not unusual to find pictures of Shaun Cassidy, Roger Daltrey, Meatloaf, Pat Simmons, and Mikhail Baryshnikov on the same wall.' So if you multiply that by thousands, what have you got? And what does *Playgirl* serve up? Tom Selleck.

Look at any copy of the sleazier rock magazines and you'll find at least as many real hot photos of men as you would in *Playgirl*. Rock stars are hardly averse to playing the sexpot in the pages of magazines, in posters, in ads, on stage, in videos . . . it's all soft core porn, to be sure, but hey, it's pretty good soft core porn.

II Are Female Fans The Same As Groupies? Give the Right Answer or Die (July '86)

Answer this question. A girl rock fan is a groupie when she:

(A) Papers an entire wall of her bedroom with posters from *Tiger Beat*.

(B) Writes a love letter to Simon Le Bon.

(C) Gets a backstage pass at a heavy metal concert by paying a roadie triple the amount he'd get from the management for bringing the band a pretty face.

If you answered (C) you're absolutely correct, and can paste a gold star next to your name on this week's chart. If you answered (A) or (B), you've been reading too much Rock criticism.

I've been reading too much Rock criticism, if it comes to that. There's two great messy piles of the stuff on either side of me, another on the floor. I managed to wrestle some of the books into a semblance of order on the bookcase, where they stand bristling with bookmarks that say things like 'bottom of page 26 – sheesh.' (*Never* underline in books, unless you want to do some heavy penance in the afterlife. One of the outer circles of Hell is presided over by librarians.)

So I've been at the stuff again, my self-imposed task being to determine: What is the difference between a girl Rock fan and a groupie, according to common Rock wisdom?

Boiled down to the simple bare bones, the answer is: There *is* no difference. *Everybody* is a groupie.

'Groupie' is a slippery term. Strictly speaking, a groupie is a person (a woman, usually), who 'chases after' rock stars, as my mother would say. But 'groupie' is also used more or less synonymously with 'girl Rock fan', 'female journalist', and 'woman Rock musician'; it's used to mean anyone working in the music field who isn't actually a Rock musician; it's used as an all-purpose insult and a slur on one's professionalism; it's used as a cute term for 'hero worship'; and it's used interchangeably with 'fan'. To some, the phrase 'fans and groupies' is redundant.

Lillian Roxon's definition of 'groupie' in her *Rock Encyclopedia* is pretty elastic.

> There are many kinds of groupies: sad groupies who never get further than screaming and wishful thinking; apprentice groupies who cut their teeth on the local high school band; compromise groupies who are prepared to settle for the road manager or even his friend; daring groupies who bravely scale walls or dangle from helicopters to get their prey . . . There are socialite groupies who give big dances and have the singer later. The most clever groupies get jobs in the industry and often persuade themselves they aren't groupies at all.

Taking careful note of the first and last categories, we see Roxon includes girls who *might* sleep with Rock stars *if* they knew any, and people who do know Rock stars and might be sleeping with some of them. Jerry Hopkins' definition of groupie is equally elastic. 'Sex obviously plays a significant role in the relationship between stars and groupies,' he writes in a chapter on groupies in *The Rock Story*:

> But other fans are committed on another level. They have, besides the emotional involvement, an economic interest in Rock. These fans usually have jobs as barbers, photographers, publicists, personal secretaries, fan magazine writers, and clothiers.

I'm sure there are people who become barbers to the stars in hopes of getting *real close* to their clients but not all of them

do. This is a minor quibble, however, since Hopkins goes on to expand his definition of groupie to include everyone in the known universe. We're all groupies on one level or another, he says, and so what? 'It's just a matter of who your heroes are. For nearly every one of us, there is someone in whose presence we'd go dumb.'

Perhaps not dumb enough to fall into bed with him – but then, according to Hopkins, you don't have to. He quotes Steve Miller:

> We're all groupies sometimes. When Eric Clapton was in town, I went to see him, but I was so awed I was just like a groupie. I just stood around and couldn't say anything. He seemed so, uh, important.

Wouldn't it be more accurate for Miller to say he was so awed he was just like a *fan*? I think so. The Everyone-is-a-groupie idea is a pretty conceit, but when it comes right down to it, some people are more groupies than others. It's one thing for a Steve Miller or a Jerry Hopkins to say we're all groupies sometimes, but to call a woman a groupie is something else again. Women, it might be noted, don't go around saying 'We're all groupies.'

Other people say it for us. Katherine Orloff writes in *Rock & Roll Woman*:

> One of the most aggravating aspects of being a young woman writer is that your motives are questioned. Rock and Roll is a very sex conscious field, and the assumption is occasionally made that female critics are just groupies with a different gimmick.

British journalist Vivien Goldman puts it more strongly in an interview with Sheryl Garratt and Sue Steward: Talking about rumors that had her sleeping with '. . . this whole list of Reggae musicians, from Big Youth to Burning Spear to Yellowman,' she says:

> In this business, there does get to be an overlap socially between your work and your life, but that's not the point.

It's another way that guys will use to trivialize your work. They will use any excuse to say you're only in it because you're a groupie.

Women journalists aren't the only ones whose work is trivialized this way. In the landmark article on groupies that appeared in *Rolling Stone* (February, 1979), the writers say:

> Some of the girls of Rock – girls who are very much a part of the scene – everybody knows them, never were groupies in the strictest sense, but are somehow, cut out of the same fabric. Like Trixie, the girl bass player and Dusty, the female recording engineer.

The Dusty in that paragraph is Dusty Street, who was a disc-jockey at two sixties progressive radio stations, KMPX and KSAN, and who was, at the time the article was written, a recording engineer at Mercury studios. Just a few sentences later, Dusty is quoted as saying, '. . . she's in it because she digs the music, not so she can ball musicians.' Indeed. 'Musicians impress me primarily as minds, as creative forces,' she says. 'What I love is good, solid music that makes you feel. *But I don't hang out with musicians.*' (My emphasis)

Nobody would think of calling a male bassist a groupie. I don't know who Trixie was (girl bass players aren't important enough to be called by their last names. We are of course all familiar with the boy guitarist, Mike) but she isn't the only woman Rock musician to be called a groupie. Lillian Roxon writes, 'The truth is, female performers are groupies of the very worst kind, eternally forming alliances with the most starstudded of their colleagues.' This makes Deborah Harry and Sheila E. groupies, among others. 'They would never be seen with a male groupie,' Roxon sniffs, as if this were somehow a character flaw. Natuarally, Chris Stein and Prince aren't groupies because *they* form alliances with starstudded woman colleagues.

In the minds of far too many Rock critics, female fans are automatically groupies, because, as the critics rather smugly imply, you just can't get around the old man–woman thing. It's true, to some extent you can't. Female Rock fans do tend to notice when a Rock star is male, especially when the guy's

wearing only enough to emphasize what he's covering up. So, if a woman looks at him and thinks to herself, 'Hot nuts, I'd sure like to roll around in a California Kingsize with that desirable hunk of beefcake,' then she's a groupie, right?

Not unless she gets him in that California Kingsize, she isn't. But since the potential is there – and Rock critics seem to feel every woman from the Tenderloin bag lady to Princess Diana has the *potential* to be a groupie – then she already *is* a groupie, sort of. (She would if she could so she probably is). Girl fans, who supposedly spend most of their time dreaming up sexual fantasies about Rock stars are seen as prime groupie material. I have before me three articles on groupies: Ellen Sander's 'The Case Of The Cock-Sure Groupies,' Tom Wolfe's 'The Girl Of The Year,' and Tom Nolan's 'Groupies: A Story Of Our Time.' In all three the line dividing girl fans and groupies is about as thin as an E-string.

Ellen Sanders begins her article with a description of girls at a Rolling Stones concert:

> They press up against the stage, the young ones, their faces bathed in delight or clenched in crumpled ecstatic agony. They lean over the edge of the platform, clutching gifts and beads or notes or the group's latest album. And some reach out, squirm on their bellies trying to get up over the edge of the stage, maybe to-touch-one-of-them . . . just once.
>
> 'Did you see them, *did* you *seee* them, oh, Cathy, they're so *beautiful*! Oh wow, the drummer, Cathy, the *bass player*! Let's go in back to the stage door, Cathy, maybe we can meet them, talk to them, *something, anything*! Cathy, come on!!!'
>
> Groupies . . .

Tom Wolfe starts out in much the same vein, describing in delectable detail the 'flaming little buds, bobbing and screaming, rocketing about inside the Academy of Music Theatre.' These are just the run-of-the-mill screamers, the ones who haven't gone beyond wishful thinking or rushing the stage in sudden frenzy. They form a backdrop for the real subject of his piece, a 'socialite groupie' named Baby Jane Holzer, who has graduated from the ranks of screaming teenyboppers to a more rarified level of sex-rock fantasy. Wolfe implies Baby

Jane and the teenyboppers are cut of the same cloth. Perhaps they are similar, but just because Baby Jane starts out as a teenybopper does not mean all – or even most – teenyboppers will end up like Baby Jane. (The logic: All cats die – Socrates is dead – Socrates is a cat.)

Tom Nolan peppers his tale of groupie Sherry Sklar with equally provocative (and provoking) descriptions of screaming girls and teenyboppers 'glomming through *Tiger Beat, Teenset, Go!*' His Sherry, like Baby Jane, starts out as one of the screechy little girls. She's precocious, founding her Boss Beatle Club at age 13. But after awhile, being a fan isn't *enough*. She keeps wanting something . . . *more*, something she can only vaguely imagine . . . Remember we're dealing with innocent child-women until the actual fall. And Sherry does fall. Her quest finally lands her in bed with a girlfriend and two members of a 'Philly Whitesoul group.' From there it's onward and upwards to the *real* stars – the Stones, the Monkees, Paul Revere & The Raiders. From there, of course she spirals downward to oblivion. There's a moral to this story.

This may be an entirely accurate account of how a fan becomes a groupie. But this oft-told tale of *teenybopper-turned-groupie* obscures the mundane truth that most girl Rock fans never become groupies. The true-life, but mostly unchronicled story of the girl Rock fan who remains 'just' a fan, who never so much as holds hands with a member of a high school garage band, doesn't make as good copy as the story of the girl who drops from a helicopter onto the balcony of Mick Jagger's hotel room. So, when critics describe 'all those legions of wistful bell-bottomed girls' who dream of 'Paulie', you know where it's leading – to the 'ambitious few who are doing something about it.'

'It was easy to slip from fan to groupie in the early sixties,' writes Gary Herman in *Rock & Roll Babylon*:

> The whole atmosphere of Rock 'n' roll concerts was charged with adolescent sexual electricity. Against the backcloth of fumbled experiences with untutored and ungainly boyfriends, the worldly image of the love-toting Pop or Rock musicians was truly seductive . . . The sexual act itself was little more than symbolic. It was

81

a demonstration that the barrier between audience and performer had come down for her, setting her above the crowd. *Sex was the show carried on backstage* – no longer a surrogate, but the act itself.

If this sounds romantic, it's also unrealistic, *and* it's contradicted by the rest of the chapter ('Stage Door Sex') which suggests that to slip from fan to groupie was anything but easy, even back in the idyllic sixties. Herman admits it takes money, looks, and guts to be a successful groupie: the kind of money to follow a group cross country; the kind of covergirl face and centerfold body Rock stars prefer in groupies: and the kind of guts to be able to lie your way backstage, climb hotel fire escapes, or walk into a bar with a couple of friends and stage an impromptu strip show. If you don't have the looks, you better have the money and the guts.

What's expected of groupies might also be daunting to most girls:

> Voyeurism, group sex and a bit of mild sadism are all important parts of the groupie scene. The Rock stars maintain the proper distance of a discerning consumer, while the groupies maintain the high standards one might expect of a . . . brothel.

A brothel? What happened to breaking down the barriers between performer and audience? Herman's description of the groupie 'hierarchy' is likely to put a damper on that idealistic notion. At the top, he says, are the models, the heiresses, and the actresses, fantasy objects in themselves. At the bottom are the 'totally disposable' girls who provide 'room service or "in-flight entertainment" – ready and and willing to be used or abused as the fancy dictates.' This is the more realistic description of the groupie's lot, and girls know it.

To be 'totally disposable' isn't among the ambitions of most girls – even those who do become groupies hope for something better. A desire to be used or abused as fancy dictates is not likely what's on the minds of girls screaming 'SIIIIMON!!!' at Duran Duran concerts; it's not in the minds of women who lust after Sting; and it's most certainly not in the minds of

female people who are, or aspire to be, musicians, recording engineers, disc jockeys or journalists.

We might 'all be groupies sometimes' but where women are concerned, that's all too often meant literally, translating as 'we're really all just sluts.' It's best to keep in mind Sheryl Garratt's warning that 'the term groupie is a dangerous one, for it is often used as a putdown for *any* women involved in the industry.' Until the word 'groupie' has stopped being a shorthand term for women involved in Rock & Roll, and until it's taken for granted that girl fans, women musicians, and female photographers, publicists, recording engineers and journalists come to Rock & Roll for the same reasons as their male counterparts, it's well to keep a sharp watch on how the word 'groupie' is bandied about.

References

Herman, Gary. 1970. Fan Dancing. In *Rock'n'Roll Babylon*. New York: G. P. Putnam's Sons.

Nolan, Tom. 1969. Groupies: A Story of Our Times. In *The Age of Rock: Sounds of the American Cultural Revolution*, ed. Jonathan Eisen. New York: Random House.

Orloff, Katherine. 1974. *Rock & Roll Woman*. Los Angeles: Nash Publishing.

Steward, Sue and Sheryl Garratt. 1984. *Signed, Sealed & Delivered: True Life Stories of Women in Pop*. Boston: South End Press.

Wolfe, Tom. 1965. The Girl of the Year. In *The Kandy-Colored Tangerine-Flake Streamline Baby*. New York: Farrar & Giroux.

Beatlemania: Girls Just Want to Have Fun

BARBARA EHRENREICH, ELIZABETH HESS, GLORIA JACOBS

> . . . witness the birth of eve – she is rising she was sleep-
> ing she is fading in a naked field sweating the precious
> blood of nodding blooms . . . in the eye of the arena she
> bends in half in service – the anarchy that exudes from
> the pores of her guitar are the cries of the people wailing
> in the rushes . . . a riot of ray/dios . . .
>
> <div align="right">Patti Smith, 'Notice,' in Babel</div>

The news footage shows police lines straining against crowds
of hundreds of young women. The police look grim; the girls'
faces are twisted with desperation or, in some cases, shining
with what seems to be an inner light. The air is dusty from a
thousand running and scuffling feet. There are shouted orders to
disperse, answered by a rising volume of chants and wild shrieks.
The young women surge forth; the police line breaks . . .

Looking at the photos or watching the news clips today, any-
one would guess that this was the sixties – a demonstration – or
maybe the early seventies – the beginning of the women's
liberation movement. Until you look closer and see that the
girls are not wearing sixties-issue jeans and T-shirts but ber-
muda shorts, high-necked, preppie blouses, and disheveled but
unmistakably bouffant hairdos. This is not 1968 but 1964, and
the girls are chanting, as they surge against the police line, 'I
love Ringo.'

Yet, if it was not the 'movement,' or a clear-cut protest of any kind, Beatlemania was the first mass outburst of the sixties to feature women – in this case girls, who would not reach full adulthood until the seventies and the emergence of a genuinely political movement for women's liberation. The screaming ten- to fourteen-year-old fans of 1964 did not riot *for* anything, except the chance to remain in the proximity of their idols and hence to remain screaming. But they did have plenty to riot against, or at least to overcome through the act of rioting. In a highly sexualized society (one sociologist found that the number of explicitly sexual references in the mass media had doubled between 1950 and 1960), teen and preteen girls were expected to be not only 'good' and 'pure' but to be the enforcers of purity within their teen society – drawing the line for overeager boys and ostracizing girls who failed in this responsibility. To abandon control – to scream, faint, dash about in mobs – was, in form if not in conscious intent, to protest the sexual repressiveness, the rigid double standard of female teen culture. It was the first and most dramatic uprising of *women's* sexual revolution.

Beatlemania, in most accounts, stands isolated in history as a mere craze – quirky and hard to explain. There had been hysteria over male stars before, but nothing on this scale. In its peak years – 1964 and 1965 – Beatlemania struck with the force, if not the conviction, of a social movement. It began in England with a report that fans had mobbed the popular but not yet immortal group after a concert at the London Palladium on 13 October, 1963. Whether there was in fact a mob or merely a scuffle involving no more than eight girls is not clear, but the report acted as a call to mayhem. Eleven days later a huge and excited crowd of girls greeted the Beatles (returning from a Swedish tour) at Heathrow Airport. In early November, 400 Carlisle girls fought the police for four hours while trying to get tickets for a Beatles concert; nine people were hospitalized after the crowd surged forward and broke through shop windows. In London and Birmingham the police could not guarantee the Beatles safe escort through the hordes of fans. In Dublin the police chief judged that the Beatles' first visit was 'all right until the mania degenerated into barbarism.'[1] And on the eve of the group's first US tour, *Life* reported, 'A Beatle who ventures

out unguarded into the streets runs the very real peril of being dismembered or crushed to death by his fans.'[2]

When the Beatles arrived in the United States, which was still ostensibly sobered by the assassination of President Kennedy two months before, the fans knew what to do. Television had spread the word from England: The approach of the Beatles is a license to riot. At least 4,000 girls (some estimates run as high as 10,000) greeted them at Kennedy Airport, and hundreds more laid siege to the Plaza Hotel, keeping the stars virtual prisoners. A record 73 million Americans watched the Beatles on 'The Ed Sullivan Show' on 9 February, 1964, the night 'when there wasn't a hubcap stolen anywhere in America.' American Beatlemania soon reached the proportions of religious idolatry. During the Beatles' twenty-three-city tour that August, local promoters were required to provide a minimum of 100 security guards to hold back the crowds. Some cities tried to ban Beatle-bearing craft from their runways; otherwise it took heavy deployments of local police to protect the Beatles from their fans and the fans from the crush. In one city, someone got hold of the hotel pillowcases that had purportedly been used by the Beatles, cut them into 160,000 tiny squares, mounted them on certificates, and sold them for $1 apiece. The group packed Carnegie Hall, Washington's Coliseum and, a year later, New York's 55,600-seat Shea Stadium, and in no setting, at any time, was their music audible above the frenzied screams of the audience. In 1966, just under three years after the start of Beatlemania, the Beatles gave their last concert – the first musical celebrities to be driven from the stage by their own fans.

In its intensity, as well as its scale, Beatlemania surpassed all previous outbreaks of star-centered hysteria. Young women had swooned over Frank Sinatra in the forties and screamed for Elvis Presley in the immediate pre-Beatle years, but the Fab Four inspired an extremity of feeling usually reserved for football games or natural disasters. These baby boomers far outnumbered the generation that, thanks to the censors, had only been able to see Presley's upper torso on 'The Ed Sullivan Show.' Seeing (whole) Beatles on Sullivan was exciting, but not enough. Watching the band on television was a thrill – particularly the close-ups – but the real goal was to leave home and meet the

Beatles. The appropriate reaction to contact with them – such as occupying the same auditorium or city block – was to sob uncontrollably while screaming, 'I'm gonna die, I'm gonna die,' or, more optimistically, the name of a favorite Beatle, until the onset of either unconsciousness or laryngitis. Girls peed in their pants, fainted, or simply collapsed from the emotional strain. When not in the vicinity of the Beatles – and only a small proportion of fans ever got within shrieking distance of their idols – girls exchanged Beatle magazines or cards, and gathered to speculate obsessively on the details and nuances of Beatle life. One woman, who now administers a Washington, DC-based public interest group, recalls long discussions with other thirteen-year-olds in Orlando, Maine:

> I especially liked talking about the Beatles with other girls. Someone would say, 'What do you think Paul had for breakfast?' 'Do you think he sleeps with a different girl every night?' Or, 'Is John really the leader?' 'Is George really more sensitive?' And like that for hours.

This fan reached the zenith of junior high school popularity after becoming the only girl in town to travel to a Beatles' concert in Boston: 'My mother had made a new dress for me to wear [to the concert] and when I got back, the other girls wanted to cut it up and auction off the pieces.'

To adults, Beatlemania was an affliction, an 'epidemic,' and the Beatles themselves were only the carriers, or even 'foreign germs.' At risk were all ten- to fourteen-year-old girls, or at least all white girls; blacks were disdainful of the Beatles' initially derivative and unpolished sound. There appeared to be no cure except for age, and the media pundits were fond of reassuring adults that the girls who had screamed for Frank Sinatra had grown up to be responsible, settled housewives. If there was a shortcut to recovery, it certainly wasn't easy. A group of Los Angeles girls organized a detox effort called 'Beatlesaniacs, Ltd.,' offering 'group therapy for those living near active chapters, and withdrawal literature for those going it alone at far-flung outposts.' Among the rules for recovery were: 'Do not mention the word Beatles (or beetles),' 'Do not mention the

word England,' 'Do not speak with an English accent,' and 'Do not speak English.'[3] In other words, Beatlemania was as inevitable as acne and gum-chewing, and adults would just have to weather it out.

But why was it happening? And why in particular to an America that prided itself on its post-McCarthy maturity, its prosperity, and its clear position as the number one world power? True, there were social problems that not even *Reader's Digest* could afford to be smug about – racial segregation, for example, and the newly discovered poverty of 'the other America.' But these were things that an energetic President could easily handle – or so most people believed at the time – and if 'the Negro problem,' as it was called, generated overt unrest, it was seen as having a corrective function and limited duration. Notwithstanding an attempted revival by presidential candidate Barry Goldwater, 'extremism' was out of style in any area of expression. In colleges, 'coolness' implied a detached and rational appreciation of the status quo, and it was de rigueur among all but the avant-garde who joined the Freedom Rides or signed up for the Peace Corps. No one, not even Marxist philosopher Herbert Marcuse, could imagine a reason for widespread discontent among the middle class or for strivings that could not be satisfied with a department store charge account – much less for 'mania.'

In the media, adult experts fairly stumbled over each other to offer the most reassuring explanations. The *New York Times Magazine* offered a 'psychological, anthropological,' half tongue-in-cheek account, titled 'Why the Girls Scream, Weep, Flip.' Drawing on the work of the German sociologist Theodor Adorno, *Times* writer David Dempsey argued that the girls weren't really out of line at all; they were merely 'conforming.' Adorno had diagnosed the 1940s jitterbug fans as 'rhythmic obedients,' who were 'expressing their desire to obey.' They needed to subsume themselves into the mass, 'to become transformed into an insect.' Hence, 'jitter*bug*,' and as Dempsey triumphantly added: 'Beatles, too, are a type of bug . . . and to "beatle," as to jitter, is to lose one's identity in an automatized, insectlike activity, in other words, to obey.' If Beatlemania was more frenzied than the outbursts of obedience inspired by Sinatra or Fabian, it was simply

because the music was 'more frantic,' and in some animal
way, more compelling. It is generally admitted 'that jungle
rhythms influence the "beat" of much contemporary dance
activity,' he wrote, blithely endorsing the stock racist response
to rock 'n' roll. Atavistic, 'aboriginal' instincts impelled the
girls to scream, weep, and flip, whether they liked it or not: 'It
is probably no coincidence that the Beatles, who provoke the
most violent response among teenagers, resemble in manner
the witch doctors who put their spells on hundreds of shuffling
and stamping natives.'[4]

Not everyone saw the resemblance between Beatlemanic girls
and 'natives' in a reassuring light however. *Variety* speculated
that Beatlemania might be 'a phenomenon closely linked to the
current wave of racial rioting.'[5] It was hard to miss the element
of defiance in Beatlemania. If Beatlemania was conformity, it
was conformity to an imperative that overruled adult mores
and even adult laws. In the mass experience of Beatlemania,
as for example at a concert or an airport, a girl who might
never have contemplated shoplifting could assault a policeman
with her fists, squirm under police barricades, and otherwise
invite a disorderly conduct charge. Shy, subdued girls could
go berserk. 'Perky,' ponytailed girls of the type favored by
early sixties sitcoms could dissolve in histrionics. In quieter
contemplation of their idols, girls could see defiance in the
Beatles or project it onto them. *Newsweek* quoted Pat Hagan,
'a pretty, 14-year-old Girl Scout, nurse's aide, and daughter
of a Chicago lawyer ... who previously dug "West Side
Story," Emily Dickinson, Robert Frost, and Elizabeth Barrett
Browning: "They're tough," she said of the Beatles. "Tough
is like when you don't conform ... You're tumultuous when
you're young, and each generation has to have its idols."'[6]
America's favorite sociologist, David Riesman, concurred,
describing Beatlemania as 'a form of protest against the adult
world.'[7]

There was another element of Beatlemania that was hard to
miss but not always easy for adults to acknowledge. As any
casual student of Freud would have noted, at least part of
the fans' energy was sexual. Freud's initial breakthrough had
been the insight that the epidemic female 'hysteria' of the late
nineteenth century – which took the form of fits, convulsions,

tics, and what we would now call neuroses – was the product of sexual repression. In 1964, though, confronted with massed thousands of 'hysterics,' psychologists approached this diagnosis warily. After all, despite everything Freud had had to say about childhood sexuality, most Americans did not like to believe that twelve-year-old girls had any sexual feelings to repress. And no normal girl – or full-grown woman, for that matter – was supposed to have the libidinal voltage required for three hours of screaming, sobbing, incontinent, acute-phase Beatlemania. In an article in *Science News Letter* titled 'Beatles Reaction Puzzles Even Psychologists,' one unidentified psychologist offered a carefully phrased, hygienic explanation: Adolescents are 'going through a strenuous period of emotional and physical growth,' which leads to a 'need for expressiveness, especially in girls.' Boys have sports as an outlet; girls have only the screaming and swooning afforded by Beatlemania, which could be seen as 'a release of sexual energy.'[8]

For the girls who participated in Beatlemania, sex was an obvious part of the excitement. One of the most common responses to reporters' queries on the sources of Beatlemania was, 'Because they're sexy.' And this explanation was in itself a small act of defiance. It was rebellious (especially for the very young fans) to lay claim to sexual feelings. It was even more rebellious to lay claim to the *active*, desiring side of a sexual attraction: the Beatles were the objects; the girls were their pursuers. The Beatles were sexy; the girls were the ones who perceived them as sexy and acknowledged the force of an ungovernable, if somewhat disembodied, lust. To assert an active, powerful sexuality by the tens of thousands and to do so in a way calculated to attract maximum attention was more than rebellious. It was, in its own unformulated, dizzy way, revolutionary.

Sex and the Teenage Girl

In the years and months immediately preceding US Beatlemania, the girls who were to initiate a sexual revolution looked, from a critical adult vantage point, like sleepwalkers

on a perpetual shopping trip. Betty Friedan noted in her 1963 classic, *The Feminine Mystique*, 'a new vacant sleepwalking, playing-a-part quality of youngsters who do what they are supposed to do, what the other kids do, but do not seem to feel alive or real in doing it.'9 But for girls, conformity meant more than surrendering, comatose, to the banal drift of junior high or high school life. To be popular with boys and girls – to be universally attractive and still have an unblemished 'reputation' – a girl had to be crafty, cool, and careful. The payoff for all this effort was to end up exactly like Mom – as a housewife.

In October 1963, the month Beatlemania first broke out in England and three months before it arrived in America, *Life* presented a troubling picture of teenage girl culture. The focus was Jill Dinwiddie, seventeen, popular, 'healthy, athletic, getting A grades,' to all appearances wealthy, and at the same time, strangely vacant. The pictures of this teenage paragon and her friends would have done justice to John Lennon's first take on American youth:

> When we got here you were all walkin' around in fuckin' Bermuda shorts with Boston crewcuts and stuff on your teeth . . . The chicks looked like 1940's horses. There was no conception of dress or any of that jazz. We just thought what an ugly race, what an ugly race.10

Jill herself, the 'queen bee of the high school,' is strikingly sexless: short hair in a tightly controlled style (the kind achieved with flat metal clips), button-down shirts done up to the neck, shapeless skirts with matching cardigans, and a stance that evokes the intense posture-consciousness of prefeminist girls' phys. ed. Her philosophy is no less engaging: 'We have to be like everybody else to be accepted. Aren't most adults that way? We learn in high school to stay in the middle.'11

'The middle,' for girls coming of age in the early sixties, was a narrow and carefully defined terrain. The omnipresent David Riesman, whom *Life* called in to comment on Jill and her crowd, observed, 'Given a standard definition of what is feminine and successful, they must conform to it. The range is narrow, the models they may follow few.' The goal,

which Riesman didn't need to spell out, was marriage and motherhood, and the route to it led along a straight and narrow path between the twin dangers of being 'cheap' or being too puritanical, and hence unpopular. A girl had to learn to offer enough, sexually, to get dates, and at the same time to withhold enough to maintain a boy's interest through the long preliminaries from dating and going steady to engagement and finally marriage. None of this was easy, and for girls like Jill the pedagogical burden of high school was a four-year lesson in how to use sex instrumentally: doling out just enough to be popular with boys and never enough to lose the esteem of the 'right kind of kids.' Commenting on *Life*'s story on Jill, a University of California sociologist observed:

> It seems that half the time of our adolescent girls is spent trying to meet their new responsibilities to be sexy, glamorous and attractive, while the other half is spent meeting their old responsibility to be virtuous by holding off the advances which testify to their success.

Advice books to teenagers fussed anxiously over the question of 'where to draw the line,' as did most teenage girls themselves. Officially everyone – girls and advice-givers – agreed that the line fell short of intercourse, though by the sixties even this venerable prohibition required some sort of justification, and the advice-givers strained to impress upon their young readers the calamitous results of premarital sex. First there was the obvious danger of pregnancy, an apparently inescapable danger since no book addressed to teens dared offer birth control information. Even worse, some writers suggested, were the psychological effects of intercourse: It would destroy a budding relationship and possibly poison any future marriage. According to a contemporary textbook titled, *Adolescent Development and Adjustment*, intercourse often caused a man to lose interest ('He may come to believe she is totally promiscuous'), while it was likely to reduce a woman to slavish dependence ('Sometimes a woman focuses her life around the man with whom she first has intercourse').[12] The girl who survived premarital intercourse and went on to marry someone else would find marriage clouded with awkwardness and distrust.

Dr Arthur Cain warned in *Young People and Sex* that the husband of a sexually experienced woman might be consumed with worry about whether his performance matched that of her previous partners. 'To make matters worse,' he wrote, 'it may be that one's sex partner is not as exciting and satisfying as one's previous illicit lover.'[13] In short, the price of premarital experience was likely to be postnuptial disappointment. And, since marriage was a girl's peak achievement, an anticlimatic wedding night would be a lasting source of grief.

Intercourse was obviously out of the question, so young girls faced the still familiar problem of where to draw the line on a scale of lesser sexual acts, including (in descending order of niceness): kissing, necking, and petting, this last being divided into 'light' (through clothes and/or above the waist) and 'heavy' (with clothes undone and/or below the waist). Here the experts were no longer unanimous. Pat Boone, already a spokesman for the Christian right, drew the line at kissing in his popular 1958 book, *'Twixt Twelve and Twenty*. No prude, he announced that 'kissing is here to stay and I'm glad of it!' But, he warned, 'Kissing is not a game. Believe me! . . . Kissing for fun is like playing with a beautiful candle in a roomful of dynamite!'[14] (The explosive consequences might have been guessed from the centerpiece photos showing Pat dining out with his teen bride, Shirley; then, as if moments later, in a maternity ward with her; and, in the next picture, surrounded by 'the four little Boones.') Another pop-singer-turned-adviser, Connie Francis, saw nothing wrong with kissing (unless it begins to 'dominate your life'), nor with its extended form, necking, but drew the line at petting:

> Necking and petting – let's get this straight – are two different things. Petting, according to most definitions, is specifically intended to arouse sexual desires and as far as I'm concerned, petting is out for teenagers.[15]

In practice, most teenagers expected to escalate through the scale of sexual possibilities as a relationship progressed, with the big question being: How much, how soon? In their 1963 critique of American teen culture, *Teen-Age Tyranny*, Grace and Fred Hechinger bewailed the cold instrumentality that shaped

the conventional answers. A girl's 'favors,' they wrote, had become 'currency to bargain for desirable dates which, in turn, are legal tender in the exchange of popularity.' For example, in answer to the frequently asked question, 'Should I let him kiss me good night on the first date?' they reported that:

> A standard caution in teen-age advice literature is that, if the boy 'gets' his kiss on the first date, he may assume that many other boys have been just as easily compensated. In other words, the rule book advises mainly that the [girl's] popularity assets should be protected against deflation.[16]

It went without saying that it was the girl's responsibility to apply the brakes as a relationship approached the slippery slope leading from kissing toward intercourse. This was not because girls were expected to be immune from temptation. Connie Francis acknowledged that 'It's not easy to be moral, especially where your feelings for a boy are involved. It never is, because you have to fight to keep your normal physical impulses in line.' But it was the girl who had the most to lose, not least of all the respect of the boy she might too generously have indulged. 'When she gives in completely to a boy's advances,' Francis warned, 'the element of respect goes right out the window.' Good girls never 'gave in,' never abandoned themselves to impulse or emotion, and never, of course, initiated a new escalation on the scale of physical intimacy. In the financial metaphor that dominated teen sex etiquette, good girls 'saved themselves' for marriage; bad girls were 'cheap.'

According to a 1962 Gallup Poll commissioned by *Ladies' Home Journal*, most young women (at least in the *Journal's* relatively affluent sample) enthusiastically accepted the traditional feminine role and the sexual double standard that went with it:

> Almost all our young women between 16 and 21 expect to be married by 22. Most want 4 children, many want . . . to work until children come; afterward, a resounding no! They feel a special responsibility for sex *because* they are women. An 18-year-old student in California said, 'The standard for men – sowing wild oats – results in sown

oats. And where does this leave the woman?' . . . Another student: 'A man will go as far as a woman will let him. The girl has to set the standard.'[17]

Implicit in this was a matrimonial strategy based on months of sexual teasing (setting the standard), until the frustrated young man broke down and proposed. Girls had to 'hold out' because, as one *Journal* respondent put it, 'Virginity is one of the greatest things a woman can give to her husband.' As for what *he* would give to her, in addition to four or five children, the young women were vividly descriptive:

 . . . I want a split-level brick with four bedrooms with French Provincial cherrywood furniture.
 . . . I'd like a built-in oven and range, counters only 34 inches high with Formica on them.
 . . . I would like a lot of finished wood for warmth and beauty.
 . . . My living room would be long with a high ceiling of exposed beams. I would have a large fireplace on one wall, with a lot of copper and brass around. . . . My kitchen would be very like old Virginian ones – fireplace and oven.

So single-mindedly did young women appear to be bent on domesticity that when Beatlemania did arrive, some experts thought the screaming girls must be auditioning for the maternity ward: 'The girls are subconsciously preparing for motherhood. Their frenzied screams are a rehearsal for that moment. Even the jelly babies [the candies favored by the early Beatles and hurled at them by fans] are symbolic.'[18] Women were asexual, or at least capable of mentally bypassing sex and heading straight from courtship to reveries of Formica counters and cherrywood furniture, from the soda shop to the hardware store.

But the vision of a suburban split-level, which had guided a generation of girls chastely through high school, was beginning to lose its luster. Betty Friedan had surveyed the 'successful' women of her age – educated, upper-middle-class housewives – and found them reduced to infantile neuroticism by

the isolation and futility of their lives. If feminism was still a few years off, at least the 'feminine mystique' had entered the vocabulary, and even Jill Dinwiddie must have read the quotation from journalist Shana Alexander that appeared in the same issue of *Life* that featured Jill. 'It's a marvellous life, this life in a man's world,' Alexander said. 'I'd climb the walls if I had to live the feminine mystique.' The media that had once romanticized togetherness turned their attention to 'the crack in the picture window' – wife swapping, alcoholism, divorce, and teenage anomie. A certain cynicism was creeping into the American view of marriage. In the novels of John Updike and Philip Roth, the hero didn't get the girl, he got away. When a Long Island prostitution ring, in which housewives hustled with their husbands' consent, was exposed in the winter of 1963, a Fifth Avenue saleswoman commented: 'I see all this beautiful stuff I'll never have, and I wonder if it's worth it to be good. What's the difference, one man every night or a different man?'[19]

So when sociologist Bennet Berger commented in *Life* that 'there is nobody better equipped than Jill to live in a society of all-electric kitchens, wall-to-wall carpeting, dishwashers, garbage disposals [and] color TV,' this could no longer be taken as unalloyed praise. Jill herself seemed to sense that all the tension and teasing anticipation of the teen years was not worth the payoff. After she was elected, by an overwhelming majority, to the cheerleading team, 'an uneasy, faraway look clouded her face.' 'I guess there's nothing left to do in high school,' she said. 'I've made song leader both years, and that was all I really wanted.' For girls, high school was all there was to public life, the only place you could ever hope to run for office or experience the quasi fame of popularity. After that came marriage – most likely to one of the crew-cut boys you'd made out with – then isolation and invisibility.

Part of the appeal of the male star – whether it was James Dean or Elvis Presley or Paul McCartney – was that you would *never* marry him; the romance would never end in the tedium of marriage. Many girls expressed their adulation in conventional, monogamous terms, for example, picking their favorite Beatle and writing him a serious letter of proposal, or carrying placards saying, 'John, Divorce Cynthia.' But it was inconceivable

that any fan would actually marry a Beatle or sleep with him (sexually active 'groupies' were still a few years off) or even hold his hand. Adulation of the male star was a way to express sexual yearnings that would normally be pressed into the service of popularity or simply repressed. The star could be loved noninstrumentally, for his own sake, and with complete abandon. Publicly to advertise this hopeless love was to protest the calculated, pragmatic sexual repression of teenage life.

The Economics of Mass Hysteria

Sexual repression had been a feature of middle-class teen life for centuries. If there was a significant factor that made mass protest possible in the late fifties (Elvis) and the early sixties (the Beatles), it was the growth and maturation of a teen market: for distinctly teen clothes, magazines, entertainment, and accessories. Consciousness of the teen years as a life-cycle phase set off between late childhood on the one hand and young adulthood on the other only goes back to the early twentieth century, when the influential psychologist G. Stanley Hall published his mammoth work *Adolescence*. (The word 'teenager' did not enter mass usage until the 1940s.) Postwar affluence sharpened the demarcations around the teen years: fewer teens than ever worked or left school to help support their families, making teenhood more distinct from adulthood as a time of unemployment and leisure. And more teens than ever had money to spend, so that from a marketing view point, teens were potentially much more interesting than children, who could only influence family spending but did little spending themselves. Grace and Fred Hechinger reported that in 1959 the average teen spent $555 on 'goods and services not including the necessities normally supplied by their parents,' and noted, for perspective, that in the same year school-teachers in Mississippi were earning just over $3,000. 'No matter what other segments of American society – parents, teachers, sociologists, psychologists, or policemen – may deplore the power of teenagers,' they observed, 'the American business community has no cause for complaint.'[20]

If advertisers and marketing men manipulated teens as consumers, they also, inadvertently, solidified teen culture against the adult world. Marketing strategies that recognized the importance of teens as precocious consumers also recognized the importance of heightening their self-awareness of themselves *as teens*. Girls especially became aware of themselves as occupying a world of fashion of their own – not just bigger children's clothes or slimmer women's clothes. You were not a big girl or a junior woman, but a 'teen,' and in that notion lay the germs of an oppositional identity. Defined by its own products and advertising slogans, teenhood became more than a prelude to adulthood; it was a status to be proud of – emotionally and sexually complete unto itself.

Rock 'n' roll was the most potent commodity to enter the teen consumer subculture. Rock was originally a black musical form with no particular age identification, and it took white performers like Buddy Holly and Elvis Presley to make rock 'n' roll accessible to young white kids with generous allowances to spend. On the white side of the deeply segregated music market, rock became a distinctly teenage product. Its 'jungle beat' was disconcerting or hateful to white adults; its lyrics celebrated the special teen world of fashion ('Blue Suede Shoes'), feeling ('Teenager in Love'), and passive opposition ('Don't know nothin' 'bout his-to-ry'). By the late fifties, rock 'n' roll was the organizing principle and premier theme of teen consumer culture: you watched the Dick Clark show not only to hear the hits but to see what the kids were wearing; you collected not only the top singles but the novelty items that advertised the stars; you cultivated the looks and personality that would make you a 'teen angel.' And if you were still too young for all this, in the late fifties you yearned to grow up to be – not a woman and a housewife, but a teenager.

Rock 'n' roll made mass hysteria almost inevitable: It announced and ratified teen sexuality and then amplified teen sexual frustration almost beyond endurance. Conversely, mass hysteria helped make rock 'n' roll. In his biography of Elvis Presley, Albert Goldman describes how Elvis's manager, Colonel Tom Parker, whipped mid-fifties girl audiences into a frenzy before the appearance of the star: As many as a dozen acts would precede Elvis – acrobats, comics, gospel singers, a little

girl playing a xylophone – until the audience, 'driven half mad by sheer frustration, began chanting rhythmically, *"We want Elvis, we want Elvis!"* When the star was at last announced:

> Five thousand shrill female voices come in on cue. The screeching reaches the intensity of a jet engine. When Elvis comes striding out on stage with his butchy walk, the screams suddenly escalate. They switch to hyper-space. Now, you may as well be stone deaf for all the music you'll hear. [21]

The newspapers would duly report that 'the fans went wild.'

Hysteria was critical to the marketing of the Beatles. First there were the reports of near riots in England. Then came a calculated publicity tease that made Colonel Parker's manipu-lations look oafish by contrast: five million posters and stickers announcing 'The Beatles Are Coming' were distributed nation-wide. Disc jockeys were blitzed with promo material and Beatle interview tapes (with blank spaces for the DJ to fill in the questions, as if it were a real interview) and enlisted in a mass 'countdown' to the day of the Beatles' arrival in the United States. As Beatle chronicler Nicholas Schaffner reports:

> Come break of 'Beatle Day,' the quartet had taken over even the disc-jockey patter that punctuated their hit songs. From WMCA and WINS through W-A-Beatle-C, it was 'thirty Beatle degrees,' 'eight-thirty Beatle time' . . . [and] 'four hours and fifty minutes to go.' [22]

By the time the Beatles materialized, on 'The Ed Sullvan Show' in February 1964, the anticipation was unbearable. A woman who was a fourteen-year-old in Duluth at the time told us, 'Looking back, it seems so commercial to me, and so degrading that millions of us would just scream on cue for these four guys the media dangled out in front of us. But at the time it was something intensely personal for me and, I guess, a million other girls. The Beatles seemed to be speaking directly to us and, in a funny way, *for us.*'

By the time the Beatles hit America, teens and preteens had already learned to look to their unique consumer subculture

for meaning and validation. If this was manipulation – and no culture so strenuously and shamelessly exploits its children as consumers – it was also subversion. *Bad* kids became juvenile delinquents, smoked reefers, or got pregnant. Good kids embraced the paraphernalia, the lore, and the disciplined fandom of rock 'n' roll. (Of course, bad kids did their thing to a rock beat too: the first movie to use a rock 'n' roll soundtrack was 'Blackboard Jungle,' in 1955, cementing the suspected link between 'jungle rhythms' and teen rebellion.) For girls, fandom offered a way not only to sublimate romantic and sexual yearnings but to carve out subversive versions of heterosexuality. Not just anyone could be hyped as a suitable object for hysteria: It *mattered* that Elvis was a grown-up greaser, and that the Beatles let their hair grow over their ears.

The Erotics of the Star–Fan Relationship

In real life, i.e. in junior high or high school, the ideal boyfriend was someone like Tab Hunter or Ricky Nelson. He was 'all boy,' meaning you wouldn't get home from a date without a friendly scuffle, but he was also clean-cut, meaning middle class, patriotic, and respectful of the fact that good girls waited until marriage. He wasn't moody and sensitive (like James Dean in *Giant* or *Rebel Without a Cause*), he was realistic (meaning that he understood that his destiny was to earn a living for someone like yourself). The stars who inspired the greatest mass adulation were none of these things, and their very remoteness from the pragmatic ideal was what made them accessible to fantasy.

Elvis was visibly lower class and symbolically black (as the bearer of black music to white youth). He represented an unassimilated white underclass that had been forgotten by mainstream suburban America – more accurately, he represented a middle-class caricature of poor whites. He was *sleazy*. And, as his biographer Goldman argues, therein lay his charm:

> What did the girls see that drove them out of their minds? It sure as hell wasn't the All-American Boy. . . . Elvis was the flip side of [the] conventional male image. His

fish-belly white complexion, so different from the 'healthy tan' of the beach boys; his brooding Latin eyes, heavily shaded with mascara ... the thick, twisted lips; the long, greasy hair. ... God! what a freak the boy must have looked to those little girls ... and what a turn-on! Typical comments were: 'I like him because he looks so mean' ... 'He's been in and out of jail.'[23]

Elvis stood for a dangerous principle of masculinity that had been expunged from the white-collar, split-level world of fandom: a hood who had no place in the calculus of dating, going steady, and getting married. At the same time, the fact that he was lower class evened out the gender difference in power. He acted arrogant, but he was really vulnerable, and would be back behind the stick shift of a Mack truck if you, the fans, hadn't redeemed him with your love. His very sleaziness, then, was a tribute to the collective power of the teen and preteen girls who worshipped him. He was obnoxious to adults – a Cincinnati used-car dealer once offered to smash fifty Presley records in the presence of every purchaser – not only because of who he was but because he was a reminder of the emerging power and sexuality of young girls.

Compared to Elvis, the Beatles were almost respectable. They wore suits; they did not thrust their bodies about suggestively; and to most Americans, who couldn't tell a blue-collar, Liverpudlian accent from Oxbridge English, they might have been upper class. What was both shocking and deeply appealing about the Beatles was that they were, while not exactly effeminate, at least not easily classifiable in the rigid gender distinctions of middle-class American life. Twenty years later we are so accustomed to shoulder-length male tresses and rock stars of ambiguous sexuality that the Beatles of 1964 look clean-cut. But when the Beatles arrived at crew-cut, precounterculture America, their long hair attracted more commentary than their music. Boy fans rushed to buy Beatle wigs and cartoons showing well-known male figures decked with Beatle hair were a source of great merriment. *Playboy*, in an interview, grilled the Beatles on the subject of homosexuality, which it was only natural for gender-locked adults to suspect. As Paul McCartney later observed:

There they were in America, all getting house-trained for adulthood with their indisputable principle of life: short hair equals men; long hair equals women. Well, we got rid of that small convention for them. And a few others, too.[24]

What did it mean that American girls would go for these sexually suspect young men, and in numbers far greater than an unambiguous stud like Elvis could command? Dr Joyce Brothers thought the Beatles' appeal rested on the girls' innocence:

The Beatles display a few mannerisms which almost seem a shade on the feminine side, such as the tossing of their long manes of hair. . . . These are exactly the mannerisms which very young female fans (in the 10-to-14 age group) appear to go wildest over.[25]

The reason? 'Very young "women" are still a little frightened of the idea of sex. Therefore they feel safer worshipping idols who don't seem too masculine, or too much the "he man."'

What Brothers and most adult commentators couldn't imagine was that the Beatles' androgyny was itself sexy. 'The idea of sex' as intercourse, with the possibility of pregnancy or a ruined reputation, was indeed frightening. But the Beatles construed sex more generously and playfully, lifting it out of the rigid scenario of mid-century American gender roles, and it was this that made them wildly sexy. Or to put it the other way around, the appeal lay in the vision of sexuality that the Beatles held out to a generation of American girls: They seemed to offer sexuality that was guileless, ebullient, and fun – like the Beatles themselves and everything they did (or were shown doing in their films *Help* and *A Hard Day's Night*). Theirs was a vision of sexuality freed from the shadow of gender inequality because the group mocked the gender distinctions that bifurcated the American landscape into 'his' and 'hers.' To Americans who believed fervently that sexuality hinged on *la différence*, the Beatlemaniacs said, No, blur the lines and expand the possibilities.

At the same time, the attraction of the Beatles bypassed sex

and went straight to the issue of power. Our informant from Orlando, Maine, said of her Beatlemanic phase:

> It didn't feel sexual, as I would now define that. It felt more about wanting freedom. I didn't want to grow up and be a wife and it seemed to me that the Beatles had the kind of freedom I wanted: No rules, they could spend two days lying in bed; they ran around on motorbikes, ate from room service. . . . I didn't want to sleep with Paul McCartney, I was too young. But I wanted to be like them, something larger than life.

Another woman, who was thirteen when the Beatles arrived in her home city of Los Angeles and was working for the telephone company in Denver when we interviewed her, said:

> Now that I've thought about it, I think I identified with them, rather than as an object of them. I mean I liked their independence and sexuality and wanted those things for myself. . . . Girls didn't get to be that way when I was a teenager – we got to be the limp, passive object of some guy's fleeting sexual interest. We were so stifled, and they made us meek, giggly creatures think, oh, if only I could act that way, and be strong, sexy, and doing what you want.

If girls could not be, or ever hope to be, superstars and madcap adventurers themselves, they could at least idolize the men who were.

There was the more immediate satisfaction of knowing, subconsciously, that the Beatles were who they were because girls like oneself had made them that. As with Elvis, fans knew of the Beatles' lowly origins and knew they had risen from working-class obscurity to world fame on the acoustical power of thousands of shrieking fans. Adulation created stars, and stardom, in turn, justified adulation. Questioned about their hysteria, some girls answered simply, 'Because they're the Beatles.' That is, because they're who I happen to like. And the louder you screamed, the less likely anyone would forget the power of the fans. When the screams drowned out

the music, as they invariably did, then it was the fans, and not the band, who were the show.

In the decade that followed Beatlemania, the girls who had inhabited the magical, obsessive world of fandom would edge closer and closer to center stage. Sublimation would give way to more literal, and sometimes sordid, forms of fixation: By the late sixties, the most zealous fans, no longer content to shriek and sob in virginal frustration, would become groupies and 'go all the way' with any accessible rock musician. One briefly notorious group of girl fans, the Chicago Plaster Casters, distinguished itself by making plaster molds of rock stars' penises, thus memorializing, among others, Jimi Hendrix. At the end of the decade Janis Joplin, who had been a lonely, unpopular teenager in the fifties, shot to stardom before dying of a drug and alcohol overdose. Joplin, before her decline and her split from Big Brother, was in a class by herself. There were no other female singers during the sixties who reached her pinnacle of success. Her extraordinary power in the male world of rock 'n' roll lay not only in her talent but in her femaleness. While she did not meet conventional standards of beauty, she was nevertheless sexy and powerful; both genders could worship her on the stage for their own reasons. Janis offered women the possibility of identifying with, rather than objectifying, the star. 'It was seeing Janis Joplin,' wrote Ellen Willis, 'that made me resolve, once and for all, not to get my hair straightened.' Her 'metamorphosis from the ugly duckling of Port Arthur to the peacock of Haight Ashbury'[26] gave teenage girls a new optimistic fantasy.

While Janis was all woman, she was also one of the boys. Among male rock stars, the faintly androgynous affect of the Beatles was quickly eclipsed by the frank bisexuality of performers like Alice Cooper and David Bowie, and then the more outrageous antimasculinity of eighties stars Boy George and Michael Jackson. The latter provoked screams again and mobs, this time of interracial crowds of girls, going down in age to eight and nine, but never on the convulsive scale of Beatlemania. By the eighties, female singers like Grace Jones and Annie Lenox were denying gender too, and the loyalty and masochism once requisite for female lyrics gave way to new songs of cynicism, aggression, exultation. But between

the vicarious pleasure of Beatlemania and Cyndi Lauper's forthright assertion in 1984 that 'girls just want to have fun,' there would be an enormous change in the sexual possibilities open to women and girls – a change large enough to qualify as a 'revolution.'

Notes

1 Lewis (1963, p. 124).
2 Green (1964, p. 30).
3 'How to Kick . . .' (1964, p. 66).
4 Dempsey (1964, p. 15).
5 Quoted in Schaffner (1977, p. 16).
6 'George, Paul . . .' (1964, p. 54).
7 'What the Beatles Prove . . .' (1964, p. 88).
8 'Beatles Reaction . . .' (1964, p. 141).
9 Friedan (1963, p. 282).
10 Quoted in Schaffner (1977, p. 15).
11 'Queen Bee . . .' (1963, p. 68).
12 Crow and Crow (1965, pp. 248–9).
13 Cain (1967, p. 71).
14 Boone (1967, p. 60).
15 Francis (1962, p. 138).
16 Hechinger (1963, p. 54).
17 'Shaping the '60s . . .' (1962, p. 30).
18 Quoted in Norman (1981, p. 200).
19 Grafton (1964, p. 36).
20 Hechinger (1963, p. 151).
21 Goldman (1981, p. 190).
22 Schaffner (1977, p. 9).
23 Goldman (1981, p. 191).
24 Quoted in Schaffner (1977, p. 17).
25 Quoted in Schaffner, ibid., p. 16.
26 Willis (1981, p. 63).

References

Beatles Reaction Puzzles Even Psychologists. 29 February 1964. *Science News Letter.*
Boone, Pat. 1967. *'Twixt Twelve and Twenty: Pat Talks to Teenagers.* Englewood Cliffs, N J: Prentice-Hall.
Cain, Arthur. 1967. *Young People and Sex.* New York: The John Day Co.

Crow, Lester D. and Alice Crow. 1965. *Adolescent Development and Adjustment*. New York: McGraw-Hill.

Dempsey, David. 23 February 1964. Why the Girls Scream, Weep, Flip. *New York Times Magazine*.

Francis, Connie. 1962. *For Every Young Heart*. Englewood Cliffs, N. J.: Prentice-Hall.

Friedan, Betty. 1963. *The Feminine Mystique*. New York: W. W. Norton.

George, Paul, Ringo and John. 24 February 1964. *Newsweek*.

Goldman, Albert. 1981. *Elvis*. New York: McGraw-Hill.

Grafton, Samuel. 15 December 1964. The Twisted Age. *Look*.

Green, Timothy. 31 January 1964. They Crown Their Country with a Bowl-Shaped Hairdo. *Life*.

Hechinger, Grace and Fred M. 1963. *Teen-Age Tyranny*. New York: William Morrow.

How to Kick the Beatle Habit. 28 August 1964. *Life*.

Lewis, Frederick. December 1 1963. Britons Succumb to 'Beatle-mania'. *New York Times Magazine*.

Norman, Philip. 1981. *Shout! The Beatles in Their Generation*. New York: Simon & Schuster.

Queen Bee of the High School. 11 October 1963. *Life*.

Schaffner, Nicholas. 1977. *The Beatles Forever*. New York: McGraw-Hill.

Shaping the '60s . . . Foreshadowing the '70s. Janauary 1962. *Ladies' Home Journal*.

What the Beatles Prove About Teen-agers. 24 February 1964. *U.S. News & World Report*.

Willis, Ellen. 1981. *Beginning to See The Light*. New York: Alfred A. Knopf.

6

'I'll Be Here With You': Fans, Fantasy and the Figure of Elvis

STEPHEN HINERMAN

We have lost the relative strength and security that the old moral codes guaranteed our loves either by forbidding them or determining their limits. Under the crossfire of gynecological surgery rooms and television screens, we have buried love within shame for the benefit of pleasure, desire, if not revolution, evolution, planning, management – hence for the benefit of Politics. Until we discover under the rubble of those ideological structures – which are nevertheless ambitious, often exorbitant, sometimes altruistic – that they were extravagant or shy attempts intended to quench a thirst for love. To recognize this does not amount to a modest withdrawal, it is perhaps to confess to a grandiose pretension. Love is the time and space in which 'I' assumes the right to be extraordinary. Sovereign yet not individual. Divisible, lost, annihilated; but also, and through imaginary fusion with the loved one, equal to the infinite space of superhuman psychism. Paranoid? I am, in love, at the zenith of subjectivity.

Julia Kristeva (1987, 5)

Although Elvis Presley has been dead for more than 10 years, fans who believe that he is alive send him an average of a letter a day.

Newspaper report (*San Francisco Chronicle* 1987, p. A10)

STEPHEN HINERMAN

Introduction

Perhaps no modern figure has held our attention like Elvis Presley. In life, he was held responsible for: building the populist base of rock 'n' roll by mixing black and white musics; articulating the sound of a youth rebellion; taking rock into the world of traditional entertainment; showing that a rock career could sustain longevity with a consistent fan base; practically inventing the idea of rock music 'selling out'; and finally showing how it was possible to be relevant, then irrelevant, then finally relevant again before becoming a caricature of his early image-making and dying a spectacularly inflated death. With Elvis Presley alive, it always depended on 'who you asked' as to what any of this meant; and when you did, the response always showed that whoever and whatever Elvis was said to be, he always appeared to matter. But the significance of Elvis Presley did not end when his life did, for in death he remains: an icon for fan worship; a textual mine for artists of various media; a subject of in-jokes; a signifier of both hipness and the retrograde; and a viable commercial marketplace. And now, Elvis (all one ever needed, *especially now*, is the first name) has become a country unto himself; he has shown that in matters of commodity capital, death is of no importance whatsoever.

One is tempted, in this atmosphere where the difference between cliche and subversion is barely visible, to stay away from the Elvis phenomenon altogether. How can one say anything new about Elvis or his fans? Is there anything worth saying that can escape tedium, self-parody, the mundane or pretension? Haven't we, to put it another way, had enough of this Elvis-thing?

The answer appears to be 'no.' The writing goes on, the tabloid articles continue, the books are still published, new combinations of previously released material appear on CDs, and Graceland continues to play host to apparently unending battalions of the curious and the ceaselessly devoted. There is a continuing appetite for what-has-become-Elvis and it shows no sign of abating.

108

How could anyone, then, who seeks to understand what it might mean to be a 'fan' today pass over the site of Elvis? Not only does the Country of Presley contain virtually every type of media relationship between a star and his consumers, it also contains some of the most pronounced structures of feeling in all of popular culture. Every fan may be like Elvis fans; but there are no fans like Elvis fans.

My own interest here is to explore a certain type of fan encounter: the particularly active fantasies of fans whose interactions with a star are generated with either memory or secondary material. In this light, I am interested in what lies behind or within a few of the encounters that fans have had with Elvis since his death. The accounts I have chosen are often extreme, exhibiting just how far some fans *can* go with fantasy material. Some of these are paranormal; some are simply daydreams. While not all Elvis fans have such encounters, I would maintain these represent a generalized set of responses that fans can have to media figures today when they engage in what we commonly refer to as a full-fledged fantasy narrative. With Elvis, the juice often gets turned up and the stakes are raised; and because of that, the results become particularly enlightening in trying to understand both the nature of 'fandom' and that of the 'fan–star fantasy.'

First, in order to provide a theoretical framework with which to approach these after-death fantasies of Elvis and his fans, I will elaborate a psychoanalytic perspective of fantasy out of Freud and Lacan. Then, I will attempt to use this perspective to 'read' some Elvis fantasies, making the argument that fantasies centered around Elvis (or any other media figure) are not delusional or maladjusted scenes, but are instead statements that serve at least two functions. First, they 'suture' a potentially traumatic threat to a person's psychological identity, reassuring the fantasizer that full presence, satisfaction and sense might one day be obtained. Second, fantasies engage the world ideologically from a specific political place, speaking a language of individuals and classes who are denied more 'direct' and confrontive solutions to crisis. Some implications for the study of fans and fantasy arising out of these tendencies are then offered.

The Nature and Function of Fantasy

Laplanche and Pontalis (1973) offer the following definition of fantasy (or, as they call it, 'phantasy'):

> Imaginary scene in which the subject is a protagonist, representing the fulfillment of a wish (in the last analysis, an unconscious wish) in a manner that is distorted to a greater or lesser extent by defensive processes.
>
> Phantasy has a number of different modes: conscious phantasies or daydreams, unconscious phantasies like those uncovered by analysis as the structures underlying manifest content, and primal phantasies. (p. 31)

I would argue that many of the scenes in which fans confront the images of a star today are well within the parameters of this definition and conform to the description of fantasy. From daydreaming about a particular figure to experiencing extra-sensory encounters (both of which fill the literature of Elvis fans), part of what it means to be a fan for some people in some places clearly involves fantasy-work. We may be able to gain valuable insight into the process of what it means to be a fan by exploring the psychoanalytic roots of fantasy.

Fantasy occupies a central place in the project of analysis undertaken by Freud.[1] From his early studies of women's hysteria, the questions of fantasy as illusory episodes were of paramount importance. Daydreams, scenes, romances and fictions which were recounted by the hysteric while awake were raw material for his analysis. While this work has its share of problems, we can sketch a useful foundational explanation of how fantasy begins and what paths it takes as psychosexual development occurs, building upon the work undertaken by others following in Freud's path.

Mitchell (1984) offers the following scenario as a prime instance where Freudian psychoanalysis seeks to explain the origins of fantasy using the 'oral stage' as an idealized example of the pre-Oedipal. She argues that in the oral stage, when a child first experiences the sucking of the Mother's breast, a certain undifferentiated satisfaction is produced. The child

feels at one with the breast. The child *is* what it experiences; it is its own universe.

However, when the biological need is fulfilled and the breast is removed, the child experiences a lack. Because the child not only enjoyed the nourishment of the breast but the act of sucking itself, the child misses the sucking and the pleasure it granted. This longing for pleasure-for-pleasure's-sake (or sucking for the sake of sucking) is posited by psychoanalytic theory as the beginning of the erotic. The wish for pleasure is now present where before there was once only the need for nourishment. From this moment on, the child begins to learn to tend toward those acts which reduce tension and maximize the seeking of pleasure, a tendency Freud called the 'pleasure principle.' (Freud 1928)

The child, now missing the satisfaction of the breast and longing for its return, is left with a 'memory-trace' of the pleasure object and a sense of loss that 'something which was here is no longer here.' The child therefore begins to experience absence; a sense which is, at this point, internalized in a feeling that 'I am not whole or complete.' A lack is felt, and it is in the 'space' of this lack (for Lacan and others following Freud) that there comes the beginning of a gap, a growing sense that the 'world is not simply my pleasure experience' but, in fact, is made up of both the presence and absence of pleasure. If we explain this in linguistic terms, the child begins to see the difference between 'I' (my pleasure experience) and 'not/I' (the absence of my pleasure). The young child, both pre-Oedipal and pre-language, cannot formulate or express this feeling of lack or difference, but in the movement toward the Oedipal stage, this condition will be elaborated until at the Oedipal moment it is expressed and felt with the development of the unconscious.

Before the Oedipal moment, however, the child is motivated by 'drives' which are simply 'movements' toward full satisfaction. The child tends toward the reenactment of the moment of undifferentiated pleasure; she is *driven* in that direction. The pre-Oedipal child is, therefore, marked by the drive toward pleasure.

Such a simple formulation of drives and unity cannot last. The child must 'take its place' in a world where undifferentiated

pleasure is not possible, where there are not only 'I's' but 'Others,' where one must experience limits upon subjective satisfaction. In order to elaborate this development and its role in the formation of fantasy, we turn to the work of Jacques Lacan and his discussion of psychosexual development.

For Lacan, following Freud, the gap or lack we have been discussing becomes the foundation for the child's entrance into the social.[2] The child, in the Lacanian world-view, begins in the realm of the Imaginary, which is his term for the undifferentiated experience of pleasure when the child and Mother were one. However, this experience is quickly changed in child development. For Lacan, the child moves from the Imaginary into a world of differences (or presence/absence) which he terms the Symbolic.

Instead of the story of the breast, Lacan makes use of the example of a child who looks in a mirror (Lacan 1977, 1–7). When a child first looks into the mirror, he or she thinks that the image reflected back is the self. Yet, this is clearly not the case; the image is of the child yet not the child itself (it is, if you will, a re-presentation of the child). But the child at first mistakes (misrecognizes) the image as if it were simply an extension of the child. The child continues this basic process and begins to interact with the whole of the outside as if it were simply an extension of its own 'I' (which implies, for Lacan, that identity is always somehow grounded in narcissism and misapprehension). As in the story of the breast, the child begins in full presence, without a sense of subjectivity. But, for Lacan, such an understanding is a misreading, a missed-take on the image.

This perception of the outside as narcissistic is the way, Lacan argues, that the ego is built, beginning with childhood but carrying throughout adulthood. We build what Eagleton (1983, 165) calls a 'fictive sense of unitary selfhood' by identifying with objects in the world, apprehending them as extensions of self and therefore stable in their identity. Yet, as we have seen, this is hardly the 'reality' of the world. The stability of the outside world is only a fiction, a fiction organized around our sense that the Other (the external) is a reflection of our own unitary identity and therefore as apparently stable as the 'I' we experience.

As the child enters the world of the parents, the split

in identity between I/Not I (the I/Other) will become more pronounced and the early unity of self/other will be finally shattered. When the child moves from the duality of Breast-Absent/I (or Mirror/I) into the triangular relationship of the Oedipal situation, the separation of the child from the Mother is moved toward completion. Now, the child must recognize that, in order to 'fit' and attain full identity in the social world, represented in the first instance by the family, she must respect the family order and the world of language already in place. She must recognize in a fuller sense than ever before that her drives will not always be granted priority; that she must face a world with full prohibitions on continuing a certain kind of relationship with Mother; and one with certain 'laws' against the total expression of drives. In a larger sense, she must realize that the world is no longer fully 'I' but is made up of 'I' and 'Other.' Drives, which are not going to be automatically satisfied and will even be prohibited, must be submerged.

Lacan calls this mechanism of prohibition which enforces the split the 'Law of the Father'. It causes the child fully to repress its drives to recreate the undifferentiated pleasure of the breast (creating unconscious desire) and accept the system of differences which first appeared in the mirror-stage (or the absent breast). The child emerges from the Oedipal situation understanding that the world is made up of less-than-total satisfaction and an always present feeling of absence.

As I have mentioned, for Lacan, this developmental process is intimately bound up with the idea of language. Language, from his perspective, makes use of a system of differences (much like the 'I/Not I') in order to create meaning. Eagleton (1983) explains the process in the following:

> We can think of the small child contemplating itself before the mirror as a kind of 'signifier' – something capable of bestowing meaning – and of the image it sees in the mirror as a kind of 'signified.' The image the child sees is some-how the 'meaning' of itself. Here, signifier and signified are as harmoniously united as they are in Saussure's sign.
> ... It is a world of *plenitude*, with no lacks or exclusions of any kind: standing before the mirror, the 'signifier' (the child) finds a 'fullness,' a whole and unblemished identity,

in the signified of its reflection. No gap has opened up between signifier and signified, subject and world

With the entry of the father, the child is plunged into post-structuralist anxiety. It now has to grasp Saussure's point that identities come about only as a result of difference – that one term or subject is what it is only by excluding another. Significantly, the child's first discovery of sexual difference occurs at about the same time that it is discovering language itself. . . . In gaining access to language, the small child unconsciously learns that a sign has meaning only by dint of its difference from other signs, and learns also that a sign presupposes the absence of the object it signifies. (p. 166)

Such a realization, as we have seen, is implied from the first moment of the child realization of absence with the breast. But it reaches a full flowering in the world of the social (the world of language, the world of the Oedipal). In this world, language awaits the child, ready as a pre-existent system to assign a 'place' to the child. Parents await, in much the same way, with a pre-existent system of rules and roles ready to have the child 'fit' its drives in certain socially acceptable ways. All of this pushes the child's drive for unity and pure pleasure into the framework of desire, repressed and formed in the unconscious.

Therefore, we can see that in the moment of the Oedipal (which is simultaneously a moment of language), a child is formed as a social creature. Drives are displaced by desire; the ego is formed which allows the child to 'fit' into the world of language and family while the unconscious is formed to house repressed desire.

Yet, repressed desire, a longing for full satisfaction, for merging, for plenitude, for oneness, for full identity of self, remains. And it must, on occasion, to a greater or lesser degree in each person, reemerge. We call this reemergence fantasy. Fantasy expresses the desire for fullness and the hope for the eradication of the troubling Absence. Fantasies promise a full satisfaction and total meaning in a world marked by separation, absence, and traumatic disruption.

This implies, among other things, that fantasy, in so far as it

is the seeking of pleasure of the absent Other which promises full satisfaction, marks us as social creatures, as meaning producers. Just as being able to repress drives is necessary to life, so too is the functioning of desire and the want to increase pleasure towards satisfaction. Fantasy, then, may well be a foundational mark of human existence. The absence of fantasy in a life would be the mark of full repression and a sign of the 'non-human.' It would be as impossible to imagine as a person who never dreams.

Other aspects of fantasy also must be commented on. First, since the desired object is absent and the beginning of desire is in the Oedipal situation, the site of desire is also a site of prohibition. Something (more properly, the feeling of full satisfaction, total subjectivity and complete presence) has been taken away and is denied a return. Drives are repressed in order to fit into the social structure. Because repression is so linked with the Law of the Father, the child quickly learns that punishment is a possibility for feeling desire and certain desires are prohibited. Fantasy will, therefore, always gather around what is outlawed. This means that the site of fantasy will also be the site where defense mechanisms develop. These aid the child (and later the adult) in coping with absence and the possibility of prohibition and punishment.

But since desire never completely goes away, one finds that there are ways to 'disguise' the feeling of desire in various forms of fantasy. In other words, fantasies allow one to 'get around' the outlawing and prohibition. This 'disguising' of desire in fantasy form will inevitably distort and 'hide' the desiring wish, but that wish always remains present for us to access in the fantasy narrative.

Fantasies are, then, one way humans have to negotiate a troubling situation. They bridge the gap that is created when desire is prohibited but the longing for full satisfaction is still there. Fantasies allow us to 'close the distance' between what we need or want and what we can have. When the unconscious desires and the ego prohibits, throwing open questions of identity and the self, fantasies step into the breach.

In this sense, fantasies work much like a 'suture' that a doctor uses to close a 'gap' in a wound. The use of the term 'suture' has been explored in Lacanian theory by Miller (1977/8) and in film

theory by Oudart (1977/8) and Heath (1977/8) but I would argue that it also has a place in fantasy theory. It stands to reason that if fantasy is a way of negotiating a space that grows up between the unconscious and symbolic worlds, it would be particularly present when desire is blocked by prohibition. Fantasy can act as a way the individual sutures his or her own identity back together (bonding the ego to the unconscious) when it is most vulnerable.

For instance, when an event happens where I 'feel' dissatisfied or threatened (where desire is prohibited), my whole sense of self can be disrupted. If this disruption is prohibited direct expression, then the fantasy can be a way to 'travel' the disruptive area, allowing me to 'stitch' my identity back together without being banished from the culture in which I live and regain my sense of self. When in doubt, in other words, I can always dream.

This suggests that we should find fantasies around particularly traumatic situations which involve real threats to identity, where the sense of a stable 'I' is facing the Absence which stands ready to destroy it. Situations (following Freud) around the issues of death or sex, which can raise traumas around the crisis of identity, would cry out for fantasy as a way of suturing the self 'back together.' Because both situations are often culturally prohibitive (people are not necessarily, in certain cultural formations, allowed to speak freely on either subject), fantasy becomes even more important as a 'safe' way of giving the self the 'answers' required to go on believing in the stability of the 'I' who believes.

One can immediately see, however, how much of the above is reliant upon various cultural forms of life. In the first place, sites of prohibition might change depending upon the culture and the place of the individual within it. What is seen as a 'prohibitive expression of desire' in one place may not be in another. The options open for an individual to suture around trauma may vary within cultural formations. In some cultural 'places' one may be allowed a visit to an analyst; in another, Elvis might have to arrive from outer space. In both cases, albeit through different techniques, an ongoing, provisional sense of identity is restored.

Finally, the narratives themselves which make up dreams and

daydreams are linguistically-bound scenarios, and as such, I would argue that both the form and content would vary from culture to culture. So, while the latent desire of fantasy may be a fundamental mark of the human, the manifest form and content will often be highly cultural.

This is what allows us to move from a theoretical discussion of fantasy to specific fantasies concerning, in this case, Elvis Presley. It is no secret that since the rise of mass media in Western-style commodity capitalism, one way fantasies get 'cast' are with star figures. These star images often become wrapped up with the life of the individual who fantasizes and become crucial signs of repressed desire seeking fullness. So, in America, it causes few eyebrows to be raised if one 'dreams' of a sexual encounter with Paul Newman or daydreams about fighting in the streets alongside Sylvester Stallone. Star fantasies are now a matter of cultural course, from childhood on.

Yet, just because they are so common, we should not be blind to the cultural forces at work in these fantasies. Dyer (1986) observes that:

> We're fascinated by stars because they enact ways of making sense of the experience of being a person in a particular kind of social production (capitalism), with its particular organization of life into public and private spheres. We love them because they represent how that experience is or how it would be lovely to feel that it is. Stars represent typical ways of behaving, feeling and thinking in contemporary society, ways that have been socially, culturally, historically constructed. Much of the ideological investment of the star phenomenon is in the stars seen as individuals. . . . [What] makes them interesting is the way in which they articulate the business of being an individual. . . . Stars are also embodiments of the social categories in which people are placed and through which we make our lives – categories of class, gender, ethnicity, religion, sexual orientation, and so on. (pp. 16–17)

This is particularly true of the presence of stars within fantasy. Why do we pick one figure over another to fantasize about?

117

What do they 'do' in the fantasy, and what do those behaviors reveal about the prohibitions being invoked, the traumas involved or the desire and longing being fulfilled?

These questions only begin to raise others, which move us further in the cultural forces at work in the star fantasy. If American culture tends to 'traumatize' adolescent sexuality, for instance, would it not also be a site where we find many fantasies and fantasizers? Are other stages of life particularly ripe for fantasy? If our culture is heavily patriarchal, then do biological males and females have different forms of fantasy, which raise different questions around desire? Does the patriarchy make it more inviting for women to articulate their fantasies publicly, and does that articulation also invoke sanctioning from the rational (often privileged) side of cultural discourse?

The discussion that follows can only hint at some of the answers to these questions. Still, it is my belief that viewing specific fantasies concerning Elvis can give us a start toward finding those answers.

The Elvis Fantasies

Images of Elvis live on to one degree or another in the fantasy life of almost all who live in the Western world. Since his death, that image has been displayed by some as a way of playing any number of social roles, from 'true fan,' to 'rebel,' to 'hip,' to 'hipper-than-you.' It has been used to sell products both related and unrelated to his music. It has even become a text which weaves its way through any number of films and any number of comedy routines. It is no wonder that so many access the man in their waking and sleeping moments.

In the midst of this, many accounts have appeared which place Elvis as either a paranormal figure, a guide to the world beyond, and/or an image of salvation. All are, in essence, fantasy accounts. (It is important to stress once again that this is not a judgement as to their 'truth' value; all fantasies are outside of the categories of truth.) I will discuss five such accounts here, citing other fantasy accounts when relevant. In doing so, I am not arguing that they represent the totality of Elvis fantasies; simply that they begin to illuminate the nature of

stars and fantasies in our own cultural formation. In recounting the fantasies, I will show how they serve as sutures which, gathering around trauma and prohibition, attempt to resolve a crisis of identity and desire.

Before beginning, however, I want to refer back to the preceding discussion of the impact of patriarchal structures on fantasy. Out of the five fantasies discussed below, women predominate. This is also true of the literature which is extant. The phenomenon is not due to the fact that men have no Elvis fantasies; after all, there are, at last count, some 3,000 Elvis impersonators in America, all of whom must be said to be living out some kind of fantasy relationship to Presley. Yet, when one surveys the Elvis literature, women not only speak their fantasies more freely and in more detail, they speak them more often.

Perhaps this is the impact of culture which we mentioned earlier. Perhaps in a patriarchal society, with many men raised to cling to the 'rational/concrete' side of discourse, women are simply more comfortable speaking about fantasies. Perhaps women, being denied in certain social classes certain forms of emotional support, are forced to turn to the fantasy with idealized male figures more often. The subject of Elvis himself, as suggested below by Jimmy Reed, may be more easily accessed by women in our culture. Perhaps, finally, given the demands of the marketplace and the wrongheaded tendency to link fantasy with 'emotional instability,' the preponderance of women's fantasies in the public domain is just one more example of the power of patriarchal culture to 'display' women as 'emotional subjects.' Whatever the reason, the fact that women speak more of Elvis here is only a sign of the available data and should not be linked to arguments which tie fantasy to positive or negative social judgements about the individual who 'tells' of Elvis.

One other caveat is necessary. By necessity, the fantasies below work with material that is highly personal and emotionally charged. It is also material that is incomplete. A full psychoanalytic reading would involve a level of disclosure that is virtually impossible without extensive therapeutic work, which may not even be desired by those who fantasize. Consequently, my 'reading' of the fantasies below involves certain leaps and presumptions that I hope the data justifies. The 'point'

119

of these readings is not to pass judgement or articulate a 'truth' about the meaning of the fantasy; it is simply to illustrate how such readings might be accomplished and to theorize larger structures of the possible relationship forms between fans and stars.

The first fantasy I will consider is one recounted by Moody (1987) involving Vanessa and Harry Grant. The Grants' fantasy is one which takes a very traditional form, that of the 'daydreaming fan.'

It seems that Vanessa Grant began a fantasy life around the figure of Elvis when she was in high school in the 1960s. At that time, she would daydream that Elvis 'and I were friends and he would invite me to come to Graceland and we would ride horses together.' (p. 108) This fantasy relationship was so important that when she met her husband-to-be during this time, she made sure that he understood her 'love' for Elvis and that marrying her involved, to some extent, 'sharing' her with Elvis.

The Elvis fantasies increased for Vanessa. After marriage, she says that she would fantasize about Harry, Elvis and herself 'being friends.' 'In the daydream,' she states, 'Harry got a job with Elvis on the soundcrew, because Harry has always been good with electronics, and we would travel around with Elvis as he gave concerts.' (p. 108)

Three traumas then came into Vanessa and Harry's life. First, Vanessa found that she was unable to bear children. This saddened both, and as a response to the situation, they decided to travel more and more to see Elvis perform in person. Then, Elvis died, followed six weeks later by a painful death of Vanessa's step-sister. Vanessa remembers 'Nobody knows what a hard year that was for me, the year that Elvis died. . . . (My) step-sister died six weeks later. She had been one of my best friends since I was seven years old. After she died I could hardly get out of bed for a month. I would stay in bed and try to sleep and forget it all.' (p. 107)

Within the next year, fantasies increased. Vanessa recalls: 'I would have these little imagined conversations in my head with Elvis. I would ask him what he was doing, and where he was, and things about his life, personal things mostly, and then I would imagine him giving his answers back to me. I would

try to imagine what his voice would sound like as he gave his answers back to me.' (pp. 107–8) She reports that these fantasies began to help her recovery, while at the same time placing some strain on the marriage as she withdrew into her inner conversations.

In an effort to help his wife, Harry invented a computer program which allowed Vanessa to communicate with an Elvis-like program, asking it/him questions while he/it 'answered' from a programmed set of responses. With the fantasy moved from individual daydream to the social setting of their basement, Vanessa began to brighten. Her solitude lessened and she finally recovered from the various traumas. Vanessa and Harry now spend hours communicating with their version of Elvis Presley, which makes Vanessa, 'actually feel that he really does talk to me . . . through the computer.' (p. 113)

Vanessa has recounted a daydream, a fantasy which is much like the fantasies many fans recount in Fred and Judy Vermorel's collection, *Starlust* (1985). Elvis becomes a conversational partner, taking an active role in the life of the fan while the fan generates responses based upon his or her memory and his or her knowledge of the star's tendencies, history and images. Yet, it is clear that for Vanessa Grant, particularly, the Elvis-relationship is a response to a set of traumatic events in her life. Fantasies clearly accelerate around her experience of high school and the death of Elvis and her step-sister.

Both events are potential sites for prohibitions. In American middle-class culture (to which the Grants belong), high school represents a place and time when adolescent sexuality is worked through. Vanessa clearly sees Elvis in such a light; not only does she fantasize being 'singled out' by the romantic male figure of Elvis, she sees him in competition with her husband-to-be, a competition resolved only when Harry agrees to 'share' her with Elvis. While the data is less than complete, it is not unreasonable to think that this is the way many young girls in the 1950s and early 1960s employed the image of Elvis. He became an 'idealized male hero,' a pin-up, a male who offered to resolve the confusions of adolescent sexuality, allowing it full (imaginary) expression while keeping the fantasizer from having to enact the fantasy with nearby (and often unpredictable) boys.[3] I will return to this point in detail later.

The real acceleration in fantasy material, however, comes with the depression Vanessa experiences around the real deaths of her fantasy hero and her step-sister. The fact of death, the way in which death (particularly the death of a sibling who is still young) often seems to call into question the very structures by which we make sense of things, only highlights the prohibitive place of death in our culture. Death tends to be 'talked around,' and the grieving spend tremendous resources trying to 'make sense' of the death. In a very real way, death is the 'Not I' made nervously present, and carries with it the real anxiety that full presence may never be fully obtained again, that desire will one day extinguish without reaching its *telos*.

Obviously unable to communicate with the world in a way that provided satisfaction, Vanessa begins to conduct fantasy conversations with the figure who once had resolved an equally troubling moment. The deaths (and whatever else may have led to this moment) have left her in need of the fullness of the 'I' one experiences early in life, the moments when one feels full connection, identity and sense. Denied other ways to articulate her need (and the reasons why are not clear), she turns back to Elvis, who provides her with a sense of identity, of self. Elvis becomes the way to deal with the prohibitive site of death while restoring the hope for life. Through her conversations with Elvis, she begins to feel identity regained and a 'sense' of life restored.

Harry's creative technological solution to the fantasy work allows Vanessa to be social in her expression of longing, thereby brightening her mood. But whether she does it alone or with Harry at the computer, the fantasy work she undertakes is clearly a longing for security and stability in the face of changes that cannot be spoken in her cultural milieu. Around the prohibition of death (and earlier, sexuality), Elvis provides a way for desire to find some satisfaction and still allow her to function in the non-fantasy world.

Sherry and Jimmy Reed offer a more elaborate version of Elvis-as-the-resolver-of-trauma. As recounted by Moody (1987), both Sherry and Jimmy are fans of Elvis from their adolescence. Sherry's account sounds a familiar note to readers of the Elvis fan literature.

I remember it like it was yesterday. I was in the sixth grade, and my friend Susan Logan was having me and several other girls over to her house for a spend-the-night party. Susan was playing some records on her record player, some Perry Como ones and some Tennessee Ernie Ford, I believe, that belonged to her parents, and then she got one out of her drawer and she said, 'Have you heard Elvis Presley yet?' None of us had and she played 'Blue Suede Shoes.' It was just terrific, of course, and we must have played it ten or fifteen times that night until Susan's mother and father came in and told us we had to be quiet and go to bed. For the rest of my life, since that night, I have liked Elvis Presley. (pp. 49–50)

Sherry's account is mirrored over and over again by women growing up in America of the 1950s. Witness the following, from a woman who became a friend of Elvis later in life:

When Elvis made it big I was in elementary school. I lived in Corinth, Mississippi, right on the Tennessee line, and we didn't have any theatres, except the one with rats that nibbled our toes, but we did have the Skyline Drive In. When I couldn't get Mama to take me to see Elvis movies (which she didn't like because he 'made that motion' with his hips), I'd go over to Patti's and we'd sit out in her back yard where we could see the screen for free. We'd call over the fence for someone to turn up the speaker for free. On the back row, no one watched the movie. Some didn't even get the speaker off the pole. Anyway, when Elvis sang, Patti would moan and groan and I'd do the twist.
(Deen 1979, 169)

The literature of Elvis is full of similar accounts. Elvis records are hidden away in bedroom drawers until the crucial moment when they emerge among girls who dance in secret from their parents' gaze (Hecht 1978, 60). Girls sneak out of church to view clandestinely Elvis's first TV appearance (Lasker 1979, 205). These accounts make clearer what Vanessa Grant hinted at, that Elvis is linked for many females of the 1950s and 1960s to adolescent sexuality (as a promise that desire will indeed find

total fulfillment and as a seductive presence) and to sites of prohibition (much of his appeal is that such sexuality/resolution is displayed *away from* the adults, in the presence of other girls but outside of the possible punishments of the Law of the Father). Elvis is, to these women, the promise of full sexuality and passion, the desire-that-must-be-hidden made manifest, who promises a solution to the trauma of adolescent sexuality. As such, he can then be accessed in narratives later in life to suggest the solution to other problems which grow around later traumatic prohibitions.

Jimmy Reed, Sherry's husband, was also an Elvis fan. But as a man of the South during the 1950s, his fantasies were not given as free a rein. He remembers that during a party in the sixth grade, Elvis records were played and he was 'impressed.' But, Jimmy continues, 'several of the boys said they didn't like it and so I went along with the guys because I didn't want to seem different. . . . (In) secret, of course, yes, I did like Elvis from the very beginning. . . . Later on, in my twenties, well, then I got over that envy and could enjoy Elvis in public, just like anyone else.' (pp. 50–1)

Jimmy and Sherry Reed illustrate the way cultural pressures can shape fantasy and its expression. Sherry and her girl friends 'hid' away together, but in doing so were communally building elaborate fantasy interests in the figure of Elvis. Jimmy simply hid his enthusiasm, channeling, no doubt, his fantasies into more culturally sanctioned models (say, wearing his hair like Elvis, dancing like Elvis, and so on) when he finally displayed such interests.

Jimmy and Sherry later married, both now 'out' Elvis fans. Then, a tragedy struck. Their daughter was born with Down's syndrome. A week later, they find the baby was born with a defective heart. In the midst of this trauma, the Reeds adjusted as best they could. But one thing they claim they did that had a real impact on their daughter was the way they immersed her in the images of Elvis which they had carried forward from their own youth.

Naturally, Jennifer (the daughter) loved Elvis. We played Elvis records all the time for her and sang his songs for her. The first time she saw him perform, I think, was on

his TV special from Hawaii, and she smiled and laughed and danced the whole way through. She would watch Elvis movies on TV and I would show her pictures of Elvis from magazines. (p. 53)

When she was ten, Jennifer was rushed to the hospital near death. Right before her death, her parents recall that she looked upward, stretched out her hands, and said, 'Here comes Elvis.' Then she died.

For the Reeds, the signs are clear. Sherry says, 'Elvis came to meet her and help her as she died.' (p. 55) For Jimmy, 'God came through and he sent Elvis.' (p. 56) Both parents now feel their minds clear on the death of their daughter, and they feel as if her death is not a thing to fear, but an event ensuring her eternal life. Both are sure that Elvis appeared to their daughter in the operating room and escorted her to Heaven.

Again, an absence has been felt around a prohibitive site. Death has taken a child and rational explanations fail. Jimmy, Sherry and (before) Jennifer Reed all return to a figure who stands for identity (the identity of Jennifer's growing up against the odds, the presence of the pre-Oedipal, the miracle of survival and growth). The image of Elvis has allowed the couple to 'suture' the narrative of Jennifer, disrupted so violently by disease. By recreating a narrative where Elvis becomes a central 'sense-making' image, the desire for fullness, sense and identity is (temporarily) satisfied. Life can go on for the Reeds with the knowledge that Elvis's role in their daughter's death 'makes sense' as an ongoing event which stamps 'meaning' upon tragedy.

Dorothy Sherry's fantasy is even more elaborate. She began as an Elvis fan around the age of ten or eleven. While she was a real fan at that age, as she became older, the passion for Elvis subsided. She was married and had children. Then, when she was 32, Elvis came to visit.

According to Dorothy (Holzer, 1978), Elvis appeared to her in a vision and told her that they had once been married. He tells her he is at the end of a long search for her and explains to her that their marriage has been going on throughout 'many, many lives.' (p. 86) Somehow in this life, however, things have gone wrong and they have become separated. In order to be with her and re-establish their rightful connection, Elvis takes her on a

series of journeys to the Other Side, showing her the world of the souls.

Dorothy's fantasies with Elvis occur with more and more frequency as Elvis takes Dorothy on many trips throughout the psychic realm. These place a strain on the Sherry marriage. Dorothy's mother has her get in touch with psychic Hans Holzer, who interviews her, while at the same time exploring with her the ramifications of the encounters, which take Dorothy from automatic writing to seances with Elvis's relatives financed by the *National Enquirer*.

The main narrative features of Dorothy's highly detailed fantasies are simple. Elvis, as stated earlier, claims that he and Dorothy have been married. (This is only 'the second time' they have been apart in Time.) With the onset of the fantasies, Elvis has arrived, according to Dorothy, to 'take care of me, now'. (p. 93) She meets Elvis's caregiving reasoning with some protest, arguing with Elvis that she is a 'nobody': 'I said, do you realize who you are and I'm a nobody. I'm a housewife from New Jersey, I said, which is no big thing. You are a popular man. I said, how come you're coming to me. He said, I explained this to you over and over, up there I'm like everybody! I'm no star or shining light.' (p. 48)

But Elvis clearly disagrees with her assessment of herself as a 'nobody,' and does several things to show her her own 'special' place in the universe. Elvis tells Dorothy that he has 'special permission' to visit her. (p. 52) He speaks to Holzer through the medium of Dorothy and tells him: 'At times there are mistakes. But I will wait for her. The bond between us is very strong.' (p. 33) And he tells Dorothy that even if she doubts now, she will get 'stronger' in the days ahead (p. 85) and more convinced of her special place in Time.

A bond grows between Elvis and Dorothy. She now wants the relationship to 'go on' (p. 55) and wonders what to do. (Should she divorce? Leave town?) Elvis finally gives her a message to stay in her current situation for now 'because I have to raise those children,' but after they are grown, he assures her that 'we will be together.' (pp. 47–8)

If fantasy is a suturing event, then it should be a response to some kind of trauma surrounding identity for Dorothy Sherry. While she voices none (claiming that the marriage problem

came after the fantasies started, not before), the message Elvis delivers certainly indicates something more. The structure of the fantasy narrative is one where the individual is 'found.' She at first feels a 'nobody' in the face of her fantasy, but the figure of Elvis manages to give her a sense of mission, granting her a purpose and even an agenda for the future. In other words, a new, stronger sense of identity is granted through the Elvis fantasy.

The fantasy seems to function like many media fantasies, in that it appears to resolve a crisis of meaning of the self. In this sense, it functions as an empowerment, suturing a place where absence has become so powerful a threat that the ego appears in danger of dissolution. Was Dorothy Sherry feeling an increasing sense of crisis? Was her life lacking direction, focus? Was she losing any idea of who 'she' might 'be'? Was her very ego falling apart?

The best way to answer is simply to look at how the fantasy functions and what its results are; and in Dorothy Sherry's case the fantasy clearly leads to increased ego-maintenance and a renewed sense of presence (exhibited in her newfound beliefs in the ideology of Romance and the conviction that she now must carry Elvis's message of peace, love and happiness to the world). The fantasy obviously changed Dorothy Sherry and gave her a new sense of identity over what certainly must have been prohibited before in her life: the idea that both Romance and Mission were impossible for someone who was a 'nobody.'

Another Elvis fantasy involving the paranormal is related by Bess Carpenter (in Moody 1987). According to Carpenter, Elvis had always been special to her. As she says, 'I have a thing about Elvis. He was the man of my dreams from the time I was fourteen. At my fifteenth birthday party, my girlfriends gave me a cake that had 'ELVIS and BESS' written in pink icing on the top of it. Our names were enclosed in a heart. I love Elvis.' (p. 44) Again, Elvis has functioned as a fantasy figure around the issue of adolescent sexuality and the ideology of romance which attempts to resolve the struggle.

So, when Ms. Carpenter found herself, in 1979, pregnant, unmarried and deserted by the child's father, it is not surprising given our other examples that Elvis returns to function in

another prohibitive site of trauma. While Ms. Carpenter has had two children previously and wished to give birth to this one, when she told her parents of her condition, they 'freaked out.'

This 'disowning,' coupled with the father's desertion, leads to a traumatic condition. The culture has left Carpenter isolated. She enters into a self-described 'depression,' which is broken only on the day of the birth and Elvis's appearance. This is her account of her Elvis fantasy:

> When they wheeled me into the delivery room, they put this mask on me and I breathed the anesthetic. I was conscious the whole time, but I had a weird experience. The doctors and nurses were all around me in these white gowns, looking at me. Right there among them, Elvis Presley appeared. He smiled and winked at me. He said, 'Relax, Bess, it's O.K. I'll be here with you.' It looked just like him. I stared into his face, then I would blink and look away, but when I looked back he was still there. The others had on surgical masks but Elvis didn't. It was his voice, too. I'm certain of it. When you hear Elvis Presley's voice speaking to you, there can't be any doubt whose voice it is.
>
> I stared into his face the whole time. He was so sweet. He stood there the whole time. Then, when the baby came, it was he who said, 'It's a boy!' For an Elvis Presley fan, there can't be a bigger thrill than hearing Elvis himself telling you you have a new baby.
>
> All the commotion started then. Doctors and nurses were running here and there, checking the baby and sewing me up and I sort of lost Elvis in the crowd. I didn't see him anymore after that . . . I feel like he came through for me when I was feeling low. (p. 6)

The Elvis fantasy has sutured another prohibitive site. He has granted a sense of presence to the crisis of the ego encountered by desertion and anxieties around childbirth (which invoke both questions of sex and death). Through Elvis, Bess Carpenter's sense of ego is restored. By his role in her fantasy, he has sutured the battering crisis around the ego caused by the desertion of all outside support systems from Bess Carpenter's life.

Of course, there are patriarchal issues abounding in this account as well as running through previous ones. Is is necessary for these women that a male *always* act as a 'suturing/fantasy agent'? Hopefully not. Isn't such a use a comment on how deep male authority both causes and permeates the prohibitive sites of fantasy? Certainly. Yet, if these women live in cultural situations where more 'liberating' practices are not available, does the difficulty lie in the figure of Elvis, or in a culture that proscribes the set of available fantasy practices and images?

The image of Elvis obviously functions for many fans as an initial figure around the question of what it means to be 'female' or 'male' in our culture. Women have a series of options by which they may respond to him; men another series. Some overlap, some appear widely apart. One Elvis may be used by gay men, another by heterosexual men; one Elvis may be used by lower-class Southern women, another by bohemian New York artists. But the use of the Elvis image as a fantasy figure brings with it a whole range of commentary on the culture, on prohibition and the sites of trauma over identity in our everyday lives.

To illustrate this point further, one final fantasy must be considered. Since its publication, Lucy De Barbin and Dary Matera's (1987) account of a 'secret life' between Lucy and Elvis (and a resulting child) has been controversial. Many in the Elvis 'camp' deny the book's claim; even Geraldo Rivera spent air-time on 'Entertainment Tonight' investigating the claims only finally to doubt their truth.

Such arguments over truth and fiction do not concern us here.[4] De Barbin's account *is* a narrative, and we can assume it has traces of desire throughout. The question we will ask is simply: if we treat the account as fantasy, will it further illuminate the problem this paper addresses?

De Barbin's story certainly has all the marks of a fantasy. Her narrative of Elvis begins with a trauma around a site of prohibition (that of sexual seduction) and ends with the figure of Elvis offering to suture a return to pre-Oedipal plenitude and identity.

The initial trauma of De Barbin's life is a forced seduction. At the age of twelve, she is sold to an older man to be his wife. He repeatedly rapes her and denies her any sense of her own

pleasure. That this has occurred after her own father (whom she idolizes in pre-Oedipal memories) dies while she is very young only serves to make the account more 'tragic.' De Barbin's life is, in many ways, a classic one: a lower-class girl, who early in life loses her loving Father, finds herself tyrannized by a male dominator.

In one way, De Barbin's account differs from the others we have considered, in that she has no knowledge of Elvis as a singer/star when she first meets him. But in every other way, particularly the role Elvis will play in her own sexual/romantic reawakening, her fantasy is similar.

Elvis, as in other fantasy narratives, is always met in secret. In fact, De Barbin claims that only the two of them knew of the affair until Elvis's death. But in this secret place, Elvis becomes the 'gentle' lover that De Barbin has been denied by the conditions of her existence. When she meets him, early in the relationship, her account illustrates Elvis's 'difference' from other men she has met. (It also reverberates with many other fantasies in the Elvis literature.)

> Elvis came into the room fifteen seconds later, hardly discreet. His presence changed the entire room. It was as if a warm light flashed on, softening all the hard edges. He held me, and I inhaled his nice clean smell. I didn't know if it was his soap or the hair tonic he carried in a tall, skinny bottle with a shiny silver top, but it was enough to drown out the rug (which was musty).
>
> I fought to keep my emotions in check. (p. 50)

For some time, De Barbin continues to have an affair with Elvis while living with her husband, who she refers to as The Man. Elvis offers her sexual awakening, compassion, sensitivity. The Man beats her. As she states it, 'Elvis was Heaven. Home was Hell.' (p. 7)

Things obviously change as Elvis is said to change. He comes under more 'pressure' to be all things to all people and keep up a public image, while De Barbin resists the temptation to become more attached publicly to Elvis, fearing a scandal. Still, throughout the fantasy, Elvis embodies characteristics

FANS, FANTASY AND THE FIGURE OF ELVIS

which allow De Barbin to suture the trauma that abuse causes her ego: 'He was a man beyond the image everyone saw. The only man I could love without being afraid. Before him, I was so afraid. He came and took the pain away. He was strong, indomitable, and sure of himself and his beliefs. He was tender, kind, gentle, and loving. He was my lover, my inspiration, my deliverer.' (pp. xix–xx) Elvis saves De Barbin from the world of forced seduction, from male violence and power, and allows sexuality to flourish in a context of romance and passion. Through Elvis, Lucy De Barbin grows in ego strength that allows more commonly accepted practices for the display of desire.

In this sense (and this holds true for all the fantasies), Elvis is truly a 'deliverer.' If the fantasy is the wish for plenitude, Elvis seems to deliver such plenitude to the fantasizers, standing as a site of completion, an alternative to the world which prohibits or circumscribes full expression of desire. In this sense, Elvis Presley is a continuing figure bringing the salvation which desire always asks for in any situation of trauma.

Conclusion

This paper is an attempt to rehabilitate the fantasies of fans in light of media studies. For too long, we have dismissed many of the practices of both sexes in relation to star commodities. We have failed to treat them as serious attempts to address life-situations, choosing instead to characterize them as sometimes laughable, sometimes delusional products of 'weaker' minds.

Instead, I have argued that fantasy is a necessary component of the fundamental tension between the Imaginary and Symbolic in life, between the unconscious and ego formations. Every individual will be driven by desire toward presence just as the social formation of the ego seeks to repress and redirect that desire. At sites of trauma, marked by social prohibition, the gap between desire and ego will be marked, calling Identity and Self into question. At this point, fantasy can be a way in which Identity is sutured together, a way in which desire and ego are stitched and which allows healing.

The use of media figures in fantasy does bring with it a host

of questions, some of them as troubling as the culture which both prohibits and provides images. Some of these questions are political, and spin from those asked in another context, that of fantasy–romance novels, by Modleski (1982, 113). She observes, for instance, that, 'while popular feminine texts provide outlets for women's dissatisfaction with male–female relationships, they never question the primacy of these relationships. . . . Indeed, patriarchal myths and institutions are, on the manifest level, whole-heartedly embraced, although the anxiety and tensions they give rise to may be said to provoke the need for the texts in the first place.'

To say this another way, the female fantasies around Elvis discussed here, while often constituting a critique of male inadequacy and female sexual repression, never raise the question that the conditions *creating* the need for such fantasies are engendered by institutional and social systems of power and control. This will immediately make the texts somewhat 'suspect' for many feminists, who believe that the critique of patriarchy must take place at an institutional level as well as a personal one.

Yet, perhaps these women (and some men, no doubt) who fantasize about Elvis are of a class and social formation that experience the domination of men firsthand, in such a way that the idea of an 'institutional critique' seems impractical. Certainly, it is hard to believe that someone like De Barbin could have faith in institutional critiques of patriarchal power when she is being beaten regularly by a powerful male in her household. It may be that her only option was the promise offered by the figure of Elvis. And while that promise may not change the system which created The Man and his violence, it does, in some sense, help her redeem her life.

For whatever else you can say, fantasies of Elvis fans are important to many of them as signs of *personal* liberation. We may quarrel with the form, but we cannot deny their power as testified to by thousands of fans who speak of being transformed by Elvis's voice, his visage, his magnetism. For these women and men, he is, in certain ways, the light of the world and the glory of glories. And still, they line up, row upon row, at his altar locations, dreaming their dreams, making their wishes. For them, there is absolutely no doubt. Elvis will always be alive.

Notes

1 Much of the following review of fantasy and Freud is indebted to Laplanche and Pontalis (1973).
2 A full explanation of post-structural linguistics would take us even further afield, but for a more complete explanation of this initial formation stage, see Lacan (1977, 1–7).
3 There is a substantial body of literature on this particular facet of fantasy. I refer the reader, in particular, to Radway (1984) and Modleski (1982). Connell *et al.* (1981) offer a more 'personal' reading of the issue, while Kaplan (1986) makes important qualifications on the tendency to make such analyses too general and outside of social formations of class. Finally, Coward (1985) offers a specific reading of 'male crooners' that could certainly be applied in this situation to Elvis as a 'male idealized' figure who promises certain women fulfillment.
4 Laplanche and Pontalis (1964/87) argue that such judgements are, in fact, definitionally impossible.

References

Bizjak, Tony. 1987. Elvis Worshippers Are Keeping the Memory Alive. *The San Francisco Chronicle*, 10 August, 42.
Connell, Myra, Tricia Davis, Sue McIntosh and Mandy Root. 1981. Romance and Sexuality: Between the Devil and the Deep Blue Sea. In *Feminism for Girls: An Adventure Story*, eds Angela McRobbie and Trish McCabe. London: Routledge & Kegan Paul.
Coward, Rosalind. 1985. *Female Desires*. New York: Grove Press.
De Barbin, Lucy and Dary Matera. 1987. *Are You Lonesome Tonight?* New York: Villard Books.
Deen, Jeannie. 1979. A Young Girl's Fancy ... In *Elvis: Images and Fancies*, ed. Jac L. Tharpe. Jackson: University of Mississippi Press.
Dyer, Richard. 1986. *Heavenly Bodies: Film Stars and Society.* New York: St Martin's Press.
Eagleton, Terry. 1983. *Literary Theory: An Introduction.* Minneapolis: University of Minnesota Press.
Freud, Sigmund. 1928. *Beyond the Pleasure Principle.* Translated by James Strachey. New York: Bantam Books.
Heath, Stephen. 1977/78. Notes on Suture. *Screen* 18(4): 48–76.
Hecht, Julie. 1978. I Want You, I Need You, I Love You. *Harpers* 256, 59–67.
Holzer, Hans. 1978. *Elvis Presley Speaks.* New York: Manor Books.
Kaplan, Cora. 1986. The Thorn Birds: Fiction, Fantasy, Femininity. In

Formations of Fantasy, ed. Victor Burgin, James Donald and Cora Kaplan. New York: Methuen.

Kristeva, Julia. 1987. *Tales of Love*. Translated by Leon S. Roudiez. New York: Columbia University Press.

Lacan, Jacques. 1977. *Ecrits*. Translated by Alan Sheridan. New York: W. W. Norton.

Laplanche, Jean and Jean-Bertrand Pontalis. 1964/1987. 'Fantasy and the Origins of Sexuality.' In *Formations of Fantasy*, eds Victor Burgin, James Donald and Cora Kaplan. New York: Methuen.

Laplanche, Jean and Jean-Bertrand Pontalis. 1973. *The Language of Psycho-analysis*. Translated by David Nicholson-Smith. New York: W. W. Norton.

Lasker, Patsy. 1979. Wife Was A Four Letter Word. In *Elvis: Portrait of a Friend*, eds Marty Lasker, Patsy Lasker and Leslie S. Smith. Memphis: Wimmer Brothers Books.

Miller, Jacques-Alain. 1977/78. Suture. *Screen* 18(4): 24–34.

Mitchell, Juliet. 1984. *Women: The Longest Revolution*. New York: Pantheon Books.

Modleski, Tania. 1982. *Loving With a Vengeance: Mass Produced Fantasies for Women*. New York: Methuen.

Modleski, Tania. 1986. Femininity as Mas(s)querade: A Feminist Approach to Mass Culture. In *High Theory/Low Culture: Analyzing Popular Television and Film*, ed. Colin MacCabe. New York: St Martin's Press.

Moody, Raymond. 1987. *Elvis After Life*. Atlanta: Peachtree Press.

Oudart, Jean-Pierre. 1977/78. Cinema and Suture. *Screen* 18(4): 35–47.

Radway, Janet. 1984. *Reading the Romance*. Chapel Hill: The University of North Carolina Press.

San Francisco Chronicle. 5 November 1987: A10.

Vermorel, Fred and Judy. 1985. *Starlust: The Secret Fantasies of Fans*. London: W. H. Allen.

'Something More Than Love': Fan Stories on Film

LISA A. LEWIS

In the 1950 film, *Sunset Boulevard*, Norma Desmond, a great movie star of a bygone silent picture era, is reduced to a pathetic, narcissistic figure when her fans withdraw their support of her. When the man she loves walks out on her, she summarizes the movie's premise before shooting him: 'No one ever leaves a star, that's what makes one a star.'

Looking to Hollywood to reveal the nature of fan–star relationships may at first seem inappropriate, but when you consider that the film industry helped create the star system and the fact that many of its directors, producers, and writers trace their creative influences to their own fandom, it becomes a reasonable critical resource. In fact, Hollywood has managed to portray the fan impulse on the screen with a sensitivity and insight that rivals the analyses of critics. This essay explores the depiction of fans and fandom in several Hollywood films. Two early versions, *Sunset Boulevard* (1950) and *Hollywood or Bust* (1956), provide the backdrop for the more recent fan portrayals of the past two decades, including *I Wanna Hold Your Hand* (1978), *The Fan* (1981), *Come Back to the Five and Dime Jimmy Dean, Jimmy Dean* (1982), *King of Comedy* (1983), and *Heartbreak Hotel* (1988). These film stories about fans range from sympathetic celebrations to darker, accusatory statements, particularly as they enter the 1980s. As a group, they offer an expansive view of the tensions that result from a textual relationship of adoration in portraits that oppose

135

LISA A. LEWIS

contradictory gratifications of love and hate, sustenance and destruction, privilege and deprivation, popularity and the lack of recognition, ownership and friendship, myth and social reality.

Hollywood or Bust

Hollywood or Bust breaks ground for a number of the themes which become more intricately developed in later films. In the movie, textual competency is the trait which first identifies Malcolm Smith as a fan. He is introduced standing in line waiting to enter the stadium where a drawing for a new car will be held. He reads a fan magazine about his movie idol, Anita Ekberg, and rattles off details from her movies including production credits and character descriptions for Steve Wiley, the man behind him in line. He breaks into a rendition of the Balinese dance Ekberg performed in one of her films, demonstrating the fan propensity to reproduce the style or performance modes of favored stars.[1]

His campy performance foregrounds the issue of sexual confusion in the male fan thereby representing the ideological position that fandom is a sign of immaturity and femininity, a recurring motif in fan movies. As the film progresses, Malcolm's fandom is repositioned, to an extent, to accommodate the more socially acceptable context of heterosexual attraction but not before he is pegged as an arrested adolescent with latent homosexual tendencies. The film chooses to emphasize Malcolm's conflict with the masculine norm by opposing him with the Steve Wiley character, who pursues a real woman, albeit an aspiring entertainer, throughout the film.

Malcolm wants to win the contest car so that he may drive to Hollywood to meet Anita Ekberg in person. The goal of advancing a textual relationship with a star through a 'close encounter' is one which repeatedly motivates fan characters. Malcolm, in fact, registers the extension of this desire – the hope that he can establish a relationship of parity, of friendship, with the favored star. His wish is manifested in the fantasy of becoming Anita Ekberg's neighbor, a scenario encouraged by Wiley who lies that he lives next door to Ekberg. Wiley pledges

to introduce the two if Malcolm agrees to drive the car, which they both win, to Hollywood, where Wiley wants to sell it for the best price to repay a mob debt.

Wiley ultimately convinces Malcolm to go with him by pretending to be his buddy, an act which represents the conditions of loneliness and subordination that fan movies often explore as motivations for fan behavior. Malcolm, we are told by the film, holds a low status job as a delicatessen worker. He has never managed to cultivate friendships, except, that is, with his dog. His social alienation comes out most clearly in a statement he makes about why he identifies with Ekberg's movie persona: 'She is always searching, searching, searching.' The words reveal the shadow of dissatisfaction that darkens his life and contextualizes his preoccupation with Ekberg.

In fan movies, the fan character's lack of social recognition and popularity is held accountable for the intensity of his or her star obsession. This sensibility is codified by permutations of the phrase 'to be chosen.' When Wiley (dishonestly) declares himself to be Malcolm's friend, Malcolm responds enthusiastically, 'I've never been chosen.' 'Being chosen' encompasses a broad system of desire and includes the goal of befriending the star, as well as actions taken to make the fan popular with an audience and, therefore, famous, like the star. Malcolm fulfills both fan imperatives by acquiring his own celebrity status at the film's end. His dog becomes the source of inspiration for a new Ekberg film entitled *The Lady and the Great Dane*, with the backstory of Malcolm's encounter with Ekberg used to promote the film. The dog, which the film positions as essentially interchangeable with Malcolm, acquires fans as a result of his movie appearance and is asked for his autograph (a paw print). And in the final scene, Malcolm is Ekberg's escort for the premiere screening of the new film.

In Malcolm's first encounter with Ekberg he is all fan. Their chance meeting in Las Vegas turns into a collision which hints at the antagonistic and dangerous side of fandom. Malcolm's Great Dane spies Anita's small pet poodle and falls in love after the little dog performs a two-legged dance for him. The scene reenacts the moment of fan seduction by a performer and, as the Dane pursues the poodle, the fan quest for the star. When Malcolm chases after his dog he comes face to face with his adored star. His adolescent bunglings and overwhelming

demonstrations of affection cause the star to fall into the hotel pool. The unplanned dip results in Anita catching a cold that prevents her from fulfilling a movie commitment. Thus the edge that characterizes the fan–star relationship, the tension between the fan's love and his ability to hurt the star, are highlighted without threatening the celebratory, comedic tone of the film. This lighthearted nod to the darker side of fandom sets the stage for the exploration of danger and expressions of hatred by fans in later fan movies.

I Wanna Hold Your Hand

I Wanna Hold Your Hand is also a comedy but one in which greater attention is given to the contradictory category of hateful fans. In the movie, several versions of fandom are presented through the use of an ensemble cast. The constellation of characters originates with a nucleus of four girlfriends and builds slowly over the course of the movie to include four boys. Female fandom is prioritized but eventually balanced against forms of male fan expression. The girlfriends – Rosie, Pam, Grace and Janis – are very different kinds of girls and their fandom takes different forms as a result. All four are introduced in a record store in Maplewood, New Jersey. New Beatles records have just arrived in conjunction with their 1964 US tour and the store is awash with consumer enthusiasm. Rosie bops into the store dragging a reluctant Pam. She rifles through the records, one more shark in the feeding frenzy, and squeals in fan rapture when a lifesized cardboard cut out of the Beatles is paraded through the store. Pam is distracted by her impending marriage, uninterested in participating. Janis enters the frame carrying a 'Boycott the Beatles' sign and attempts to agitate customers with lines like 'You don't really want to buy this' and 'It's a money-making scheme.' She spies her friend Rosie and tries to dissuade her from another purchase but is drowned out by the sound of a Beatles trivia contest announced on Rosie's pocket radio. Grace comes into the store looking for Rosie and finds her stuffed into a phone booth with Pam, frantically dialing the radio station with the answer to the trivia question. Grace presents the girls with a plan to get into the Plaza Hotel where the Beatles are

holed up in New York before their scheduled appearance on 'The Ed Sullivan Show.'

Rosie is portrayed as the quintessential female Beatles fan. Her fandom is communicated by extreme forms of hysteria, screaming and fainting, most typically associated with female fan expression of the period. She possesses a high level of textual competence and is shown to be very involved in media interactions generally, two traits of avid fandom. Rosie's infatuation with a specific Beatle, Paul, codes her in classical terms as motivated by heterosexual attraction.

Grace's version of intense female fandom is more in keeping with Cline's (1986) vision of a decidedly female fan fantasy.[2] Her goal in life is to become a journalist and her plan to get close to the Beatles is motivated by her desire to capture exclusive photographs to launch her career. Grace's fandom is most clearly presented as a product of use value.

Pam, on the other hand, is no fan at all, or rather, as the film reveals slowly, she is a fan in the making. At the start of the movie, she is defined as a follower. She is led into the record store by Rosie, and, in life, is led into an early marriage. She follows the trail of female destiny, adjusting all expectations to her role within the nuclear family. When Rosie suggests buying her a Beatles album as a wedding present, Pam corrects her saying she is supposed to be given more practical gifts. She explains her disinterest in the Beatles with the phrase, 'I can't chase the Beatles and be a married woman.'

Janis, who protests against the Beatles, is a fan, but in the contradictory category of 'hater.' Her motivations surface when her father enters the story to reprimand her for picketing the record store. He is the store's owner and her attack on Beatles customers is a way of attacking his capitalist values, a means of expressing teenage rebellion. Janis's protest activity is wielded by the filmmakers to present a particular point of view about fandom, its tie to consumerism. Janis views the Beatles' popularity in terms of consumer manipulation rather than authentic popular support and defers to the 'folk model'[3] of authentic expression when she angrily questions her father about why Joan Baez records aren't in his store. His answer – 'She doesn't sell!' – only underscores her political position.

The four female-fan characters work with and against each

other to reveal the multiplicity of expectations that rule female adolescent lives and the nuances that make fandom a complex arena of social practice. Whereas Rosie is constantly on the verge of losing control, Grace is directed and in control throughout the film. Pam, the good girl, longs to fulfill feminine expectations while Janis goes out of her way to resist them. Rosie revels in adolescence, in the fantasy attractions which fandom provides. Pam, alert to the transitional status of adolescence and its mere postponement of social expectations, rushes into adult womanhood and into an actual heterosexual relationship.

Grace's plan to get close to the Beatles calls for the girls to drive a limousine up to their hotel entrance, an act she gauges will ensure their admittance. Unable to afford an actual limo, Grace persuades Larry, the undertaker's son, to drive them in his father's funeral car. Driving out of their hometown, the group is followed by Tony who transfers himself from his friend's car into theirs while both cars are in motion. With the introduction of the two boys, Larry and Tony, the film begins to hone in on forms of male adolescence and male fandom.

Larry is something of a nerd. His interest in technology (he helps out in the school's audiovisual department) foregrounds his masculinity, however. He is also, briefly, identified as a musician of sorts – an accordion player. But the film does not take advantage of the opportunity to portray Larry as having a musical affinity with the Beatles and thus misses out on presenting an important aspect of male fandom. Larry's interest is casual rather than intense. When questioned as to his feelings about the Beatles, he responds with a non-committal, 'they're OK.' He does represent the classical model of fandom – heterosexual attraction – keeping pictures of 'star' women of the period in his wallet (Patty Duke, Tuesday Weld, Ann Margret and Jacqueline Kennedy).

Tony is perhaps the most contradictory and complexly drawn character in the film. As a fan in the 'hate' category, he demonstrates textual competency but directs this knowledge into expressions of hatred towards the Beatles. He alters Beatles lyrics into a sexual slur: 'Yeah, yeah, yeah, I wanna hold your *glands.*' He participates in style imitation by donning a black Beatles wig until Rosie tells him he looks like Paul and he takes it off in disgust. He says he hates the Beatles, but through

mimicry and parody he reveals his true level of involvement with the text of the band. Tony's fandom is linked in a number of ways to masculine identity conflicts. Tony is a bad boy, full of bravado, a living example of the paradigm of male adolescent license. He is prone to wild stunts, drinks beer at all hours of the day, is always in hot pursuit of girls, and shuns affection for members of the same sex by playing the role of bully. He objects to the Beatles because they are 'limey fairies,' a description that simultaneously represents the homophobia caused by his masculine insecurities and the xenophobia that flows from his lower-class, ethnic background. The film, however, hints that this reaction is a cover for his true concern over the fact that girls prefer fantasy men to real men, a maneuver which tips the balance of power between the sexes.

The other two central male-fan figures, Peter and Richard, appear later in the film at the Beatles' hotel where thousands of mostly female adolescent fans are maintaining a vigil. Peter, a boy in early adolescence, also imitates the Beatles but with more conviction. His Beatles haircut becomes an issue in the film as Peter's irate father holds his tickets to 'The Ed Sullivan Show' ransom until Peter agrees to a military haircut. Richard imitates the Beatles' style by adopting their mode of dress. The best way to describe Richard is to say that he is a male version of Rosie. Rosie choses a specific Beatle, Paul, as her object of affection. Richard identifies with Ringo and calls himself Ringo when asked his name. Like Rosie, he delights in trivial knowledge about the Beatles and his actions and emotions are as frantic and uncontrollable as hers. He is linked to the feminine by his inability to understand the mechanics of a broken down elevator in the film's third act. He solves the problem of being trapped inside by abandoning control, flailing himself through a plate glass frontpiece. Richard's brand of fandom is distinguished by his collecting activity. His prize possession ('my masterpiece') is a turf of grass where Paul supposedly stepped. Although his collections grow out of a fan's producerly impulse, he is also shown to be excited by their monetary value. He exhibits an entrepreneurial motivation that lines up with Grace's quest for exclusive Beatles photographs.

To understand fully the character stakes in this movie, the pathways taken by the unfolding plot, requires sensitivity to

the different versions of fandom and modes of fan gratification. Rosie's hysterical fandom ultimately prevents her from seeing the Beatles. After successfully entering the hotel, her impatience drives her to take the most direct (and guarded) route to the Beatles' suite, up the elevator to the twelfth floor, where she is immediately caught and escorted away. Her fan knowledge does win tickets for her and Richard to attend 'The Ed Sullivan Show,' but her uncontrollable fan passion causes her to faint and miss the whole performance. Her textual relationship with the Beatles is so strong that it is fitting that she never sees them in person. Richard, her counterpart, because he is a boy does not faint, but he does abandon control by swinging wildly on a suspended microphone, an instrument of technology, throughout the show.

Pam, inadvertently, gets close to the Beatles and is transformed into a fan by the encounter. She misses the elevator up to their suite because she must grovel on the ground looking for the engagement ring she drops, the symbol of her impending marriage. She gets trapped, appropriately, in the hotel's service area and becomes privy to a view of the Beatles exiting through a back entrance. Hiding under a room service cart, Pam is escorted up to the Beatles' empty suite. Her luck astonishes her. Putting her engagement ring away in her shoe, she discovers her repressed sexuality and channels it in a fan's orgy. She makes love to each and every item touched by the Beatles – the guitar, the soiled napkin, the foodstuffs. She pulls out hair residue from a Beatle's brush and rubs it over her face in a moment that pumps pleasure into a crude and vulgar act. The filmmakers take their time with the scene allowing the audience a simultaneous period of arousal. Her escapade makes her into a minor celebrity and she becomes an object of identification for other girls who now ask her for her autograph. She calls her fiancé to come take her home but then realizes the depth of her feelings for the Beatles and calls off their marriage. Pam's new-found fandom rescues her from conformity to feminine expectations and releases her sexual yearnings.

Grace, who, next to Rosie, most wants to see the show, also misses it, but by her own choice. She is resourceful in her bid to see the Beatles, first at the hotel, and then at the studio. Unlike Rosie, she reasons that the Beatles will be heavily guarded and

gets off the hotel elevator at the eleventh floor and sneaks up, but arrives moments after their departure. When she discovers a guard at the CBS studios who will accept a bribe, she organizes Richard's collectible Beatles' bedsheets into a money-making scheme until a female gang threatens her with bodily harm if she doesn't turn over the money. As a last resort, she decides to sell her body to a businessman in search of female company, but ends up trapped precariously in his closet when the real prostitute arrives. She snaps their picture and then blackmails the man into giving her the bribe money she needs. Larry finally asserts himself by bursting in and saving Grace from the man who grabs for her after their transaction. Grace discovers her love for Larry and instead of using the money to enter the studio, she bribes a policeman to keep Larry from going to jail for bad driving. True to her character and her brand of fandom, she never loses sight of real relations, never abandons control, and is rewarded for her distanced perspective by getting closer than anyone to the Beatles. At the show's end, the 'fab four' pile into the funeral car parked by the studio's back entrance and Larry and Grace drive away with them.

The two fan-haters progress by the movie's end in two different directions. Janis becomes a fan 'lover' when she discovers fandom's political side. Janis and Peter are pursued by the police after attempting a break-in at the studio. They duck into the crowd of fans outside, hoping to hide, but Peter's haircut is so distinctive that the police quickly pinpoint him. The politically-impassioned Janis pleads with the police to let Peter go, accusing them of unfairly singling him out because of his style-imitation practice. The crowd of fans become involved in the dispute, throwing things at the police and surging forward until Peter is released in an effort to avoid an all-out riot. The fans' spontaneous act of defiance on her and Peter's behalf awakens Janis to the political gratifications of belonging to a fan community.

Tony actually becomes more and more bitter and threatening as the film's plot advances. His hatred intensifies with every rejection from female fans who prefer the Beatles to him. Tension mounts as he grabs a fire axe inside the studio and approaches the stage. The film pauses long enough for audiences to contemplate whether Tony has indeed been pushed

over the edge of ordinary fan hatred to commit a fan's assassination of the stars.[4] But Tony has textual murder in mind, not bodily harm. He heads for the roof where he intends to cut the television transmission lines to disable the national broadcast. As he climbs the tower, a storm builds, lightning strikes the axe, and he is thrown down onto the rooftop. Divine intervention quells his hatred. When he sees that the Beatles are popular with God, he finally accepts them.

The film inventories both the pleasures and dangers of fandom. One clear attraction is the carnivalesque inversion of rules and norms that fan events facilitate. Lawlessness pervades the ensembles' actions in the form of unlicensed driving, police evasions, attempted break-ins, bribery, blackmail, prostitution, property damage, drinking, theft, and civil disobedience. Freedom from the rigidity of sex-roles is realized by certain characters – Pam avoids the role of wife, Peter gets to keep his 'feminine' haircut. There is also a patterned presentation of the fan desire to become famous like the adored star. All the major ensemble players have a brush with stardom by the film's end: Rosie wins a trivia contest and is heard over the radio airwaves; Pam receives an unexpected fan-following after she hides out in the Beatles' suite; Richard speaks before Ed Sullivan's studio audience; Grace, we can assume, gets famous for her exclusive photographs. Even Janis who exhibits opposition to commercial exploitation reveals her hope that her protest activity will attract national press coverage. And Tony, of course, gets an audience with God.

The Fan

The joy and pleasure of fandom which is privileged and largely sustained in the previous films is submerged in *The Fan*, a slasher film in which a deranged fan stalks his adored star. The film opens on Douglas Breen in the act of typing a fan letter which reads, 'Dear Miss Ross, I am your greatest fan. I am not like the others. I adore you like no other.' The words hint at a recurring motif in fan films, the crazed fan's tendency to claim him or herself above the pack of nameless fans and to attempt a special, exclusive relationship with the star. This 'special' fan

typically derides other fans or claims not to be a fan at all in order to force a distinction. Douglas Breen demonstrates his lack of fan comraderie in a second letter in which he scolds Ross's secretary, who writes the responses, for calling him a member of 'The Sally Ross Fan Club': 'I am not one of those cheap, anonymous little star-gazers.' And when a throng of fans swarm Ross as she exits the theatre, Douglas is present, but keeps his distance.

The film represents fandom in terms of degrees of normality and abnormality. The crowd outside the theatre is made up of 'ordinary' fans who behave within the socially approved mode of fan–star interaction – asking and receiving autographs. The balance of this structured reciprocity, however, is tipped by Ross when she offers her own ink pen in the place of a fan's failed pen. This slight break-down of proper distance provides an opportunity for an unstable fan to take advantage by reaching out and stealing Ross's pen. The woman is identifiable in the crowd even before the act is committed by a slightly crazed facial expression. The bit-part comments on fan collecting practices, but it also serves to render Douglas as extreme in his fandom for it is he who trips the female fan and coldly snatches Ross's pen for himself.

Care is taken to highlight the star's point of view, to show her side of the fan–star interaction. Before we see Sally herself, we see through her eyes, in a point-of-view shot of autograph hounds surging towards the camera. Sally is the one who is presented as an ordinary person, not her crazy, menacing fan. She experiences ordinary hopes and fears, albeit in the context of her extraordinary status. She is the product of a failed marriage, lonely and vulnerable with her ex-spouse. As in *Sunset Boulevard,* the star is adored by millions of strangers but lonely for the love of one man. She expresses trepidation about the success of her new role in a musical. A birthday reminds her she is getting old so she drinks too much. Yet she is marked as a star by the overabundance of love and adoration she encounters wherever she goes and the support staff who manage the mundane aspects of her life, one of which, it turns out, is her fan correspondence.

The film provides audiences with a scenario for how fan letters are handled. Ross's long-time personal secretary screens the

letters and writes personal responses which routinely include autographed photographs. Although her secretary shares some of the fan verbiage with Ross, the star is shown to be largely shielded from the process. When the secretary alerts Ross to a change in tone in Breen's letters and suggests ignoring future correspondence from him, Ross accuses her of endangering a fan's relationship with her. As it turns out, the secretary's warning is on the mark and Ross is the one who is in danger. The existence of staff who act as 'speedbumps'[5] to slow the fan's access to the star is what angers the fan in this and other fan movies. The fan textually experiences a direct relationship with the star, but when he attempts to advance that textual relationship to an actual one-on-one encounter, protective barriers are discovered. Thus, Ross's secretary becomes the first victim for Breen's razor in a slashing spree that injures or kills the major support staff in the star's life, including her choreographer and housekeeper.

The film operates within the paradigm of male–fan representation by portraying Douglas Breen as an arrested adolescent, a child who never learned the difference between fantasy and reality. At one point in the movie, Breen's sister arrives at the door, interrupting the fantasy dinner Douglas has prepared for Ross. She scolds him with the statement: 'It's one thing when we were kids to dress up, collect things, and pretend – but when you grow up . . .' Douglas is also portrayed as a latent homosexual. He picks up a young man in a bar and they retreat to the roof where the boy performs fellatio on him. The camera lingers on Douglas's face revealing an instant of pleasure before he brings the razor blade down on his lover. As Douglas lights the dead boy on fire, the plot function is revealed and we understand that he intends to fake his own suicide and thus bring Sally out of hiding so that he may stalk her anew.

The final scene is a tour de force presentation of the dual impulses of love and hate that exist for both fan and star, the relations of power that structure the fan–star interaction. Douglas begins his final terrorizing of Sally by violating the sanctified space of the star, her backstage dressing room. Her knowledge of backstage areas allows her to hide successfully for several moments undiscovered. When the pursuit continues, Sally runs out onto the theatre stage, the space that most

signifies her power before an audience. Here she is able to fight off the fan and she strikes Douglas across the face. But as she runs into rows of empty auditorium seats, the audience's turf, Breen exercizes his power and sends her grovelling to the floor to cower in the space normally occupied by spectators' feet. Finally, she rises and meets Breen face to face initiating an exchange that reveals their differences. Speaking of his lifelong commitment to his adored star, Douglas says, 'I gave you everything.' Ross responds assertively, 'Took, took, like the animal you are.' She speaks for the film's audience of ordinary fans when she continues, 'It's not just me. We are all sick of this reign of terror.' As Breen raises the razor to strike her down, he falters, suspended between love and hate, fantasy and reality. Finally, lowering his weapon, he embraces her. Sally takes advantage and kills him with his own blade. The scene cuts to Douglas propped up dead in one of the audience seats while his first fan letter to Ross is read in voice-over. The journey of the adoring fan ends in death at the hands of the adored star.

Come Back to the Five and Dime Jimmie Dean, Jimmie Dean

This film traces the lives of a group of women who formed a James Dean fan club in the fifties as teenage girls and then meet for a reunion in 1975 on the twentieth anniversary of Dean's fatal car accident. It concentrates on the pain and subordination of life in a small Texas town to reveal how fandom operates within a specific social context. Religion and morality are the overwhelming influences in the town and fandom provides the girls with an apparent escape from oppressive dictums, although, in practice, they organize their fandom according to religious models, calling themselves the 'Disciples of James Dean.'

The film's action takes place in one setting – a Woolworth's store which Juanita, the store's proprietor, has made over into a house of worship. She uses the store as a forum to air religious values and to display religious icons. Her store-opening ritual consists of turning on the radio to a religious music station and lighting the neon Jesus that hangs above the soda fountain counter. She admonishes the group of girls, who have adopted

the store as their fan club headquarters, about the length of their hemlines, their occasional use of profanity and their indulgences in popular culture. Yet she is mostly tolerant of their fandom and appreciates the female comraderie. She employs two of the girls, Mona and Cissy, the fan club's President and Treasurer respectively, as well as the only male member of the club, Joe.

Mona, more than the other fans, resembles a religious zealot. From Juanita, her surrogate mother, she learns discipline and faith in spiritual values but employs them in fandom rather than Christian worship. Mona parallels Juanita's store-opening ritual each day by lighting tiny Christmas lights surrounding a publicity still of James Dean. She describes her adoration of Dean as 'something more than love' and when Cissy challenges her assessment saying that 'love is the end,' Mona corrects her with the statement, 'there is something beyond the end.' She sees in Dean the same kind of immortality represented in Jesus Christ. Mona strives to set herself apart from the other girls, to 'rise above' her friends and her town and, as in *The Fan*, this marks her as abnormally attached to the star. Mona is a product of star ideology, the belief that rare individuals will be discovered (chosen) and catapulted to fame. Her belief system corresponds perfectly with the patriarchal and religious frameworks that control her life, encouraging passivity in the face of narrow female roles and predestination. When she is 'chosen' to be an extra in the movie *Giant* she thinks her beliefs are beginning to find fruition. She experiences the moment as an epiphany, describing it in terms of a 'premonition' that her life is about to change, and marks the occasion by having her first sexual encounter with Joe. When an illegitimate pregnancy reroutes her life back to the scenario of a small town girl in trouble, she recreates the moment of 'being chosen' by claiming her baby to be the son of James Dean. She copes with real trauma by constructing a fantasy solution. Mona's claim awards her prestige in the world of fandom as thousands flock to the town to see the son of James Dean, granting the mother a modicum of stardom.

Joe, the baby's father, protects Mona by not revealing the truth about his paternity, but at great expense to his own psyche. Joe's character replicates the typical treatment of male fans

as sexually confused, but with a more serious tone. When he begins to flaunt his adept imitation of the McGuire Sisters' singing act in the 'Senior Talent Show' he is ostracized by the homophobic community. For Joe, the act, which he performs with Cissy and Mona, is a way to explore his adolescent conflicts over sexual identity and to partake in the pleasures of girl friendships. He dresses female, as a McGuire Sister, to participate in fan activity but also to escape his discomfort with the narrowness of the male role. Texas conservativism rises up to squelch the boy's experimentations. He is fired from his job at the store, accosted by a group of the town's men who rape him as punishment for what they consider to be homosexual transgressions and, finally, driven out of town. Joe's love for Mona, which could redeem him in the eyes of the town, goes unrecognized because he is not allowed to claim her baby as his own. On the day of the reunion, Joe returns as Joann, an unhappy transexual with regrets that stem from his oppressive childhood in the Texas town.

Cissy's fan motivations align most directly with the myth of James Dean. Dean was characterized as a dissatisfied youth from a rural community who escaped into a show business career.[6] The mythic story provides the perfect corollary to Cissy's impulse to flee her bigoted home town. As a girl, she displays talent and ambition which fuels her escape plans. She choreographs an imitation of the McGuire Sisters act and teaches it to Mona and Joe. She wins local skating competitions by imitating the moves of female ice-skating star, Sonja Henny. Cissy acts on her 'wanna be' impulse in the only way available to a young Texas girl, by gaining proficiency at the town roller-rink. She envisions skating as her ticket out of town, but her character is defined by the phrase 'too late.' She is always late for work and by the time the Ice Capades come to town with the promise of auditions, twenty years have passed. Her hopes of being rescued, of being chosen, are finally dashed when Mona and Juanita laugh and remind her that she is too old to skate and has never even skated on ice.

The film presents Cissy's unrealized ambitions as attributable, in part, to gender discrimination. Try as she might to achieve fame through performance activity – skating and singing – the only notoriety she is permitted comes as a result of her large

breasts. We witness how the male gaze molds her self-image to enforce acquiescence to the town's values in a scene with Mona in which Cissy refers to her breasts as 'bazooms.' The term, she explains to Mona, is 'what the boys [call] them.' Cissy's fan gratifications shift gradually to accommodate male control over female representation and female star images. She abandons her desire for Sonja Henny's athleticism, fame won by activity, in favor of a comparison with Marilyn Monroe's breasts, a passive preoccupation with her looks. Cissy is further victimized when a mastectomy results in her being abandoned by her husband. There is, nevertheless, a resilience to Cissy. One fallout of Lester T.'s departure is an increased acceptance of self.

The fan club reunion, in fact, provides the opportunity for each participating member to confess the damage done to them by the town and to begin the healing process together. Fandom is treated as a manifestation of a specific time and place, star adoration as an attachment mired in social condition. In the last scene of the movie, the Woolworth's store appears in the present reduced by the ravages of time, its occupants gone and presumably rid of the everyday sorrows it represents.

King of Comedy

In *King of Comedy*, Rupert Pupkin, the main character, begins as a fan but ends up as a star in his own right. He initiates the transition by taking advantage of a fortuitous set of circumstances which put him in a 'close encounter' with his idol, talk-show host, Jerry Langford. As the film opens, Langford is exiting the back door of the television studio. He makes his way through a mob of fans, more hostile than those that appear outside the theatre to greet Sally Ross in *The Fan*. This particular night, security is lax, and he is accosted by Marsha, the other main fan character, who jumps into his car screaming 'I love you' and flailing her arms with such compulsion that Jerry is forced to exit the car. What follows is an ugly scene in which Langford is mauled by the hysterical crowd. Rupert, who has made his way to the star, becomes cognizant of Langford's distress and assumes the position of bodyguard, restraining the mob just long enough to allow Jerry to reenter his car after Marsha is

carried off by the studio's security force. Rupert then jumps into the car as well and is allowed to drive off with Langford after he reminds him that he 'put himself on the line' for Jerry.

Rupert manifests many of the attributes of the ordinary fan. He collects autographs, the accepted mode of interaction with a star, and revels in extratextual information about celebrities. He knows the name of Jerry's butler and the state of Jerry's golf game, for instance, information which he manipulates to gain entrance to Langford's house. But Rupert is no longer content with fandom. He has developed the fan's vague desire for fame into a specific career goal. As in *Come Back to the Five and Dime Jimmie Dean, Jimmie Dean*, fandom functions in Rupert's life to provide inspiration and motivation to rise above the material conditions of his life. He has studied Jerry's career moves and comedy act as any fan in the process of acquiring textual competency, but now directs his fan knowledge towards making himself into a star comedian. In his home stands a replica of the show's set complete with life-sized figures of Jerry and his guests. Rupert sits in the center chair practicing small talk with guests and casual interaction with Jerry. His comedy instruction is a product of a fan's imitation of the star, but his producerly impulses have advanced him to the point where he has developed his own act. Although Jerry's timing and comedy sense are foundational, Rupert now writes jokes based on his own experiences. 'I'm ready,' he tells Jerry on their car ride.

Because Rupert's comedy act has arisen in the context of fandom, he believes personal contact with Jerry will lead to his start as a professional comedian and television star. He expects Jerry to share fame with him. As a fan, Rupert believes in 'being discovered,' in the ideology of 'the big break,' and he looks to Jerry to facilitate it. Jerry's first piece of advice to Rupert, however, is to get experience, to 'pay dues' by honing his craft in front of live audiences. Yet Langford contributes to Rupert's confused belief that he can expect help from him by telling Rupert to drop off a tape at his office.

The directive springs, innocently, from Langford's need to escape Rupert's attentions. Safe passage from one location to the next is the celebrity's biggest concern. Jerry has developed a variety of defense mechanisms which allow him to make his way through the fan onslaught he faces everyday. On the

street outside his office he tells fans 'I'm late' in an attempt to maintain his stride. He is willing to participate in 'acceptable' fan behavior, stopping to sign an autograph on demand, but when a middle-aged autograph hound insists that he speak to her sick nephew holding on a pay phone, he quickly removes himself from the scene. The moment becomes the occasion for an economical display of the two competing fan impulses, love and hate, as the woman shifts from praise ('You're the joy of the world!') to insult ('You should get cancer'). When Rupert enters Jerry's car and asks him to drive on, Jerry protests that he does not allow fans such a privilege, but relents, when pressed, in order to flee the mob of fans. Likewise, he seemingly acquiesces to Rupert's request to listen to his act, but only as a way to keep the fan calm until he can make his escape. In fact, Jerry affects the stance of friend and helpmate purely as a means to protect himself. Rupert, however, interprets the face-to-face meeting as a signal that he is moving beyond the exclusively one-sided, textual relationship of the fan toward actual friendship with the star.

The film as a whole is interested in exploring the confusion between the categories of fan and friend. When Marsha pesters Rupert to reveal the content of his conversation with Langford, Rupert replies, 'I can't even be seen with you. Jerry and I have a *real* relationship.' Rupert's fan fantasies, represented in fantasy sequences throughout the film, further inflate his expectations of Jerry and exaggerate the closeness of their relationship. In the first fantasy sequence, which immediately follows his conversation with Jerry in the car, Rupert imagines himself already successful, so much so that Jerry Langford begs him to take over his show. In the vision, the power disparity of the fan–star relationship has equalized, even reversed. In another sequence, he fantasizes that Jerry listens to a tape of his act and loves it. Jerry expresses both envy and hatred saying Rupert's material is good enough to steal – all sentiments that Rupert has evidently felt about Jerry.

Rupert pursues his vision by calling and then dropping by Langford's office but encounters only slick rejections from Jerry's staff, another 'speedbump' scenario. Eventually his frustration drives him to kidnap Jerry. He enlists the help of Marsha, the female fan whose fandom is manifested as

an extreme and unbalanced version of classical heterosexual attraction. It is Jerry's body that she loves and she wants the right to possess it as a lover, not inhabit it as in Rupert's fantasy. During the time she spends alone with Jerry as his captor, she attempts to attract him sexually. The film evokes a rape situation as Marsha makes advances on Jerry's bound body. Her belief in fantasy scenarios overtakes her sense of reality making her believe Jerry when he asks to be untied to make love to her. When she does, he punches her in the face – an act that replays the contradictory relations of power between fan and star in the final scene of *The Fan* when Douglas is slain after he embraces his beloved star.

Langford's escape is too late to prevent the appearance of Rupert Pupkin as guest host of 'The Jerry Langford Show.' Rupert serves time in jail for his offense, but resourcefully uses it to write a best seller and, upon his release, acquires his own show where he performs as confidently as he did in the first fantasy sequence. As he predicted, the appearance on Jerry's show functioned as a 'big break' and he is chosen for fame. In the end, the film illustrates, fandom has use value. It enables Rupert to channel his drive, ambition, resourcefulness, hard work, and imagination towards realizing his dreams.

Heartbreak Hotel

The plot of *Heartbreak Hotel* revolves around a teenage boy who kidnaps 'the King' during the Cleveland stop of his 1972 tour, driving him back to his small Ohio town to bolster the spirits of his unhappy mother, an avid Elvis fan. In the process, Elvis, as the publicity copy reads, 'comes to grip with a few hard truths about himself.'[7]

Chris Columbus, the film's (first-time) director and scriptwriter, is a professed fan of Elvis Presley and the film was marketed essentially as a piece of fan writing. *Premiere* magazine reported that the film 'began with a conversation that Columbus always wished he could have had with Elvis.'[8] In the write up which preceded the film's release, the director–writer explains his movie as a fictional enactment of his own fan-inspired guilt over Elvis's career decline, a feeling of responsibility

that plagues many fans whose adored star meets a premature demise. Columbus manifests the underlying frustration, even hostility, characteristic of fan adoration when he says, 'I felt he could have been saved. Or at least had some sense knocked into him.'[9]

The script hangs on characters and plot devices conventional to Hollywood movies, except in its integration of Elvis into the narrative line. Turning Elvis, the known star, into a character in a fictional film world constitutes enough of a departure from classical storytelling to make the film's form an issue. An introductory title sequence, designed to prepare audiences for the unusual narrative structure, calls the film 'a fable,' underscoring the liberties taken with actual people and events. *Premiere* described the odd mixture of biography and fiction with the awkward phrase 'a fictionalized movie about the King.'[10] Perhaps the only ones who did not dwell on the story configuration were fans in the audience. They would have no difficulty understanding the film's formal framework, for it reproduces the attributes of fan writing.

Fan writing takes as its point of departure the 'primary text' of the adored program or star. The fan writer maintains allegiance to the constituting elements of the favored object or subject, the loyal fan's first imperative, yet intervenes in the primary text to create new story angles, new character relationships, additional resonances and meanings. In *Heartbreak Hotel*, Elvis's life and work are treated as the primary text. A family from Ohio serves as an interventionary agent forcing Elvis in new directions.

Columbus's textual competency infuses the script with precise allusions to Elvis's career history and personal life. The film's action takes place, an intertitle announces, in 1972, a time frame carefully selected to coincide with Elvis's actual concert tour of the Midwest. The date also references the 'beginning of the end' for Elvis, a historical moment Columbus wants to rarefy as the point when a fan's intervention might have made a difference in the star's final years. As Elvis scholar Lee Cotton (1987) details, by 1972 Elvis was increasingly unhappy. His Vegas performances were wearing thin, the concert touring schedule was starting to gain its grueling momentum, and Priscilla Presley had just moved with Elvis's daughter to California thereby effecting their separation. In

1972, Elvis's body had not yet swelled to dangerous proportions although his drug use was apparently an ongoing problem, an area the movie chooses to ignore. To create the film's dramatic premise, Columbus may have used the fact that Elvis received a kidnapping threat during a concert the previous year. Certainly the fact that the star was between steady female relationships in 1972 supports the love story between Elvis and John's mother, Marie. Elvis's jewelry is another sign of the period which becomes narratively activated when John asks what the letters 'TCB' stand for and then adopts it as his own motto towards the film's end. Cotton (1987) confirms that the 'taking care of business' jewelry was commissioned by Elvis for himself and the male members of his entourage in 1971, the year before the one in which the film is set. The kidnapping is accomplished by luring Elvis from his hotel room with a Gladys Presley look-alike, a nod to the publicized intensity of his relationship with his mother. The plan is concocted by John and his high school buddies as a way to 'mess with his mind' for they are aware that Elvis is 'into Middle Eastern bullshit.' A Kahil Gibran book placed in the shot of Elvis's hotel suite provides visual evidence for audience members unfamiliar with the star's reported quests for spiritual guidance. Columbus further engages in fan gossip by casting Tuesday Weld in the role of the mother, an actress with whom Elvis made a movie and had a brief affair.

The film embellishes on the public memory of Elvis, restructuring historical events while playing out a fan's fantasy of making a difference in a star's life. David Keith, the actor who portrays Elvis, performs on stage at the film's beginning in the manner of Elvis in 1972 and, at the film's end, as he performed in 1956. The two modes of performance function not only as textual revelry, but also to privilege Elvis's early years of popularity when he was helping to pioneer a new cultural form – rock'n'roll. In fact, the script is designed as a reprimand for Elvis's later career directions. The male character, seventeen-year-old John, is the medium through which Columbus presents the questions he says he would have asked Elvis if only he'd had the chance: 'Why did you turn your back on rock 'n' roll?' 'Why did you go to Vegas?' 'Why did you start making those lousy movies?' Throughout the film, John jokes to his mother about Elvis's movies, his greasy hair, his

music, which he says are all 'songs about Hawaii.' 'And,' he adds, 'he sucks at guitar.' When Elvis awakens from his chloroformed state in Taylor, Ohio after the kidnapping, John hurls accusations in a last desperate attempt to make him stay. He accuses Elvis of 'kissing the same ass you used to kick.' When Elvis objects that he is only giving the people what they want, John shouts, 'You used to give people what they *didn't* want. In 1956, you were a rebel.' Mention of the year 1956 summons up the supposed 'golden age of Elvis' when his popularity surged despite the moral outrage of an older generation. It also expresses concern over consumerism, parallelling Janis's objections to the Beatles in *I Wanna Hold Your Hand*. John's righteous attitude is designed to speak for a new generation of rock'n'roll fans who appreciate Elvis's contribution to rock but cannot tolerate the consequences of his aging process and his generic cross-overs to religious, pop and country musics, and his heavy involvement in movie-making. John, in effect, is made to stand *for* rock, to embody rock ideology's opposition to commerciality and complacency. As both a musician and a male adolescent, he perfectly summarizes the youthfulness, rebelliousness and masculinist assumptions ideally associated with rock music.

In his preoccupation with 'the music,' John activates an arena of male fandom. Nevertheless, much of the film is given over to representing female fandom. Columbus relies on the classical paradigm of female fandom when he paints the figure of John's mother. Marie's life is motivated by the fixation with Elvis that she developed as a teenager during Elvis's heyday. Although she is a grown woman and mother of a teenaged son, the representation casts her in the category of female adolescent. Marie's fan obsession is shown to be motivated by sexual attraction and a desire for romance. She married a man who reminded her of Elvis, John's father, but who, ultimately, was unable to live up to her expectations or match the pleasure of her fantasy life. Her fandom endures despite Elvis's career and genre changes because it hinges on an amalgamated sexual/romantic textuality that remains consistent across both his rock music and his movie roles. Marie tells John 'A boy your age could learn a lot from Elvis . . . about how to treat a woman.' Against John's insistence on

musical purity and authenticity, Elvis's movie representations are held up as pulp images addressed to female spectators.

One of the film's major themes is the gulf between Elvis's extraordinary existence and ordinary life. From the opening scene, Elvis demonstrates a desire to reconnect with ordinary experience. Locked up tight with his entourage in a Cleveland hotel suite, Elvis voices an urge to walk anonymously down the street, to eat cheeseburgers in a cafe down the block. When he decides to stay in Taylor after his kidnapping, his wish for an ordinary life is temporarily fulfilled. He sits down to a 'real family dinner' and is served up Marie's finest cheeseburgers. But the film does not permit fans totally to skirt the blame for the star's pathetic problem. By creating a star, it is they who have created his prison. The longer Elvis stays in Taylor, the more his notoriety starts to close in on him. The first night John's friends and relatives take advantage of their relationship to get close to Elvis. By the end of the second act, complete strangers have begun a vigil outside the family's house and Elvis is forced to consider leaving Taylor.

Fan writing, as Jenkins (1988) points out, involves a 'translation of personal response into a social expression.'[11] *Heartbreak Hotel* walks the fine line between idiosyncratic interpretation and conformity to the cultural consensus, and is itself contradictory about Elvis's problems and their causes. The film is highly selective about which textual details and meanings are to be evoked. A dedicated fan might wonder, for instance, why Elvis does not fend off his kidnappers with karate moves. The most glaring omission is any consideration of Elvis's dependence on drugs. But then in fan writing, selective memory is utilized to uphold an idealized vision of the adored star. Fan writers exercise their prerogative by revising what has already been written in history.

In the seven films I have highlighted, 17 major fan characters and five star characters have appeared. The characterizations are richly varied, yet organized around several central representations and issues. Fandom is overwhelmingly associated with adolescence or childhood, that is, with a state of arrested development or youth-oriented nostalgia, not mature adulthood. Furthermore, the fan impulse is presented as feminine,

not masculine. The combination of adolescence and femininity in a system of representation is significant because, culturally and ideologically, adolescence tends to be defined in terms of male rather than female experience.[12] Although nine of the major fan characters in the films are male, and only eight female, a feminine sensibility structures all portrayals. The link made between immaturity and femininity operates as a strategy simultaneously to deride women and fandom, although, as a filmic system, the representation of fandom also grants women and girls a wider range of roles than is typically found in Hollywood cinema. Men's roles are constricted by the female orientation in that they must consistently be represented as sexually deficient, more dangerous and deranged than their female counterparts.

The films grant fandom a place within everyday life by creating character motivations that are appropriately grounded in subordinate social experience. At the same time, they express concern over the potential dangers of the fan–star relationship and accentuate fandom as a conflicted area of love and hate. Fame is presented as a solution to fan yearnings and most of the films feature fans achieving a level of stardom in their narrative resolutions. Fandom, the films suggest, stems from a lack of recognition, from loneliness and oppression, a condition that fame resolves. Yet stars are consistently shown as lonely and isolated individuals who have difficulty coping with their extraordinary lives. Indeed, fans and stars are portrayed as parallel personalities. The bottom line in fan movies is that stars love, yet hurt, their fans; fans love, yet hurt, their adored stars.

Author's note: appreciation to Ken Kwapis for suggesting the fan movie, *Hollywood or Bust*.

Notes

1 It is interesting to note how the fan/star theme in *Sunset Boulevard* and *Hollywood or Bust*, both Paramount Pictures films, is used to promote the Paramount studio, its corporate image and properties.
2 See Chapter 4 in this volume.
3 See Frith (1981) for a discussion of folk and rock ideologies.

4 Ironically, Theresa Saldana, who plays Grace in the film, was brutally stabbed in 1982 by a fan (as reported by Axthelm 1989).

5 I am indebted to actor Tim Reid, who coined the term 'speedbump' in reference to junior executives in the television industry whose job, he reports, is to slow access to senior executives who have the authority to develop and approve story ideas. Reid made the statement at an American Film Institute seminar in May, 1990.

6 The director of *Come Back to the Five and Dime Jimmie Dean, Jimmie Dean*, Robert Altman, co-produced and directed *The James Dean Story* for Warner Bros in 1957. He is quoted in Wakeman (1988, p. 30) saying, 'I started with the idea of taking Dean to bits, but in the end I guess we all got caught up in the mystique of the man.'

7 See Scott Immergut, 'Heartbreak Hotel,' *Premiere*, Vol. 2, no. 10, p. 66.

8 ibid.

9 ibid.

10 ibid.

11 See Jenkins (1988), p. 99.

12 See my discussion of female adolescence in *Gender Politics and MTV: Voicing the Difference* (Philadelphia, PA: Temple University Press 1990).

References

Axthelm, Pete. 1989. An Innocent Life, A Heartbreaking Death. *People* 32(5): 60–6.

Cline, Cheryl. 1986. Are Female Fans the Same as Groupies? *Bitch: The Women's Rock Newsletter with Bite* (6): 11. (reproduced in this volume)

Cotton, Lee. 1987. *The Elvis Catalog*. Garden City, New York: Dolphin Books (Doubleday).

Frith, Simon. 1981. *Sound Effects: Youth, Leisure, and the Politics of Rock'n'Roll*. New York: Pantheon Books.

Immergut, Scott. 1988. Heartbreak Hotel. *Premiere* (2) 10:66.

Jenkins Henry. 1988. *Star Trek* Rerun, Reread, Rewritten: Fan Writing As Textual Poaching. *Critical Studies in Mass Communication* 5 (2): 85–107.

Lewis, Lisa A. 1990. *Gender Politics and MTV: Voicing the Difference*. Philadelphia, PA: Temple University Press.

Wakeman, John, ed. 1988. *World Film Directors Vol. II 1945–1985*. New York: The H.W. Wilson Co.

PART III

Fans and Industry

8

Fans as Tastemakers: Viewers for Quality Television

SUE BROWER

One of the most complex elements of a program's presence in our culture has to do with what Ien Ang (1985) has called its 'social image.' We might define this term as the shared notion of a program's aesthetic worth, the class of its audience, and its positive or negative 'effects.' Ang observed that many of the 'Dallas' viewers in her study – both detractors and fans – clung to the ideology of mass culture, classifying 'Dallas' as 'bad.' As Ang suggests, we can trace such judgements back to the pronouncements of academics and other prestigious critics, but we might also consider the role fans play in circulating social and aesthetic opinions in our culture. A type of music, a star's media image, or a television series develops a following among people who both discover and create, in Dick Hebdige's terms, a 'symbolic fit' between certain expressive materials and their lives (1979, 113). By their activity in relation to the cultural form, they refine and enhance its social image while, as fans, claiming it as symbolic of their identity.

In the case of a group called Viewers for Quality Television (VQT), the process has become even more complex. As mature, middle class, well-educated women and men, members of this organization are aware of another social image – that of the fan – as foolishly obsessed, lacking education and critical distance. These devotees of prime time network television have, therefore, fashioned themselves as a rational, well-organized group engaging in aesthetic criticism

(defining and discriminating 'quality television') and social activism (advocating the continuance of 'quality television' on the three major commercial networks). But within the rational, structured, critical style of the organization lie the underpinnings of fan behavior.

The group represents two seemingly contradictory impulses. Despite their avoidance of the term, VQT members are fans of specific series, writer-producers, and stars. Yet, the mission they articulate, of 'making a difference' in television, is outwardly directed, almost evangelical. In this way, VQT may be said to assume a role that Russell Lynes, in the midst of the mass-culture debate, called 'tastemakers' – groups that historically have attempted to promote and deploy their taste in art, architecture and fashion throughout society (1954). In their efforts not only to celebrate but perpetuate the type of programming they enjoy, Viewers for Quality Television has become caught by the very nature of its fandom between desire and duty, pleasure and obligation.

'Quality television'[1]

The story of Viewers for Quality Television is intertwined with the history of 'quality television' as an alternative to the 'vast wasteland' image of US television dating back to the 1960s. Network television's enduring image as mass culture inevitably has implied a low class and uneducated audience. This set of assumptions was given greater commercial significance in the industry when, in 1970, the A.C. Nielsen Company was able to offer advertisers refined demographic categories. Consequently networks and producers were motivated to 'target' programming, not to the greatest mass of viewers, but specifically to younger, affluent viewers most likely to buy the advertisers' wares (Brown 1971; Kerr 1984).

As Paul Kerr (1984) explains, the new attention to demographics corresponded with cultural changes that materially affected the prime (and prime-time) target audience. Women viewers 'covered' by daytime programming and advertising began to work outside the home in increasing numbers, earning disposable income and watching TV at night. These

cultural changes, he suggests, along with changes in the industry (such as new FCC regulations that called for program production outside the networks) brought about a rapid shift in prime-time programming. In some cases, the result was television produced for specific types of (upscale) viewers by independent producers who sought a relationship with viewers distinct from the one historically forged between networks and their audiences. 'MASH,' the socially conscious sitcoms of Norman Lear and 'The Mary Tyler Moore Show' were among the shows that came to be known as the 1970s 'renaissance' in American television.

Feuer (1984) observes that the MTM production company was one of the first program suppliers (Lear being the other) to cultivate a *house style* and a coherent *image*. The MTM shows that were spun off from the 'Mary Tyler Moore Show' and, later, from the various branches of MTM's 'family' of writers and producers shared a number of characteristics with high art connotations: emphases on character development, structural complexity, reflexivity, aesthetic innovation (Feuer 1984, 32–60). In retrospect we might add to this list of quality attributes: creation by writer-producer 'auteurs' (most notably 'Hill Street Blues' creator Steven Bochco); mildly liberal anti-establishment politics; excellence as defined by Emmy awards and critical praise; and, as Thomas Schatz (1987) has observed, 'feminine' narrative elements.[2]

As early as the mid-1970s the term 'quality' began to pass from the trades to public discourse and assume complex dimensions involving artistic excellence, sophisticated subject matter and commercial effectivity with an educated, affluent audience. In the spring of 1977, the cast and producers of 'The Mary Tyler Moore Show' voluntarily ended the series, and out of the beloved half-hour comedy came 'Lou Grant,' an hour-long drama that transformed the newsroom premise of the comedy into a dramatic vehicle to explore controversial issues (see Schudson 1987). It was an Emmy winner from its debut, racking up five major awards in its third season alone. Although, as Schatz (1987, 89) has observed, 'Lou Grant' was not a 'genuine hit series' on the basis of ratings, it was one of the first series to win renewal largely because of the *quality* of its viewers.

165

SUE BROWER

The following, 1981–82, season was a significant one for 'quality television' and the popularization of the concept. In 1981, Grant Tinker, head of MTM, became chief executive of the third-ranked NBC. Within a year, the artistic reputation of MTM as a 'writers' shop' began to rub off and NBC came to be known as 'the producers' network' (Christensen and Stauth 1984, 48). MTM's 'Hill Street Blues' which premiered in January 1981, was slowly building a reputation among critics and viewers for narrative innovation and gritty realism. By 1983 'Hill Street,' with its initially low ratings, its record number of Emmy nominations (21) and awards (8) in one year, and its young, affluent audience, symbolized the concept of 'quality television' in the popular press: *quality* was the stepchild of commercial television, the brave rebel against mediocrity, a moral force in a money-hungry industry. Its 'effect' was considered to be the stimulation of viewers; it forced those, 'who use television as a narcotic,' in Bochco's words (1983), to watch in a new way. 'Quality television' was promoted as a social and aesthetic alternative to standard television – a 'cause célèbre' (Jenkins 1984, 197).

This image was further supported by publicity concerning individuals forced out of their 'quality television' jobs by network decision-makers. Bochco's well-publicized conflicts with NBC, and ultimately MTM, may have been seen by 'Hill Street' fans as *proof* of the program's genuine departure from standard television. Similarly, 'Lou Grant' star Ed Asner's trouble with CBS over his political activity ended in what some felt was a premature cancellation of the series in 1982 (see Gitlin 1985). An undercurrent of personal commitment and jeopardy thus traversed quality fictions and backstage publicity. 'Hill Street' had been publicly threatened with cancellation at the end of its first season, but between its showing in the Emmys and the NBC Tinker policy of letting audiences for quality shows build, the innovative cop show managed to stay alive until it caught on with upscale viewers. The creators of 'St Elsewhere' (debuting in 1982) reflexively incorporated the show's precarious ratings position and seemingly imminent cancellation in its spring cliffhangers: each year, before NBC announced renewals and cancellations, St Elegius hospital faced yet another crisis in staffing or funding.

166

In 1982 another cop show – this time featuring two women as its heroes – slipped into the nine–ten o'clock Monday night 'quality' slot on CBS vacated by 'Lou Grant'. 'Cagney & Lacey,' like 'Lou Grant,' presented itself as a serious, issue-oriented program. And like the new breed of MTM dramas, its early publicity juxtaposed critical praise with stories of the network's threats of cancellation. Indeed, as Julie D'Acci (1987) recounts, CBS renewed 'Cagney & Lacey' only after the Cagney character, then played by Meg Foster, was recast with the 'more feminine' Sharon Gless (see also Gitlin 1985). Traces of the negotiations between the network and executive producer, Barney Rosenzweig, appeared in *TV Guide*, followed in later issues by a volley of letters from outraged fans. Their display of support for the show was part of a growing number of viewers' campaigns in defense of 'quality television.'

The 'Quality Audience': Fans and Tastemakers

The sort of fan letters that appeared in *TV Guide* for 'Cagney & Lacey' assumed two purposes. The letters were tributes *to* the object of affection, but, circulated in the media, they also joined the popular and critical discourse *about* a program and its stars. The letters opened up the networks' privileged discourse about television by appearing in a venue usually reserved for industry-produced publicity. Moreover, the letters attempted to influence other viewers' opinions as well as the network's decision regarding the program's fate. By engaging in such a practice, fans asserted their authority as viewers and began to assume the role of tastemaker.

The first instance of fans organizing in defense of a television program may have been for 'Star Trek,' a show well outside the 'quality' social image. In 1967, and again in the 1967–68 season, 'Star Trek' fans wrote NBC to protest the program's threatened cancellation. Organizer Bjo Trimble (1983) claims fans eventually produced over a million letters for their cause, which ended in the show being renewed for a third season. In 1981, when the new 'Hill Street' was rumored to be threatened with cancellation, Buffy Johnson, a California mother and property manager, organized a letter-writing campaign by contacting

police agencies across the country and urging them to form local chapters of 'Viewers for the Support of "Hill Street Blues".' In this case, Johnson's strategies not only involved appeals to the network, but she also pleaded with potential sponsors to support the show, and contacted television journalists and critics, urging them to watch the program and cover it in their columns. The 'Hill Street' campaign thus marked a shift from sole reliance on numbers of viewers to critical judgements of 'quality.' A year later, however, after 'Hill Street' had become a prestigious success, Johnson was still receiving 100 pieces of mail a day in support of the program (Schweich 1982). A similar campaign was organized the following year by Donna Deen in Plano, Texas, in support of the low-rated, critically acclaimed 'St Elsewhere.'

As all three of these cases suggest, because of the unique form of television series and serials, fans not only 'follow' a program, but they are invested in its *continuance*. The letter-writing campaigns began to popularize a set of practices whereby fans attempted to override the power of the Nielsen ratings and assure this continuance by other means. Although soap opera fans have frequently written to the creators of their favorite soap about a character's development or a plotline, this was a different order of involvement. Fans were challenging the very structure of the industry and the 'prevailing taste' the networks claim is revealed by the ratings. These fans argued instead that their programs *should* be continued because of a 'quality' that admittedly only a minority seemed to prefer.

In the case of 'Cagney & Lacey,' producer Barney Rosenzweig had encouraged such involvement from the beginning. When CBS aired the pilot TV movie in October 1981, it earned a cover story in *Ms.* magazine (Rosen 1981). The article's theme – the struggle of Rosenzweig and writers, Barbara Corday and Barbara Avedon, to produce a 'women's buddy movie' in the face of industry sexism – followed the now-familiar 'quality' backstage story of network–producer conflict and was to become standard publicity for the show. The article was coupled with an invitation to viewers and readers wanting the movie to become a series to write to Filmways, who had backed the project. In essence, the publicity for the TV movie attempted to characterize 'Cagney & Lacey' as something apart from the

usual network fare, asking (potential) fans to get involved with it for social and political reasons. These practices surfaced again in 1982 when, as we have seen, the new series was in danger of cancellation and the industry–fan exchange over Meg Foster's 'feminity' appeared in *TV Guide*.

According to Julie D'Acci, viewers wrote not only to *TV Guide*, but to CBS and to the show, protesting the cast change, arguing, 'I enjoyed seeing a tough female,' and, 'With Cagney and Lacey, Meg and Tyne [Daly], we at least have a programme that shows two women doing a hard job, but we also see an honest and warm friendship.' Some viewers wrote to protest the industry's failed courage in representing women beyond their stereotypes: 'I read in last week's *TV Guide* something about replacing Meg Foster for such reason as she is too threatening? . . . I get the feeling there's a card game at the Hillcrest Country Club called "let's go with the path of least resistance when it comes to women on TV"' (all quotes in D'Acci 1987, 214). For these fans, 'Cagney & Lacey' had become an example of the incompatibility between the networks and 'quality television.'

The show began to rebuild its following after the cast change, but it faced cancellation again in the spring of 1983 – this time an apparently non-negotiable network decision. In Fairfax, Virginia, a substitute school teacher in her forties had become a fan of the show: 'I just thought, "This is like watching me and my friends. This is how I had always known friendship to be." And I had never seen it portrayed on television before quite so honestly and directly. And I thought this was good' (Swanson 1987). When Dorothy Swanson learned 'Cagney & Lacey' had been cancelled, however, she also became a tastemaker. She placed a call to Barney Rosenzweig in Los Angeles asking what she could do. 'He started all this activism stuff. He didn't invent it, he just showed us how and who to write to, and he's the one who said, "Write to the network executives, but if they don't read their mail, write to your newspapers, too. Write to the *New York Times*, the *L.A. Times*, the *Wall Street Journal*. Write to your television critic." He really was the start of this. He wanted to save his show, and it was worth saving' (Swanson 1987).

Rosenzweig didn't invent the letter-writing campaign, and indeed seems to have been inspired by earlier fan-organized campaigns. Rather, this producer's strategies converged with

those of Swanson and other fans to create grass-roots support that in turn generated publicity both for the program and for Dorothy Swanson as an organizer of viewers. Although Swanson guesses she initially generated 500 letters, the campaign is estimated eventually to have drawn 10,000 letters in support of 'Cagney & Lacey' (Ryan 1988, 10).

The practices of 'Cagney & Lacey' fans became the lynchpin in the ongoing 'non-Hollywood,' 'grass-roots,' 'quality' promotion for the show, while encouraging a new avenue of involvement for the fans themselves (Brower 1989; 1990). The story of viewer support for the program became an integral part of the series' publicity and even production practices (D'Acci 1987). Rosenzweig further nurtured his relationship with the audience through various public relations strategies, including a newsletter, mailed to everyone who wrote to the show or its stars. Each issue offered hints of upcoming plotlines and lavished praise on those who continued to support the program through what became somewhat ritualized cancellations in subsequent seasons.

Rosenzweig further supported fans' involvement and the social image they conferred on his show by promoting these fans as more than (*better* than) fans: 'These [letters] were not the traditional fan letters written in Crayola by people saying, "I kiss my pillow every night thinking of you." They were affluent, well-educated people. There were petitions from working women and college students' (quoted in Turner 1983, 57). Building on the quality demographics rationale that stood 'Hill Street' in good stead, the fan–industry discourse surrounding 'Cagney & Lacey' furthered the MTM 'quality critique' of network television. Indeed, the series' precarious position with the network, these practices suggested, was *due* to its quality. Swanson began rallying viewers not only to save 'Cagney & Lacey,' but to 'make a difference' in television.

Criticism by Consensus

In 1985, as rumors of 'Cagney & Lacey's' cancellation again circulated, Dorothy Swanson combined forces with Donna Deen, who two years earlier had organized the campaign

to rescue 'St Elsewhere', and founded Viewers for Quality Television. Appropriating Rosenzweig's newsletter idea the VQT newsletter[3] alerted viewers to possible cancellations and published TV industry names and addresses in each issue. But Swanson and Deen also initiated an ongoing process focused on defining 'quality television' and establishing a canon of endorsed programs that would receive the organization's full letter-writing support should these programs be threatened. Swanson frequently publishes some version of her definition of 'quality': 'A quality show is something we anticipate before and savour after. It focuses more on relationships than on situations; it explores character, it enlightens, challenges, involves and confronts the viewer; it provokes thought and is remembered tomorrow. A quality show colors life in shades of grey' (*VQT*, August 1987). In what would become a bi-monthly publication, VQT rationalized its brand of fandom as a democratic form of criticism and social activism.

Each issue of the newsletter includes a survey instrument of some sort, rotating demographic surveys, assessments of the current programs, and annual ballots for VQT's awards. The resulting list of endorsed programs, updated annually, becomes the mandate for the group's campaigns, which are waged not only through the mail, but in the media. A basic premise of the organization has always been that the Nielsen ratings are inadequate measures of the television audience.[4] Swanson has said she doesn't 'buy the theory that 1,700 people accurately represent . . . the millions of us that watch. I also know that *why* people watch a show has never been measured' (1987).

While the group continues to be led by Swanson, now in a paid position as director of VQT and editor of the newsletter, many of the group's practices are rigorously democratic, tapping into more traditional fan practices. VQT's continual polling of members has evolved into a complex system of defining and updating the criteria for 'quality,' and evaluating programs by those shared criteria to generate a list of 'endorsed' and 'tentatively endorsed' programs. The concept of quality is therefore repeatedly negotiated in members' ballots for quality programs and in their accompanying comments, many of which are then published in a 'Members Forum' or 'Soapbox' in

subsequent issues. Definitions and examples of quality are further solicited in the newsletter's interviews with creators and stars of the organization's endorsed programs, completing a homologous circuit that reaches from producers to consumers of the shared 'product' and back again – significantly tending to leave the networks out in the cold. Unlike most TV-related special interest groups, who also attempt to influence industry practices, the concern of VQT is less with specific content or subject matter, such as violence or images of minorities, but rather with linking a taken-for-granted set of 'enlightened' middle-class, liberal, feminist values with a repeatedly examined set of aesthetic concerns – writing, acting, 'realism,' and authorship. Although many members classify television in accordance with the mass culture ideology, they discuss their favorite programs as art. As Swanson put it, 'We're not pretending "Cagney & Lacey" is like reading James Joyce – after all, it's television. But why can't it be good?' (quoted in Ryan 1988, 10).

VQT has conducted four full campaigns since their efforts on behalf of 'Cagney & Lacey' and 'St Elsewhere.' In 1987, the producers of 'Designing Women,' Harry Thomason and Linda Bloodworth-Thomason, asked VQT for support of their endangered sitcom. The debate over whether the program was 'quality,' and therefore worthy of support, resulted in co-founder Donna Deen's resignation. The campaign went forward and CBS received some 5,000 letters generated by VQT members. The attendant publicity focused on a grass roots organization taking on a television network. 'Designing Women' not only was granted a reprieve, but was returned to a slot in CBS's Monday night line-up which also included 'Kate & Allie,' 'Newhart' and 'Cagney & Lacey' – all VQT-endorsed programs. Less successful campaigns have been mounted for 'Frank's Place,' 'A Year in the Life,' and ABC's historical news magazine, 'Our World,' a campaign which alone generated 20,000 letters to the network (Davis 1987).

It is in this context that the members negotiate both the definition of quality and the endorsement of specific programs. In a 1987 'Soapbox,' for example, members' comments agreed in their critique of 'L.A. Law,' and implicitly in their definition of quality:

My favorite show of the '86–'87 season has become plagued with mediocre writing and repetitiveness. Instead of giving us richly drawn characters who act and interact realistically . . . [a]bsolutely none of the characters have been truly developed beyond the initial pilot and first three episodes (Jimmy Bradshaw).

I was prepared to like anything Steven Bochco was associated with . . . but this is just too poor to pardon. . . . 'L.A. Law' is indeed a hot show: all heat, and save for secretary Roz, no warmth. I hope VQT and its members will withdraw their endorsement of this fluff. I expect better from NBC and Bochco (John H. Marshall).

I enjoy 'L.A. Law,' but frankly I feel our members acted too quickly in endorsing this series. The characters are still evolving and storylines are somewhat inconsistent (Kathleen Vachon, *VQT*, June 1987).

Although Swanson and assistant editor Pat Murphy maintain they publish comments to reflect the volume of mail and range of opinions, such 'consensus' is always mediated, and to some extent orchestrated, as are critical debates, which juxtapose sharply differing comments.

But discussion of a program, even a specific episode, may stretch over several issues of the newsletter, allowing members to reply to one another in real, however mediated, dialogue. Thus a round of negative comments on 'Murder, She Wrote,' which pointed to the program's failure to exhibit the 'quality' characteristics established by the organization, was answered in the next 'Soapbox' with one letter of support and one heated letter of rebuttal to the critics in the previous issue: 'Obviously they are not and never have been readers of the proverbial detective story. The whole premise of this show is to get the viewers involved into trying to solve the murder. It is a sort of televised detective story and as far as Jessica being one-dimensional – were she to be 2-or 3-dimensional, that would take away from the main story' (Julia McKinney, *VQT*, August 1987). In this case, the viewer implies the program is 'quality' because it operates within the tradition of a genre – albeit

a genre with its own mass-culture image. Although use of generic formula is not a characteristic usually embraced by VQT members, here the claim invokes the organization's celebration of 'literary' practices. In discussing their favorite programs, then, VQT members manipulate the quality label and its definitions to justify their loyalties. In this way, even with the stabilizing and standardizing influence of Swanson and staff, the definition of 'quality' and of Viewers for Quality Television continues to change, and the 'quality' discourse operates in the service of the members' fandom.

Members' comments freely move between emotional, often autobiographical statements of response, and aesthetic or ideological criticism: 'Having served as an evac-medic in Vietnam, ['Tour of Duty'] has helped me deal with my feelings about that war. . . . To lose this program would definitely retard the recovery process of many Vets. In my opinion, this is a well made, well scripted show. . . . How else, if not through programming of this nature, can the American public relate to that war? '(Rick Allen, April/May 1988)

Comments gleaned from ballots, like the one above, foreground individual differences in members' criteria and in their motivations for participating in VQT, but the votes themselves, which construct the list of endorsed programs, affirm the *mission* that the members share.

The strategy of these campaigns never resides in sheet numbers. Rather, the newsletter, which reveals Swanson's growing sophistication in the workings of commercial television, has become an ongoing, contradictory primer and critique of the television industry's equally contradictory concern for big numbers and quality demographics. Interviews with industry people, including Thomason, Linda Ellerbee and *USA Today* critic Matt Roush, lament and explain the commercial exigencies of network television. Swanson and contributing members interpret this information in terms of the *industry's* quality rationale – television's persistent social image as mass culture and the fact that 'quality' programming historically has appealed to a group that is often smaller, but especially attractive to advertisers.

Accordingly, the annual demographic surveys that ask age, sex, income, and hours of network TV watched per week are

used to substantiate the organization's claim that they represent the quality viewers networks seek. Later surveys have even begun to look for patterns of consumption among members. As VQT membership has grown to over 5,000, there has been some fluctuation in the group's composition, but overall it has become more female, more upscale. By 1988, 80 per cent of the respondents were female, 58 per cent between ages 26 and 49, with 44 per cent earning $25–50,000 annually, and 27 per cent earning $50–100,000. These statistics and the results of the program surveys are juxtaposed in the newsletter next to the semi-regular feature, 'Ratings, Rankings and Shares,' which reports how the organization's endorsed and tentatively endorsed programs are faring in the Nielsens. The numbers often are accompanied by analyses which reiterate the organization's conviction that Nielsen ratings are inadequate bases for network decisions.

But VQT's demographics primarily are employed in the newsletter and in Swanson's contact with the media to argue that Viewers for Quality Television are also quality viewers for television, with all the cultural and commercial connotations the term has acquired. The strategy, borrowed from 'Cagney & Lacey's' Rosenzweig, is to call the networks' bluff publicly on the claim that they hope to attract a certain type of viewer. If the networks are looking for quality demographics, Swanson's argument goes, VQT has documented the program preferences of a group of viewers that clearly fall into the quality category, and their preferences should be given added weight.

Thus, while several special interest groups, according to Kathryn Montgomery (1986), have been 'institutionalized' by the TV industry's act of inviting moderate representatives to become consultants to the networks, VQT has institutionalized itself, independent of the networks. VQT uses only positive gestures such as letters of praise, ceremonial awards, and 'seals of quality' rather than boycotts or negative campaigns. Projecting an eminently rational, moderate, *nice* image, it has appropriated network practices and philosophy, in key instances reworking them to persuade the network powers that be (never opposing or undermining them) in attempts to accomplish VQT's social and aesthetic goals. The group's policies were further articulated in a press release issued amidst

the 1989 flap concerning the Fox network's 'Married . . . With Children.' VQT's 'official' statement (no doubt written by Swanson and Murphy and published in the newsletter after its release to the media) condemned another organization's negative letter-writing campaign to the show's sponsors as 'a form of censorship which VQT finds abhorrent and outrageous.' The statement continued, 'Television can and should present a broad spectrum of programming, from quality to mediocre. Over 11 million people each week enjoy 'Married . . . With Children.' While this is not a show that VQT endorses for its quality content, neither is it a show that should be targeted as offensive by a sole arbiter of morality' (*VQT*, April/May 1989).

Both VQT's institutional structure, and its moderate 'something for everybody' philosophy of broadcasting suggests that the organization increasingly replicates the networks it attempts to challenge. Moreover, this 'democratic' organization seeks to create a position of privilege – *clout* – in relation to the networks, based on its status as an elite minority, an association of tastemakers. As Swanson has written in one of her editorials, 'Perhaps the role of VQT for now will be that of conscience to the networks. . . . VQT will continue to let the networks know that there is a large force of concerned, disenfranchised viewers who will write and act and respond and insist on being heard' (August/September 1988). Acknowledging the need for all types of programming, VQT nevertheless identifies itself as distinct from the viewing 'masses' while attempting to ensure the continuance of its more exclusive favorites in the mass media by (diplomatically) imposing their taste.

Russell Lynes' conception of the tastemaker is that of a 'cultural do-gooder,' promoting spiritual, aesthetic, and at times entrepreneurial concerns with more than a dash of smugness. Swanson has said of her own constituency, 'I'm trying to educate these people to recognize quality programming – to find it and enjoy it' (1987). Externally, the organization has assumed a tastemaker role by adopting, publicizing and promoting its agreed-upon critical judgements. The very processes of internal negotiation and outwardly-directed campaigning seek to establish consensus beyond the boundaries of the organization – promoting quality television itself as a desirable, preferable form.

Nevertheless, Swanson argues against charges of elitism, claiming demographic diversity among the membership and, more convincingly, exhibiting the diversity of opinions by printing members' comments. Some members seem concerned over this diversity. In a question and answer feature, one member fretted that the growing numbers in VQT might change the character, taste and direction of the organization, resulting in VQT's supporting the 'mediocre' programs that draw millions of viewers, to which Swanson replied, 'Our theory is that viewers of mediocre programs would not sustain an interest in VQT. VQT is not a passive organization. You must *participate* in this newsletter, just as you must 'participate' as a quality program viewer. VQT is not for everyone' (June/July 1988).

Dodging requests by some members to establish a 'most entertaining' category by pleading a shortage of resources more than philosophical differences, Swanson and assistant editor Murphy nevertheless remind members that there are potentially as many places on the endorsed list as there are programs in the networks' schedule – they need only earn endorsement by the members. But, as we have already seen, in the negotiations of 'quality,' there is an ongoing attempt by some members to reconcile 'quality' and *pleasure*. Indeed, as the organization becomes more institutionalized, the disparity between members' 'official' stance and personal preferences has become apparent, co-founder Deen's resignation being only the first, if most dramatic, sign of conflict. In past years, programs on VQT's 'quality' list, such as 'A Year in the Life' and 'The Disney Movie' have made their way on to the group's 'most watched' list which included 'Dallas' and 'Moonlighting.' As Lynes observed, 'Taste . . . is often sold on the grounds that it is good for you, rather than on the grounds that you will enjoy it.' In the case of VQT, at some level the conflict between taste and pleasure persists.

Passion, Pleasure, and Guilt

Although Lynes argued that 'taste merely becomes a substitute for understanding and pleasure' (1954, 39), it would seem that in the case of VQT, the interplay of taste and

pleasure is more complex. Many of the members' endorsements are both heartfelt responses and critical evaluations. Moreover, to clarify the criteria for letter-writing campaigns, Swanson and Murphy have added that 'the show must have passionate viewer support.' It is this passion that suggests the members of VQT are as much *fans* as they are 'cultural do-gooders.'

Lines of memorable dialogue from the endorsed shows (often submitted by members) appear in the newsletter, set in large type, framed almost as aphorisms. VQT members know specific episodes by title; they are familiar not only with the names of their programs' stars and producers, but with those of the writers and directors of individual episodes. The canon of endorsed programs serves as a core of shared texts to which viewers refer almost in shorthand, assuming knowledge and appreciation among other members. Thus the date-rape episode of 'Cagney & Lacey' was never described; rather, members supported their rave reviews of the episode with their emotional responses.

The pleasure VQT's members experience is most apparent at the organization's annual convention. Although originally an informal affair in Washington, DC, near Swanson's home – so small that attendees brought cakes and cookies for refreshments – the convention is now held in Los Angeles, usually one or two weeks after the Emmy Awards. Members attending this rather upscale affair visit the set of at least one endorsed program, rub elbows with the stars and creators of the favorite programs receiving VQT's awards in categories that parallel the major Emmys, and bask in celebrities' praise and affirmation of VQT. Even this opportunity for classic star-struck fan behavior is framed by 'serious' and even 'educational' events and speeches. Highlights from these speeches, like favorite lines from the quality shows, appear as memorable quotes in the newsletter. Accoutrements of fandom are sold in each newsletter as well. The organization now offers a line of 'commemorative products' – a series of T-shirts and mugs printed with the slogan, 'You Made a Difference' or 'Together We Make a Difference' and the signatures of the stars of programs saved and celebrated by the organization. Recent products also bear the programs' logos.

As the newsletter has evolved, Swanson and Murphy have encouraged 'tributes' to quality shows that have met the network ax or have self-destructed. Members have responded with favorite scenes, favorite lines, and special moments from beloved programs, including 'Hill Street Blues,' 'St Elsewhere,' and the short-lived 'Frank's Place.' Upon the (final) cancellation of 'Cagney & Lacey,' the outpouring from grieving members spilled over three issues, with several of the tributes appearing as open letters to the program's two stars, thanking them for their work and for the stories they told. In the discourse of many VQT members, then, tastemaker and fan impulses merge; the concept of 'quality' blurs with the 'specialness' the programs have for them, which also becomes symbolic of their own identity as 'special,' 'quality' viewers, committed to defending their programs.

The rational, democratic structure and published negotiations over programs and VQT criteria become occasions, at times pretexts, for viewers to share personal feelings about favorite shows. This is particularly true of programs that members concede – even *confess* – do not fulfill the requirements for quality, but which they are compelled to share with members nonetheless. Pat Murphy's evaluation of 'Beauty and the Beast' as 'almost quality' opened a floodgate of members' responses, some of which were published in the next newsletter. Here some of the basic tenets of 'quality' were set aside for a program which certain members, nevertheless, identified as special – about which they felt passionately. Although a few published comments complained of violence, several members argued that the program *was* quality, acknowledging its departure from the 'gritty realism' and confrontational nature of most VQT-endorsed programs, but proclaiming, as evidence of quality, the program's music, poetry and visual beauty. Others offered thematic readings of the series that brought it in line with other endorsed programs:

It's a fantasy, heavily laden with sentiment, unrequited love and at the same time has many elements of an action-adventure. Vincent is a gentle but grotesque beast ... a man who knows he'll never live in the mainstream, despite the fact that he's intellectually and culturally

179

superior to most people. He understands the plight of the outcast and the underdog. (Karen Hurst)

a glimpse of another world, a world where peace, love and acceptance are the rule, not a longed-for headline. It is a combination of the oldest and the newest concepts in Utopianism. (Liz Ostman)

a modern day classic that speaks of personal commitment to one another. . . . It speaks of deep trust and the willingness to become involved with others. . . . We need this modern tale of beauty. (Cynthia Turner, February 1988)

'Beauty and the Beast' eventually won endorsement from VQT.
Members whose non-endorsed favorites have less highbrow social images have begun to confess to the 'guilty pleasures' of loving and never missing a program that fails to meet VQT's quality guidelines. Some of these appear in the newsletter merely as one-liners without apology; others do apologize, but, as with 'Beauty and the Beast,' use their 'confessions' to justify their favorites in quality terms, occasionally in an attempt to muster grassroots support outside the official VQT structure for endangered programs such as 'Starman.' In these ways, members have not sacrificed pleasure to the dictates of taste, but have incorporated the two.

Making a Difference

John Fiske (1989) has suggested, 'fandom is characterized by two main activities: discrimination and productivity.' He argues that fans engage in textual discriminations of what or who is 'worthy' of their fandom: 'These textual discriminations are often homologous of social discrimination. Choosing texts is choosing social allegiances. . . . The links between social allegiance and cultural taste are active and explicit in fandom, and the discrimination involved follows criteria of social relevance rather than of aesthetic quality' (147). Moreover, Fiske observes, fans produce their own texts. From

casual soap opera gossip to fan-produced video and audio tapes, the fan-produced text 'reinterprets, re-presents, reproduces.'

In Fiske's conception, however, fandom is linked with subordinate positions in society, a conception that is problematized by the largely female but also upscale, professional membership of VQT. Clearly, in its conferral of the complex and shifting 'quality' stamp on select programs, VQT does practice textual discrimination along social and cultural lines, and members do produce readings and critical commentary. But aesthetic quality is also central to the interests of the organization; members typically invest social relevance with the aesthetic. Viewers for Quality Television are fans – of a specific constellation of stars, fictions, and industry practices adopted and read by members as representing the cultural category *and the mission* of 'quality television.' VQT's form of fandom is the enactment of that mission.

Even after 'Cagney & Lacey's' cancellation in 1988, the VQT newsletter and its surrounding publicity associated the group's activities with the heroism of the program's marginalized protagonists and their 'embattled' creators (Brower 1990). The pattern recurs among VQT's other endorsed programs – many of which are stories read by members as possessing heroes outside the mainstream, produced by creators with the courage to resist the pull of mediocrity – 'underdogs' of social and cultural superiority. These stories gain resonance in the practices of VQT: 'quality television' is at once a shared collection of stories, a revered cultural form, and an ongoing metanarrative about the system of commercial television into which VQT members may insert themselves as agents, even heroes who also take unpopular stands in the effort to 'make a difference.' Here, educated, upper-middle-class fandom is articulated in intellectual and 'pro-social' terms. Fandom, for them, *is* tastemaking.

Like other fan organizations recognized by the media industries, VQT has become a promotional tool – both a means of 'selling' taste and of 'selling' a specific program. While the letter-writing campaigns, the annual conventions and the commemorative products have given the organization and its critical views wider circulation, and the evolving prestige

image has made membership attractive, these activities also benefit the favored programs, as both Barney Rosenzweig and Dorothy Swanson understood from the beginning. Even as the networks have begun to discount the campaigns as 'orchestrated' – forcing Swanson to advise members against identifying themselves with VQT in their letters – the networks benefit by the organization's continued focus on network television as the primary venue for quality television. Yet passion, rather than promotion, is the underlying concern of the organization. VQT members are as much fans as tastemakers.

Viewers for Quality Television is a nexus of contradictions and crossed purposes. In challenging the institutions of commercial television it also imitates them; it applies certain high art criteria to popular forms; and although its program evaluations are democratic within the group, its constituency is far from representative of TV viewership, and its communications are mediated by a self-appointed, self-interested staff. Indeed, the conflict between fan and tastemaker impulses has created a tension that has forced some members to leave the organization. The growth, stability and continuity of Viewers for Quality Television, however, suggests that the very contradiction between fan and tastemaker articulates the position of many upper-middle-class fans of TV. Still espousing the mass-culture ideology, these viewers have both appropriated and contributed to the 'quality' discourse in order to permit themselves the pleasure of fandom.

Notes

1 A lengthier discussion of the image of quality television appears in my dissertation (Brower 1990).
2 Schatz notes that 'Lou Grant' marked a shift not only from comedy to drama, but a move from a female to male world view (1987, 92).
3 *VQT*, Inc. is a bimonthly newsletter edited by Dorothy Swanson for Viewers for Quality Television. The address is P.O. Box 195, Fairfax Station, Virgina 22039.
4 This also echoes Rosenzweig's argument.

References

Ang, Ien. 1985. *Watching Dallas: Soap Opera and the Melodramatic Imagination*, trans. Della Couling. London: Methuen.

Bochco, Steven. 1983. Too Many People Use TV 'as a tranquilizing presence': A Conversation with Steven Bochco. *US News and World Report* 94(24): 68.

Brower, Sue. 1990. *The Poetics of Marketing: Promotion and the Fictional Processes of Television*. Dissertation. University of Texas at Austin.

———.1989. TV Trash and Treasure: Marketing 'Dallas' and 'Cagney & Lacey.' *Wide Angle*, 11(1): 18–31.

Brown, Les. 1971. *Televi$ion: The Business Behind the Box*. New York: Harcourt Brace Jovanovich.

Christensen, Mark, and Cameron Stauth. 1984. *The Sweeps: Behind the Scenes in Network TV*. New York: William Morrow.

D'Acci, Julie. 1987. The Case of 'Cagney & Lacey.' In *Boxed In: Women and Television*, eds Helen Baehr and Gillian Dyer. New York: Pandora.

Davis, Bob. 1987. 'This TV Fan Wages Campaigns to Rescue Her Favorite Shows. In *The Wall Street Journal*, August 4.

Feuer, Jane. 1984. The MTM Style. In *MTM 'Quality Television,'*. eds Jane Feuer, Paul Kerr, and Tise Vahimagi. London: BFI.

Fiske, John. 1989. *Understanding Popular Culture*. Boston: Unwin Hyman.

Gitlin, Todd. 1985. *Inside Prime Time*. New York: Pantheon.

Hebdige, Dick. 1979. *Subculture: The Meaning of Style*. New York and London: Methuen.

Jenkins, Henry, III. 1988. *Star Trek* Rerun, Reread, Rewritten: Fan Writing as Textual Poaching. In *Critical Studies in Mass Communication* 5(2): 85–107.

Jenkins, Steve. 1984. 'Hill Street Blues.' In *MTM 'Quality Television.'*

Kerr, Paul. 1984. The Making of (The) MTM (Show). In *MTM 'Quality Television.'*

Lynes, Russell. 1954. *The Tastemakers*. New York: Grosset & Dunlap.

Montgomery, Kathryn. 1986. The Political Struggle for Prime Time. In *Media Audience, and Social Structure*, eds Sandra J. Ball-Rokeach and Muriel G. Cantor, Newbury Park: Sage.

Rosen, Marjorie. 1981. 'Cagney and Lacey': Can Women Be Buddies – Under Pressure? And Have Laughs and Adventures Besides? *Ms.*, October.

Ryan, Michael. 1988. The Housewife the Networks Can't Ignore. *Parade*, April 17.

Schatz, Thomas. 1987. *St. Elsewhere* and the Evolution of the Ensemble Series. In *Television: The Critical View*, 4th edn, ed. Horace Newcomb (ed.), New York: Oxford.

Schweich, Cindy. 1982. The Woman Who Fought for 'Hill Street Blues.' *McCall's* 109 (10):52.

Schudson, Michael. 1987. The Politics of *Lou Grant*. In *Television: The Critical View*, 4th ed.

Swanson, Dorothy. 1987. Telephone interview.

Trimble, Bjo. 1983. *On the Good Ship Enterprise: My 15 Years with Star Trek*. Norfolk, VA: Donning.

Turner, R. 1983. The Curious Case of the Lady Cop and the Shots that Blew Them Away. *TV Guide*, October 8.

Television Executives
Speak about Fan Letters
to the Networks

ROBERT SABAL

The following transcript was provided by Robert Sabal, a participant in the first annual Faculty Seminar sponsored by the Academy of Television Arts and Sciences in November, 1988. The questions, asked by university faculty participants, were addressed to three television industry representatives: Perry Simon, Senior Vice President for Series Programming for NBC Entertainment; Lance Evans, Director of Dramas Based on Fact for CBS Program Practices Division; and Chad Hoffman, Vice President of Dramatic Series Development for ABC Entertainment.

Question: How do you use audience feedback? There was a great deal of letter writing about 'Cagney & Lacey' and 'Hill Street Blues.'
Perry Simon: We've had a couple of different letter writing campaigns. One was for 'Max Headroom' which we desperately wanted to keep on the air but it was getting an 8 share [8 per cent of the market]. We would had to have had 12 million letters to keep an 8 share on the air. Even a 15 could have done, but an 8 was tough. We use the letters as a tool in evaluating shows – if you've given a show a chance, but it's not gotten a huge audience reaction and you wonder if there is an audience for it. If you start to get a tremendous

outpouring of both mail and acclaim from critics, print and electronic, then you sense that giving a show a little bit more time might give it a chance to take off. You can sort of take advantage of that publicity. You use it. But you don't make a blanket judgement about doing it on all shows. You have to judge each show specifically.

Question: Do you encourage letter writing campaigns for shows that you consider 'quality shows'?

Chad Hoffman: Sure, because, from our standpoint, we're in the trenches spending years of our lives trying to get something on that's different and unique. Then it goes on and suddenly no one's there for you. People are saying, 'TV is bad.' We put on something good – where's the audience? We'll try to at least encourage, or at least hope, that those people are out there and maybe talk to affiliates and say 'Look, why don't you go and talk to your TV critics and find out if there is real interest in this show?' 'Do people care about it?' Because if they don't, it's going to go.

Question: With 'Hill Street Blues,' it started with the audience and not with the network asking for audience response. Is that correct?

Perry Simon: You know who carried the demand for 'Hill Street' was the press. I remember the press tour back in 1980, when it was in its first season. The 'Hill Street Blues' producers threw a party for the press just to thank them because they were really the ones who just kept writing and writing and writing about the show. And that, in turn, led the public to keep at the network. I think NBC looked at it in those days (which were very dark days for this network) and said there is something here and we're just going to tough it out and stick with it.

Lance Evans: I think on 'Cagney & Lacey,' if I'm not mistaken, it was more the producers sensing that they were about to get a cancellation. They did a major PR campaign on their own – sending the stars and the producer out to go talk with various writers and people who cover the media. So that got that going and, of course, became a publicity campaign. I know that 'Viewers for Quality Television,' or some group like that, I think that's the title, has had some success. I know they have grabbed onto a few shows. 'Molly Dodd' was one.

186

Because of the very fact that they generate publicity about a show, they're good for the show. If the network has a show it's just not quite sure about, then that's going to help it stay on one more season.

Question: In the spring of 1984, Norman Lear had 'Aka Pablo' on the air with a six episode commitment, I believe, from ABC yet the network did not pick it up for the fall season. There was a massive, incredibly well-organized letter writing campaign throughout the entire country. I don't recall the numbers right now, but it was even greater than 'Cagney & Lacey,' but the series was not renewed for the fall. People were saying it was the first series with an all Hispanic cast and an Hispanic family and so forth, and Lear said that that kind of a series had to be an acquired taste, that six episodes was simply not enough. So in a situation like that, ABC did not respond favorably to it – to an executive producer with a very good track record and to a massive letter writing campaign.

Chad Hoffman: That was a little bit before my time. All I can tell you is that it may have been a mistake. It's hard to tell. I don't know what people were thinking or weren't thinking at that time. Six-order episodes are tough to make judgement calls on. From our point of view now, something that's different is something that is attractive to us. And our attitude is – things that are different do take time and we can't judge them in six episodes. I think shows that are different probably need at least a year to tell you whether or not they have a chance. I don't know what the other guys think.

Perry Simon: I saw 'Aka Pablo' and I didn't think it was very good. My guess is that they cancelled it because they just didn't think it was a very good show in spite of all those very legitimate factors that you just raised. In the final analysis, the show has got to be judged on its own merits. Also, just a slightly different version of the letter writing campaign is the moral-majority type group. I guess I'm really thinking of Donald Wildman in Tupelo. Several years ago he gave CBS fits. I can't think what got this going except a perception of a left-leaning posture at CBS. There was a huge letter writing campaign to advertisers which had an effect despite all the public proclamations that we are not. If you get advertisers

pulling out of a program, it has a subtle effect. And of course organized campaigns also have drawbacks because quite often people will get a newsletter saying, 'Please drop a letter today to so and so,' and you get these form letters coming. I think the network now realizes it. The letters are basically being generated on copying machines and they're not worth much. But one well-placed, well-written, letter to the correct person in New York stating a point and why you had a problem with one of our shows will work its way down the chain of command and have unbelievable power.

Chad Hoffman: That's true.

Question: Who is that person? (laughter)

PART IV

Production by Fans

10

A Glimpse of the Fan Factory

FRED AND JUDY VERMOREL

The following material has been collected as part of a continuing research project begun in 1977. The letters were sent between 1977 and 1988.

The Kate Bush Club

Abbey Road celebrated their 50th anniversary last month, quite an achievement considering the ups and downs the music business goes through. Helen Shapiro and I were asked to cut a cake they had specially made. It was 5 foot by 4 foot, covered in fresh cream and kiwi fruit and topped with 50 birthday candles. The studio which has been filled with orchestras for so many years, on that night was holding a choir of people who have loved Abbey Road, a huge cross section of fame and talent making their chitter-chatter music talk and completely filling the old studio which is hard to fill because it is so big.

Dear Katy [Bush],
 I hope you are feeling fine and I hope your life is going well. I've already written this letter to you but I didn't know the correct address so it probably won't reach you.

This is a final message. I am dying and I thought I'd let you know how much you mean to me. The only time I was ever really happy was when you embraced me and since R—— killed me and you saved me when I would have died I've been living under a spell of love for you. That spell was broken three months ago when I turned against you and smashed up the tapes I had previously worshipped and started hearing voices followed by a spell in hospital followed by olefactory [sic] hallucinations. I believed I could smell myself rotting and see it. It's just that before being attacked by R—— that day I had prayed to God and on feeling that he had forsaken me I prayed to the devil by saying the lords prayer backwards and that is perhaps where the spell or curse has come from. The senior consultant psychiatrist said 'What would Kate Bush want with you' (sneering). I then explained that you had said that you didn't want a nobody. I suppose I felt inadequate (this was my pride and stupidity). I will be waiting for you on the other side. I'm even less sure I know you since talking to the psychiatrist. I thought I was the undead and had to die. I took 90 aspirin and thought I'd pass away in my sleep but now 5 days later I'm dying of kidney failure and I'm turning yellow. It's as though my whole life has been passing through my eyes over those days the things I've enjoyed doing traveling, painting, music, etc. The sorrow I will leave with those who loved me I feel guilty I can see my little dad crying – I'd go up and visit him and take a lot of whisky. He has no friends. We'd chat for a few hours. And the girls I've known.

You are always on my mind and the psychiatrist asked me if I thought I was psychic or telepathic. I said no – but now I think I am and so are you. I know all this is very unfair of me [to lay] on you and I'm sorry.

Anyway the night I took the aspirin I was unconscious for several hours and had a dream that I was on a desert road with my bicycle which was suddenly shattered into a thousand pieces and the road and sky suddenly hurtled towards me – I yelled Katy and woke up so you're still with me.

All the best with your future.
I will love you for ever and ever.
<div align="center">bye</div>
<div align="center">[unsigned]</div>

Dear DAVID BOWIE
Gave Bob my head If I can't telepathize with him if he
isn't receiving me then maybe I am insane could be related
to Ludwig he believed in Snow White. The rainbow child
the one with the moustache perhaps is fantasy. Anyway I
wanted to thank you for your help. At least I remembered
this time, although I still take the tablets as I realized my
brain is addicted to them. They say you can't miss things
you never had but I'll miss my dreams if they're taken
from me.
<div align="center">Love</div>
<div align="center">Lucy</div>

Curled up in an armchair as he talks, dressed in grey
slacks, white tie and Adidas football boots, Bowie looks
like a schoolboy, but the mixture of anecdote and analysis
is effortless. The articulacy is almost shockingly relaxed.
<div align="right">City Limits, 26 August – 1 September 1983.</div>

Blondie fan club secretary: There's one guy who keeps
ringing who we call 'the Jesus crank.'
He writes to Debbie as 'the Angel Gabriel' and signs
himself 'Jesus.'
And he keeps ringing up and saying stuff like: 'Do you
like oral sex?' And really foul language.
And he claims Debbie Harry is persecuting him. I asked
him once: 'Are you a Debbie Harry fan?' And he said:
'No she's a fan of mine. She keeps painting my name
up on walls and using my name in interviews. She
shouldn't do it.'

Dozens of women have been tricked by a cry-baby
conman posing as pop star David Bowie's costume
designer.

<div align="center">193</div>

The man stops women to ask the way, bursts into tears then spins a sob story to wheedle 'loans' from them.
Some women hand over as much as £80 to the conman.
Daily Mirror, 25 June 1983

Faren (fan): I own 132 singles by Suzi Quatro and 50 albums, I also have 77 Lene Lovitch singles and 30 albums as well as 23 compilation LPs which feature either Lene or Suzi. I collect all variations of their records: promos, demos, white labels, 12 inches, imports, etc. I play them all the time. I also have a large collection of photos of them. I've just taken about 175 on Suzi's tour (at which I was at 16 out of 21 dates). At the moment I'm trying to get hold of all the other fans' photos from the tour. By the time I've finished I reckon I'll have at least 500 photos from the tour.

Newspaper Classified Ad

JOHN LENNON TRAGEDY. Liverpool death announcement issue 9.12.80. The original newspaper available which was sold out within minutes. Only 200 available. Rare collector's item. £6.25 each with DIY picture frame moulding (inc post and packing). Send cheque or postal order to – Pop Memories, 10 St Marywell Street, Beaminster, Dorset.

In vain do I stretch out my arms towards her when I awaken in the morning from my weary slumbers. In vain do I seek for her at night in my bed, when some innocent dream has happily deceived me, and placed her near me in the fields, when I have seized her hand and covered it with countless kisses. And when I feel for her in the half confusion of sleep, with the happy sense that she is near me, tears flow from my oppressed heart, and bereft of all comfort, I weep over my future woes.
Goethe, *The Sorrows of Young Werther*

please please please please please please please please please please

please please please please please please please please please please

please please please please please please please please please please please

please please please please please please please please please please please

please please please please please please please please please please

please please please please please please please please please please

please please please please please please please please please please

please please please please please please please please please please please

please please please please please please please please please please please

please please please please please please please please please please please

please please please please please please please please please please

please please please please please please please please please please

please please please please please please please please please please please

please please please please please please please please please please please

please please please please please please please please please please

please please please please please please please please please please please

please please please please please please please please please please please

please please please please please please please please please please please please

please please please please please please please please please please

please please please please please please please please please please please

please please please please please please please please please please please please

please please please please please please please please please please please

please please please please please please please please please please

please please please please please please please please please please

please please please please please please please please please please

please please please please please please please please please please please

please please please please please please please please please please

please please please please please please please please please please please

Dear Nick Heyward,

I have heard that when you have a dream, don't let anything dim it, keep hoping, keep trying – the sky is the limit. Well, I have a dream . . . to meet you. I think you are really neat and I would love to meet you more than you can imagine. I think of you all the time, wondering where you are or what you are doing. And I get so frustrated knowing that your life is happy without me, but mine is miserable without you.

Maybe I'm just a dreamer, and maybe it would take a miracle for my dream to come true. But if I keep praying and never giving up, maybe there will be hope.

Please don't laugh at this letter and throw it away, thinking a foolish child wrote it because I'm not a child. Please don't think that this is just a phase I'm going through, because it's not. I've been writing you letters for over a year now and I have no idea who gets them. But *whoever* gets this PLEASE let it get to Nick Heyward!!! Please try to understand how much this means to me and that I can't go on much longer.

<div align="center">Forever Yours,
Julie</div>

Dear Mr Bowie,

In the last 16 years I've done things I've found difficult but this is the worst. As it is, it has taken me 10 days to get this far and my mind has toyed with the idea for months before that.

There's something really frustrating about trying to win the respect of someone you don't know. You have no knowledge of what they admire or dislike in people so each step feels like it's in the wrong direction.

Well, what I wanted to ask was if you could let us write to each other? If you don't want to, please forgive me. I'll take it as a slap in the face for being so selfish as to suggest it.

If you do, I'd be so happy to hear from you as I've got no one I'd dare be really honest with.

I would really love to know you, even from a distance. I wish I could just be an ordinary unimportant friend to you.

<div align="center">196</div>

Anyway I can't express just how much it would mean to me.

Love,
Alan

Hi!
Thanks for writing to Nick. We are sorry that some of you have waited a long time for a reply – but we are sure that you will be pleased with our news.

Dear Nick Heyward

Eyes are staring
eyes are blue
eyes are saying
'I love you'
yeah, I remember
I want to watch you
bloom and breathe
in six months I intend to suck your prick
on your 23rd birthday!
I am a human dustbin and potty over you!
if I ever kissed you I wouldn't want to let you go
Nicky Heyward's sperm
(yum, yum, yum, yum)
I love your Beckenham accent
I love how you sing
am I your sweet angel?
haven't we turned into a handsome man
I expect you'll never be able to find my hole.
I was blonder as a baby.
I'll never forget us miming to one another on Forest Hill

Dear beautiful David I could make love to you, beautiful wo—man me too honey I'm a wo—man myself you ought to see me dressed up I'm sexier than you bautiful Goddess, Hence say HELLOW TO EVERYBODY espically to Kate Bush tell her I LOVE HER LOVE LOVE LOVE LOVE her QQQQ "All We Need IS LOVE" I WANT HER IN MY ARMS

we are altogether in mind anyway

Bridge Road, London. Never.
Yes, the rose has bloomed and is breathing.
Do you ever get a hard on when you think of me?
I'm going red
rosy cheeks red.

Love Amantha XXXX

The following is an extract from a cassette made and circulated
by Barry Manilow fans of Manilow out-takes and fragments
cleverly dub-edited into a continuous Manigasm

Hot Night With Barry Cassette

. . . Let's do it, you're looking hot tonight, let's do it, you're
looking hot tonight . . . Mm! mm! . . . Let's get on with it
. . . Ain't that beautiful, ain't that beautiful . . . Uh, uh . . .
Uh! uh! uh! . . . [Spoken] I could have done much better . . .
[Sung] I want to get it, ah haaa, ah haaa . . . Can't you feel that
something's coming up . . . uh! uh! uh! uh! . . . ah! ah! ah! ah!
. . . [Spoken] It's breathtaking . . . I wanted to, I really wanted
to . . . Please! . . . Oh, man, I just love that thing . . . Oh! oh! oh!
oh! ahh! . . . OK . . . [Sung] And here we go again . . . Ahhhh,
ahhhh . . . [Spoken] Oh, God! . . . Uh! uh! uh! uh! . . . [Sung]
It's dark, it's hot . . . Ohh, ohh, ohh . . . I want to get it . . .
uh, uh, uh, uh . . . urh! urh! urh! huh! huh! . . . ah! ah! ah! . . .
Work it out . . . Oh, God . . . Uh! uh! . . . Even now I wonder
why I can't go on . . . How does it feel? . . . ah! ah! . . . Mm!
mm! . . . Oh, man, I just love that thing . . . Ah! ah! ah! . . . Uh!
uh! uh! uh! . . . Ah! ah! . . . Oh, God! . . . Aaaaah! . . . God!
. . . Ah! ah! . . . Oh, God . . . Ah! ah! ah! ah! ah! . . . Come on!
come on! come on! come on! . . . One more time . . . And here
we go again . . . You pulled me down and gave me . . . Oh! oh!
ah! beautiful! . . . Gets hard, gets hard, hard, hard . . . I want to
do it . . . Now, now, now, now . . . Ohh, ohh . . . More, more,
more . . . Ah! ah! . . . More! more! more! . . . Ohhh, ohh . . .
Huh! huh! . . . Uh! uh! uh! uh! uh! uh! uh! uh! uh! uh! . . .
Oh, God! . . . Uh! uh! uh! . . . Ah! ah! ah! ah! . . . Lonely
boy, lonely boy . . . Ah! ah! . . . God! . . . Come, come, come,
come . . . Ah! ah! . . . All my life I would miss her dynamite . . .
Ahh-ahh-ahh-ahh-ahh-ahh! . . . [Spoken] Do I get it? . . . Now

199

I just wait for it to go down . . . Ahh-ahh-ahh, ahh-ahh-ahh-ahh
. . . [Sung] I know I'll never love this way again . . . We made it
. . . aahhh-aahhh-aahhh-aahhh-aahhh-aahhh-aaaaaaah!!!

Barry Manilow Fans Writing to One Another

Dear Mandy,
 Yes I'm over my broken friendship with my oldest
friend – but only because of people like you & all my dear
Barry friends. You make it easier to bear – the friends I
have made through Barry are the most loyal I've ever
known – It still hurts when I stop & think about it – but
it's not very often I do, because I have so much to occupy
my mind now – thanks to Barry.
 In much Mani*lust* as *always*,
 Suzanne XXXX

Dear Julie,
 On the last night I was sitting right down front and just
when he changed from Could It Be Magic to Mandy he
looked down at me, winked, smile and sung the whole
thing at me. Well it was so wonderful, He's really lovely
close up! He wears Eau Sauvage Aftershave, which has
always been a favourite of mine. Ooh I really went weak
at the knees and just sat – or collapsed onto some guy's
lap. He didn't mind – just said, 'Gee honey, you enjoyed
that, you just sit here and recover.'
 Manilove,
 Mandy XXX

Dear Monica,
 I do hope you can find a part time job. Let me know.
I'm still working my ass off – for peanuts – God! I get
taken advantage of – but I have to get all the money I
can for Barry.
 Much Manilove now & *always*,
 Suzanne XXX

Dear Mandy,
 When she realized what she had said she put her hand

over her mouth but of course Barry had heard. He looked at her and gave her a lovely smile. Then he called her over to him. 'Hi,' said Barry. 'Hello Barry,' she said feeling very emotional and very sexcited. 'I heard what you said just now.' Barry told her, 'and I'm very touched to know how much you care for me.' She said she could have crumbled like a wall and did not know how she fought back her tears. He was everything like that she has always imagined him to be: kind, gentle, and so understanding. She told me she wanted to touch him but it is like when you go to buy a piece of pure silk material, you know what it feels like, but you want to touch it all the same, only are afraid to because it is so pure and precious. . . .

Oh God, Mandy, is it so much to ask for to want to bear the child of the man you love with every ounce of your being. I'm going to start work on my poem as the follow up to my fantasy as soon as I've finished work on my labour of love for Barry's birthday.

All my love, lashings of Manilust as ever

Julie

Authors' note:
In 1984 we were given access to the files of all letters written to the pop/showbiz column of the Sun *newspaper:*

A 16-year-old boy requests Paul McCartney's address. He knows McCartney has a house in Kent and 'once caught a train towards that direction but ended up lost.' A housewife wants Michael Jackson's address immediately so she can 'fly to the States, find him and I would be a friend to him.' A born-again Christian wants the same: 'I believe very strongly that I can help him.' A boy complains he can't get near Adam Ant: 'I have forked out so much money for concerts all over Great Britain to get his name in my [autograph] book but he keeps so many security men around it's ridiculous and after concerts I still have nothing to remember.' A girl wants the *Sun* to arrange for her to spend the day with Duran Duran. Another girl, who has been a David Essex fan for eight years, begs for 'just two minutes' with him to say: 'Hello, how are you?' A

self-described former bass player with Shakin' Stevens bitterly complains that Shaky has now in his hour of fame deserted his former friends. A woman requests the name of a boy in a TV ad who resembles her dead son. Someone writes that 'a DJ' has told him Adam Ant is Gary Glitter's son. Is this true? A mother writes that her son is so desperate at not being able to get a ticket for a David Bowie concert that 'we have had him under the hospital with his nerves.' A man complains that Elton John has not replied to his 'seven letters' offering to be Elton's bodyguard. He has visited Elton John's home in Old Windsor without success. He now wishes to be Rod Stewart's bodyguard. Another man wants the address of Rod Stewart's 'daughter' who he claims is living in the home of a brigadier in the Home Counties. He wants to reveal to her his unique collection of Rod Stewart records.

An amazing 20,000 Beatles fans will have gazed in awe at Studio Two in Abbey Road Studios by the time the official tours end this Sunday.

The studio's assistant manager Peter Vince has been telling me of the fans' Pope Paul style reaction to their first sight of the Fab Four's hits factory.

'They've been kissing the floor,' says Peter incredulously. 'We've even had Americans kneel down on the zebra crossing outside.' *Standard*, 9 September 1983

The words of the song Imagine, in Lennon's handwriting, were sold for £6,600 to a Tokyo department store.
Guardian, 2 September 1983

The love for relics is one which will never be eradicated as long as feeling and affection are denizens of the heart. It is love which is most easily excited in the best and kindliest natures, and which few are callous enough to scoff at.

Charles Mackay,
Memoirs of Extraordinary Popular Delusions, 1841

After Marilyn Monroe committed suicide, the U.S. suicide rate temporarily increased by 12%.

A GLIMPSE OF THE FAN FACTORY

David P. Phillips, 'Suicide, Motor Vehicle Fatalities,
and the Mass Media', *American Journal of Sociology*,
March 1979

Professional Marilyn Monroe look-alike: One of the things
that frightens me about doing this is that you do get
nutcases. You do. I had this guy keep phoning me up: 'I just
want to talk to you. I think you're wonderful.' I said: 'Lis-
ten, I'm not Marilyn.' I mean he just talked to me as though
I was this person on his posters. Which was not on.

But what's even stranger is that even other guys, like
art directors or photographers, they get physically turned
on.

Now that is strange, because these people certainly deal
all the time with beautiful girls – a lot more beautiful girls
than me, and girls doing nude.

And yet they keep fiddling around, adjusting my bra or
trying to get my towel to slip off.

Or they come into the dressing room and they want to
see my body.

He slid from behind a blue curtain into the vast auditorium
like a gleaming blond snake, the dandy soul boy himself
. . . Mr David Bowie.

Instant pandemonium.

Four hundred cameras swivelled towards him. He
chewed amiably on gum, offering a twisted grin as he
turned to face death by media firing squad.

Daily Express, 12 May 1983

The worshipper always desires to *consume* his god. From
the cannibal repasts in which the ancestor was eaten,
and the totemic feasts in which the sacred animal was
devoured, down to our own religious communion and
receiving the Eucharist, every god is created to be eaten,
i.e., incorporated, assimilated.

Edgar Morin, *The Stars*, 1960

'Most of me didn't want to do it, but a little of me did.
I couldn't help myself.'

Mark Chapman, *New York Times*, 11 December 1980

Asked in court why he used hollow bullets Chapman replied, 'To ensure Lennon's death.'

New York Times, 23 June 1981

The fetish contains congealed anger.

Phyllis Greenacre,
'The Fetish and the Transitional Object,'
Psychoanalytical Study of the Child, Vol. XXIV

A tree planted in Martin's Hill recreation ground, in Bromley, Kent in memory of John Lennon, the former Beatle, has been destroyed by vandals.

Times, 19 December 1980

Sent to David Bowie with a photograph of the correspondent:
A happy snap to familiarise yourself with the face of an april fool. To start with JOHN I apologise for this intervention in your life. But you must realise that this letter is the culmination of centuries of training. I do not enjoy changing people's lives, but this seems inevitable. I am sorry this has become necessary. But it seems Venus's fly trap is drawing me into her pandora's box. They tell me mother knows best. Fear not my friend I will fascinate, amuse and love you and yours. Correct me if I'm wrong but it would appear that we spend some time at least together. Enough said. I haven't been out to check the pulse today so I'm not sure what I hope to gain from this letter, it might just be an address. But I could probably use a little cash, for the hire of a car. And a little white powder would not go amiss either. I need sedation. What can I say. Hope to see you soon. All my love as always.

Brian

Nebraska

Dear Peter Townshend,
Please work out the spaces between you and your wife. I didn't open the door when I heard you singing on the street corner. I paid 40 billion times for that.
If you come, see me. I need you and I want to see you.

Peter, I put your picture on Mary and Joseph's statue so they could help you straighten your mind.

I know, Peter. I know when you talked about the trees. I am happy in them. I climb them often.

All the animals love me and talk of me. Deer, birds, even coyotes. I feel so happy then. I am alone but the animals understand me.

Thanks for the diamond connections. It's better than wasted $s.

Peter, I need to marry. I need someone like me. Dad and father drink. They are in grief. I need someone to run a business, kids.

Peter, if *you* don't want to change your love reality to truthfulness then I must pick another mate. Peter, I want to really clean the place up.

<div align="right">Jane</div>

David,

You are living in my heart and in me and for that I am giving a fight not to be kept. I do not need your places but have a name 'pot' other than that meaning eating my brain.

Your lovely hair your lovely head and you you David words not enough anything's not enough to express to you the feeling I belong to you they are yours which I had like everything belongs to you.

To talk to you without stop

without stop to want you

without stop to hear you

God, I want my thinking to belong to you why

I belong to myself my everything belongs to me this maniac sadist cut offs I don't know how to stop because they bring my beloved watery from ordinary places to become one's cheapness in the world. Clean high ones any kind of insult can't touch us they are burning on the floor in the places in my feeling that belong to you.

Inside I am all alone in all this dirtiness

You are a rising sun.

David really you are the self of power with your brains and heart.

You are living in me when I am writing all my hair stands up and a song has thrown away all the headache.

Said again again again again always I want to hear you – must become enough paper – to write you to tell you – I want to live you to live you – you are my life my Breath – god knows – I want to come out from this hell –

I love you David I love you, I love you David I love you I love you I love you I love you David David David David.

David can you write like me with a feeling you are the writer you who are the source.

I feel a madness absorbing my life my feeling my heart my property my personality.

Let feeling let desire let want to live let need just like you know I can't write to you, to you media, living the sadism ordinarily but without discussing whether to eat your property your personality your life your heart also your brain.

David my dear David I understand I became very bad. I lost my voice and frightened voices coming from my throat from angry bad exclamations became like all those wires in my throat. David I really want my voice.

Flowers, rain, blowing and shining rivers sky and seas in a clear lovely place where you lay under the sun near me and you and me and I and I and I and I and I and I.

Is it possible to see your eyes so beautiful to look so deeply in.

Is it possible to find a kind of expression in your eyes that can say I kind of want to kiss them.

To love you. To live you. To want you.

But I am not living I am dying, losing. This is a hell so cheap and love dirty more than you can expect for real atrocity.

I adore you.

To set this dirtiness a dead David this dirty love murder kill me all my hair is standing up when will I finish this hell.

For all the way with love

<div style="text-align:center">Yours
Mollie</div>

We can understand why our patients often show a strange lack of zest for getting better ... for they may not be so irrational in suspecting that neurosis is more interesting than health.

The psychoanalyst, Rollo May

'Strangers No More, We Sing': Filking and the Social Construction of the Science Fiction Fan Community

HENRY JENKINS

Media fans are consumers who also produce, readers who also write, spectators who also participate.

On the one hand, these claims seem counter-intuitive. We tend to think of fans almost exclusively in terms of relations of consumption rather than production. For many critics of mass culture, the fan has been emblematic of the most obsessive and slavish forms of cultural consumption, consumption which has been understood primarily in terms of metaphors of addiction, religious zealotry, social aberration or psychological imbalance.[1] Journalistic accounts of fan culture tend to give primary attention to the exchange of mass-produced commodities, often at excessive prices, and to the worshipful approach the fans take to media producers.

On the other hand, claims about producerly fans can seem banal and self-evident. As cultural studies, cognitive film theory, reader-response criticism, and other contemporary theoretical movements have come to characterize all media spectators as 'active audiences,' the notion of textual production has been extended from reference to specific types of cultural

activities which result in material artifacts to encompass all forms of interpretive activity. In this move, the fan becomes the emblematic example of the reader's activity in making meaning and finding pleasure within commercial texts; the fan's activity is treated as different only in degree from those types of interpretive strategies adopted by all consumers of mass culture (see, for example, Fiske 1987 and 1989). Fan communities are characterized as 'audiences' and they are read exclusively in terms of their relationship to a privileged primary text, a formulation which, as Janice Radway (1988) notes, still tends to keep the media text, rather than the reader's use of it, as the central focus of analysis. Fans as audiences defined through their attachment to particular programs or genres (Madonna 'wanna-bes,' romance readers, Trekkers) are still seen as constituted by texts rather than as appropriating and reworking textual materials to constitute their own varied culture. Moreover, the fans' own cultural creations are not read as the artifacts of a larger cultural community but as the material traces of personal interpretations – or at least, of interpretations defined primarily in terms of a singular and stable social identity (housewives, children, punks, and so on). Such an account of fannish production, thus, gains general applicability at the expense of a more precise understanding of the social and cultural specificity of the fan community, allows for the construction of a theory of dominant reading practices without offering a sharper sense of the particular character of the fans' fundamental break with those practices.

To proceed, then, with any concrete discussion of fannish cultural production, we must start with a more precise definition of fandom, a definition which from the very outset recognizes that part of what distinguishes fans as a particular class of textual consumers is the social nature of their interpretive and cultural activity (Jenkins 1990). I would propose a model of fandom which operates on at least four levels:

1) *Fans adopt a distinctive mode of reception*: Ethnographic research has begun to focus more and more on understanding the specific modes of reception which are characteristic of specific social and cultural communities – the selective attention of the child viewer (Jenkins 1989; Palmer 1986) or the

housewife (Brunsdon 1981; Morley 1986), who for very different reasons divide their interest between television programming and other household activities, the more focused attention of the husband (Morley 1986), who may watch television somewhat indiscriminately but who often makes the broadcast the focus of undivided concentration, the social interaction which surrounds viewing programs within a group context (Amsley 1989), and so on. These different modes of reception reflect different interests the viewers bring to their relationship with the media and are shaped by the different social conditions which these viewers experience in their everyday lives.

Fannish viewing can be understood, then, as yet another mode of reception. First, fan viewing is characterized by a conscious selection of a specific program which is viewed faithfully from week to week and is often reread repeatedly either through reruns or through videotape archiving. Second, fans are motivated not simply to absorb the text but to translate it into other types of cultural and social activity. Fan reception goes beyond transient comprehension of a viewed episode towards some more permanent and material form of meaning-production. Minimally, fans feel compelled to talk about viewed programs with other fans. Often, fans join fan organizations or attend conventions which allow for more sustained discussions. Fans exchange letters. Fans chat on computer nets. Fans trade tapes so that all interested parties have a chance to see all the available episodes. And, as we will see, fans use their experience of watching television programs as the basis for other types of artistic creation – writing new stories, composing songs, making videos, painting pictures. It is this social and cultural dimension which distinguishes the fannish mode of reception from other viewing styles which depend upon selective and regular media consumption. Fan reception can not and does not exist in isolation, but is always shaped through input from other fans.

2) *Fandom constitutes a particular interpretive community*: Given the highly social orientation of fan reading practices, fan interpretations need to be understood in institutional rather than personal terms.[2] Fan club meetings, newsletters, and letterzines provide a space where textual interpretations get

negotiated: new readings or evaluations of shared texts are proposed and supported by appeal to certain generally accepted forms of evidence or types of inferential moves ('Roj Blake is going progressively mad throughout the second season of "Blake's 7"'), others debate the merits of these interpretations, offering counter-examples, proposing alternative readings, or challenging them according to their conformity to the group's standards of what constitutes an appropriate use of textual materials ('No, Roj Blake makes rational but unpopular decisions necessary for the conduct of a paramilitary campaign against the Federation'). Each party appeals to the primary text episodes, interviews with program producers, or general social and cultural knowledge to explore differences in the ways they make sense of the narrative events. Moreover, fans debate the protocols of reading, the formation of canons, and the ethical dimension of their relationship to primary textual producers almost as much as they discuss the merits and significance of individual program episodes. The meanings generated through this process certainly reflect, to some degree, the personal interests and experiences of individual fans; one may also locate meanings which originate from the fans' specific position within the larger social formation, meanings which reflect, say, characteristically 'feminine' perspectives on dominant culture. Yet, these readings must also be understood in terms of the ways they reflect and conform to the particular character of fandom as a specific institution of interpretation with its own distinctive reading protocols and structures of meaning.

3) *Fandom constitutes a particular Art World*: Howard Becker (1982) has adopted the term, 'Art World,' to describe 'an established network of cooperative links' (p. 34) between institutions of artistic production, distribution, consumption, interpretation and evaluation: 'Art Worlds produce works and also give them aesthetic values' (p. 39). An expansive term, 'Art World' refers to systems of aesthetic norms and generic conventions, systems of professional training and reputation building, systems for the circulation, exhibition and/or sale of artworks, systems for critical evaluation. In one sense, fandom simply constitutes one component of the mass-media Art World. Fan conventions play a central role in the distribution of knowledge

about media productions and in the promotion of comic books, science fiction novels, and new film releases. They provide a space where writers and producers may speak directly with readers and may develop a firmer sense of audience expectations. Fan awards, such as the Hugo, which is presented each year at the World Science Fiction Convention, play a key role in building the reputations of emerging science-fiction writers and in recognizing outstanding accomplishment by established figures. Historically, fan publishing has provided an important training ground for professional writers, a nurturing space in which to develop skills, styles, themes, and perhaps most importantly, self-confidence before entering the commercial marketplace (Bradley 1985).

Yet, fandom constitutes as well its own distinctive Art World founded less upon the consumption of pre-existing texts than on the production of fan texts which draw raw materials from the media as a basis for new forms of cultural creation. Fans write short stories, poems, and novels which use the characters and situations of the primary text as a starting point for their own fiction. Fans take found footage from television texts and edit them to construct their own videos which comment, sometimes with irony, sometimes in celebration, on the programs which gave them birth. Fan artists paint pictures, construct sculptures, or fashion elaborate costumes. Fan musicians record and market tapes of their performances. Much as science fiction conventions provide a market for commercially-produced goods associated with media texts and as a showcase for professional writers, illustrators, and performers, the conventions also provide a marketplace for fan-produced artworks and a showcase for fan artists. Fan paintings are auctioned, fanzines are sold, performances staged, videos screened, and awards are given in recognition of outstanding accomplishments. Semi-professional companies are emerging to assist in the production and distribution of fan products – song tapes, zines, and so on – and publications are appearing whose primary function is to provide technical information and commentary on fan art (*Apa-Filk* for fan music, *Art Forum* for fan artists, *Treklink* and *On the Double* for fan writers) or to publicize and market fan writing (*Datazine*). Fan artists develop their talent in a nurturing environment and gain

reputations, sometimes international in scope, while remaining unknown to the world outside of fandom.

4) *Fandom constitutes an alternative social community*: The fans' appropriation of media texts provides a ready body of common references that facilitates communication with others scattered across a broad geographic area, fans who one may never – or only seldom – meet face to face but who share a common sense of identity and interests. The collapse of traditional forms of cultural solidarity and community within an increasingly atomistic society has not destroyed a felt need to participate within a cultural community and to adopt an identity which is larger than the type of isolated individual demanded by the alienated workplace (Lipsitz 1989). What fandom offers is a community not defined in traditional terms of race, religion, gender, region, politics, or profession, but rather a community of consumers defined through their common relationship with shared texts. Fans view this community in conscious opposition to the 'mundane' world inhabited by non-fans, attempting to construct social structures more accepting of individual difference, more accommodating of particular interests, and more democratic and communal in their operation. Entering into fandom means abandoning pre-existing social status and seeking acceptance and recognition less in terms of who you are than in terms of what you contribute to this new community. Fandom is particularly attractive to groups marginalized or subordinated in the dominant culture – women, blacks, gays, lower-middle-class office workers, the handicapped – precisely because its social organization provides types of unconditional acceptance and alternative sources of status lacking in the larger society. For many fans, this social dimension – their allegiance to fandom – often takes precedence over their allegiance to particular media texts with fans moving from 'Star Trek' to *Star Wars*, from 'Blake's 7' to 'The Professionals,' while remaining active within the larger social structures of the fan community. Some forms of fan cultural production exist, then, not so much as a vehicle for interpreting and commenting upon primary texts, than as a means of building and maintaining solidarity within the fan community.

So, fans are consumers who also produce, readers who also write, spectators who also participate. What do fans produce? Fans produce meanings and interpretations; fans produce artworks; fans produce communities; fans produce alternative identities. In each case, fans are drawing on materials from the dominant media and employing them in ways that serve their own interests and facilitate their own pleasures. In each case, the nature of fannish production is shaped through the social norms, aesthetic conventions, interpretive protocols, technological resources and technical competence of the larger fan community. Fan texts, then, do not give us any pure, 'authentic' or unmediated access to the personal interpretive activities of individual fans; nor do they provide a very good basis for constructing a theory of dominant reading practices, since fannish production reflects the particular demands and expectations of a subcultural community which are different in kind as well as degree from the types of semiotic production occurring within the larger culture. They can, however, teach us about tactics of cultural appropriation and the process by which artworks produced for one context may be remade to serve alternative interests.

'Star Trek' fan fiction offers a particularly vivid example of some key aspects of fan cultural production (Jenkins 1988). Over the twenty-five years since 'Star Trek' was first aired, fan fiction has achieved a semi-institutional status. Fan magazines, sometimes hand typed, photocopied and stapled, other times offset printed and commercially bound, are distributed through the mails and sold at conventions. Fanzines publish both nonfiction essays speculating on technical or sociological aspects of the program world, and fiction which elaborates on the characters and situations proposed by the primary text, but often pushing them into directions quite different from those conceived by the original textual producers.

'Star Trek' fan writing is a predominantly feminine response to mass media texts, with the majority of fanzines edited and written by women for a largely female readership. These fan writers rework the primary text in a number of significant ways: they shift attention from action and adventure aspects of the show onto character relationships, applying conventions characteristic of traditionally feminine genres, such as the

romance, to the interpretation and continuation of materials drawn from traditionally masculine genres; female characters who were marginalized and subordinate in the original series (Uhura, Chapel) become the focus of fan texts which attempt to examine the types of problems women might experience as active contributors to Star Fleet and, in the process, these characters must be strengthened and redefined to accommodate more feminist interests; fan writers explore erotic aspects of the texts which could not be directly represented on network television and, sometimes, move from homosocial representations of male bonding and friendship towards the depiction of a homoerotic romance between Kirk and Spock. Fan writing, then, can be characterized as a type of textual 'poaching' (de Certeau 1984), as a strategy for appropriating materials produced by the dominant culture industry and reworking them into terms which better serve subordinate or subcultural interests. In this way, fan writing employs 'Star Trek' characters as a means of working through social experiences and concerns of particular interest to the female writing community, concerns which were given little or no attention by the original series.

Fanzine stories grow out of gender-specific reading strategies and speak to feminist issues but they do not simply duplicate the types of individual interpretive activity which initially generated fannish interest in the series. Fanzine stories are created to be circulated within the fan Art World. They conform to particular generic traditions which originate within the fan community. They foreground meanings which are of interest to other fans; they accept certain common rules about what types of uses of textual materials are desirable or appropriate. They tend to build upon characterizations and worlds already elaborated by earlier fan writers. In short, these fanzine stories are as much the artifacts of a particular cultural community as they are the expressions of personal meanings and interests.

Fan music-making (or filking, as fans call it) offers us another point of entry into the cultural logic of fandom, another way of understanding the nature and structure of the fan community and its particular relationship to dominant media content.[3] Filking, like fan fiction, may be a vehicle for extending or commenting upon pre-existing media texts; it may be a way of taking textual materials and pulling to the surface characters or

concerns which have been marginalized (Jenkins 1991). Fans often write songs from the perspective of fictional characters, singing in their voices, and expressing through musical performance aspects of their personalities or their particular perspectives on narrative events. Just as a fan writer may develop a story around the character of Uhura, a filker may develop a song centered around a Chapel or Yar, female characters whose voices are rarely allowed to be heard within the aired episodes. Singing as these characters may allow filkers to explore issues which remain unresolved by the primary text and to offer challenges to its preferred meanings; singing as these characters may also allow them to play with the possibility of shifting between existing social categories, of seeing the world from a variety of different perspectives. Moreover, filking may add yet another dimension to the practice of textual poaching since motifs and themes from media texts are often attached to tunes scavenged from popular or folk music, often with a keen awareness of the types of meanings which may be sparked by the careful juxtaposition of the two.

Yet, filking differs from fan writing in a number of significant ways. First, while fan writers tend to focus their output primarily if not exclusively around a single program text, filkers draw references from a much broader range of media products, exemplifying the more 'nomadic' aspects of textual 'poaching.' While fan writing represents a predominantly female response to the media, men and women play equally prominent roles within filk, sometimes collaborating on songs, other times exploring themes or subjects of a more gender-specific interest. If fan writing encourages individual creativity, filk more persistently promotes a communal conception of cultural production, though, as we will see, this type of folk ideology is being challenged by the promotion and marketing of individual filk artists as star musicians. Finally, if fan writing can still be understood primarily in terms of textual interpretation and appropriation, filking more often attempts to speak directly about fandom as a distinctive social community, to celebrate its characteristic values and activities and to articulate a fannish perspective on political topics, such as the space program, environmentalism, and the arms race.

Filk takes many forms: lyrics are published in fan songbooks

or as one element among many in fanzines; filk clubs host monthly meetings; filk conventions are held several times a year; filk is circulated on tapes, either informally (through barter) or more commercially (through several semi-professional filk tape distributors). Yet, it is important to position filk songs initially within their original and primary context as texts designed to be sung collectively and informally by fans gathered at science fiction conventions.

For more than six decades, the science fiction convention has provided a crossroads where fans can interact with their favorite writers (or in media fandom, the stars and creative personnel behind their favorite media texts), get to know other fans who share a common interest, and exchange ideas and showcase their own creative productions. The 'con' is the center not only of the fan Art World but also of fandom's alternative community. For some, the con may offer their initial exposure to fan culture and a point of entry into its social order. For others, the con allows a chance to renew contact with old friends known only through fandom. Many fans attend only one or two cons a year. Some can only afford to attend those held within their home town or their own geographic region. A more limited number of fans spend many weekends a year going from city to city to attend cons, constituting the 'flying island' which Barry Childs-Helton (1987a) describes in one of his songs: 'They land and play/now they're flying away/to meet you at another village, another day.' These traveling fans often sense a strange continuity as they encounter the same faces (fans, guests, merchants), the same activities, and the same attitudes as they move from con to con and it is for these fans, perhaps, that the sense of fandom as an alternative social community is most keenly felt.

While there are a number of cons which center around specific fan interests – specializing on a single program ('Star Trek') or a configuration of programs (cons devoted to spy shows, British television or homoerotic fan fiction), or on specific activities (filking, gaming, weapon-cons) – science fiction cons frequently draw together fans from across a number of different interests. As a result many of the times and spaces of the con are set aside for special purposes: panel rooms, art galleries, gaming rooms both for role-playing games and computer games,

217

masquerade halls; screening rooms for cult movies, television episodes, Japanese animation, and fan-produced films and videos; a huckster hall where fans may buy commercial merchandise and fan-produced goods. These specialized activities often overflow their properly assigned spaces, intermingling in the hallways and in the con suite, common spaces which serve as intersections where many different interests converge.

The 'filk sing' could be understood, then, as one specialized activity among others, as a time and space for fans who like to sing, but it might more productively be seen as one of the places where fans with many different interests come together, where their common identity as part of a more largely defined fan-community gets articulated. While only a small percentage of those who attend any given science fiction convention participate in the filksinging, its ranks typically embody a cross-section of the larger fan community, attracting men and women, young fans and more mature ones, and a fair percentage of minority fans. Some fans undoubtedly attend conventions just to participate within the filk sing but many more wander over to it at the end of a favourite film, after the completion of a gaming session, or after the masquerade or the guest of honor presentation. The structure of the filk sing must be one which incorporates a number of different fannish interests into its repertoire of songs, one which encourages participation and opens itself to a variety of different musical tastes, styles, and competencies.

Brenda Sinclair Sutton's song 'Strangers No More' (1989) aptly summarizes the place of filking within the science-fiction fan community, indicating both the eclecticism of its themes and the degree to which fan music creates a sense of commonality among strangers who have been drawn together through a multitude of more specialized and distinctive interests. Starting with the preparations of one couple to go to a science fiction convention, their movement from their mundane workday world into the more exciting sphere where they choose to spend their leisure, the song traces the way the fan community is built – person by person – much as the music itself is produced through many voices, 'layer upon layer'

> She drives a truck.
> He computes.

That one teaches school.
The only rule among us is
There really are no rules.
Some like ose, some fantasy.
Some science fiction strong.
The one thing which unites us
Is our love of harmony and song. . . .
Strangers no more, we sing
and sing and sing and sing.[4]

The music pulls the group together, resolving the differences
which separate them, providing a common basis upon which
to interact: 'I may not know you Friday night/ But we're
good friends when Sunday's gone. . . . Strangers no more, we
sing.'

A closer examination of one specific evening of filksinging
(the Friday night session of Philcon 1989) may allow for a more
concrete discussion of the ways that a conception of cultural
inclusion and social integration has been structured into the
filking process. Philcon, held in Philadelphia, is fairly typical
of the larger East Coast cons, featuring a mix of literary and
media-oriented programming and gaming. This particular filk
sing was scheduled to begin at 11.00 P.M., actually got underway
about half an hour later due to straggling and some confusion
about room allocations, and continued until 4:00 A.M. At its peak,
this filk sing attracted 40 participants, though more typically it
maintained a steady population of 20–30 fans and sometimes
dwindled down to six or seven.

The participants were arranged informally either on the floor
or in a somewhat lopsided circle hastily formed by rearranging
the chairs in the hotel conference room. The filk sing preserves
no formal separation between performance space and spectator
space. Indeed, the organization of the filk sing ensures that the
center of interest circulates fluidly throughout the floor. This
filk sing was organized according to the principle of 'Midwest
chaos,' which simply means that whoever wants to play a
song starts whenever there is an empty space in the flow
of music. Sometimes, there are gaps when no one seems
ready to perform; more often, several fans want to sing at
once and some negotiation occurs; eventually, anyone who

wants to sing gets a chance. Other filk sings are organized as what fans call 'bardic circles,' a practice which is also called 'pick, pass or perform.' Here, each person in the room is, in turn, given a chance to perform a song, request a song to be performed by someone else or by the group, or simply to pass, ensuring an even broader range of participation. At still other conventions, special songbooks are distributed to participants and songleaders conduct the sing.

Music is provided in a somewhat haphazard fashion with whoever happens to know a particular tune participating and a number of songs performing a cappella. A number of participants brought guitars and several performed on the harp. Filk's reliance upon tunes 'borrowed' from other well-known or traditional songs ensures that both musicians and singers typically know much of the music that is performed. Filk songs also often have repeated choruses, which can be easily mastered even by the most 'neo' of filkers and which, thus, encourage all of those in attendance to join in with the song. Those who don't sing hum or whistle, tap their feet, drum on their chairs with pencils. Some particularly complex or moving songs are performed solo, but, at this filk sing at least, the tendency was for most of the songs to become collective performances – if only during the chorus.

While some filkers have very polished voices and a few earn money by performing professionally, the climate of the filk sing is one of comfortable amateurishness.[5] The singing stops periodically as new guitars are tuned or performers struggle to find the right key for a particular song. Voices crack or wobble far off tune, and, particularly as the evening wears on, songs grind to a halt as the singer struggles to remember the words. Such snafus are accepted with good humor and vocal expressions of support and acceptance. 'If it ain't tuned now, it never will be,' one woman jokes and another responds, 'Put it this way, it's close enough for filking.' A harpist, hesitant about the appropriateness of a particular folk tune for the occasion, was reassured, 'That doesn't matter. Who do you think we steal our tunes from?'

While some filk songs evoke specialized knowledge either about fan culture or popular texts which may make them cryptic to the uninitiated, the verbal discourse surrounding the

filk sing works to introduce new fans to the types of information needed to appreciate the performed material. 'Does any one need that last verse explained?,' one performer asked after a song particularly heavy with fan slang. The climate which results both from the non-professionalism of the performance and the constant verbal reassurances of the group is a highly supportive one which encourages participation even from fans who have previously displayed little or no musical talent.

Some of the songs were original, written by the performer and 'tried out' for the first time at this filk sing; others were older favorites, either part of the singer's personal repertoire or pulled from one of the filk-song books, songs which were remembered from other cons or which were fondly associated with particular fan musicians. New songs are often greeted with waves of vocal approval, passed around the room and hastily copied by those who wish to add them to their own notebooks. Several fans played half-finished songs, asking for advice on their completion from the other filkers.

One constantly meets a sense of filking as a spontaneous and ongoing process of popular creation, one which builds upon community traditions but which is continually open to individual contribution and innovation. Some traditional filk songs have acquired literally hundreds of verses as new filkers have tried their hands at adding to the general repertoire. In other cases, popular filk songs are parodied or pirated, sometimes numerous times, and such parodies are generally regarded as compliments by filk composers since they mark the songs' general acceptance within the fan community. Several times during the evening, a traditional filk or folk song was followed by one or more of its parodies advanced by another singer in the circle. Filk songs are not closed or completed, but rather open and fluid, not so much personal expressions as communal property, a contribution to fan culture. The 'flying island' of fandom ensures that a song performed at one con may quickly be accepted into the general repertoire to be sung at other cons scattered throughout the country and, sometimes, refitted to the new context and occasion.

Songs were organized through a process of free association. One song triggers a memory or a response from another singer and initiates a cycle or exchange of songs. Roberta Rogow led

the group in a performance of a biting parody of 'Beauty and the Beast,' 'The People in the Tunnel World,' only to provoke another filker to respond with 'Living Down Below,' a song more sympathetic to the program. A song about Kerr Avon was matched with a song about Roj Blake, two characters from 'Blake's 7'. At other points, the group sang a series of songs about their misadventures travelling to various cons or a succession of tributes to the ill-fated crew of the space shuttle, *Challenger*. When the fans ran out of theme-related material or lost interest in the theme, someone introduced a new topic and the sing took a totally different direction.

Partially as a product of this fluidity, partially as a result of the climate of acceptance which characterizes the filk sing, a surprising range of texts and themes may be evoked in the course of the evening. More than 80 different songs were performed at this particular session. A fair number of them concerned fannish interests in media texts, including both those which have attracted considerable followings ('Star Trek,' 'Blake's 7,' *Star Wars*, 'Beauty and the Beast,' *Indiana Jones*) and a number of more idiosyncratic choices (*The Fly*, 'Quantum Leap'). Other songs built upon literary topics including songs dedicated to Gordon Dickson's *Dorsai* novels, Robert Heinlein's *Green Hills of Earth*, Anne McCaffrey's *Pern* books, Marion Zimmer Bradley's *Darkover* series and the writings of C. J. Cherryh.[6] The fans sang works by a number of mainstream performers whose style and subject matter make them particularly amenable to fannish appropriation, including those of Garrison Keillor, The Smothers Brothers, Tom Lehrer, Mark Russell and Allan Sherman. Space-boosting songs – songs promoting NASA and its goals – are a long tradition in fandom and were well represented during the session, yet more surprising, so were the large number of songs devoted to other contemporary events (the San Francisco earthquake, the Iran–Contra scandal, the Pentagon appropriations controversy, the fall of the Berlin Wall), suggesting the degree to which fandom provided a vehicle for more specifically political concerns.

The range of songs represented at the filk sing may be read as a palimpsest of the diverse interests which brought the assembled fans together with songs reflecting both traditional hard science-fiction and fantasy, technoculture and mythic

romance, politics and pleasure, war and romance. One reason why filking attracts both men and women is that within the fairly open space of the sing, many different perspectives and interests may be explored, whereas both traditional literary fanzines and the new media fanzines embody more narrowly specialized interests and particular styles of interpretation. Filker Mark Blackman (personal interview) predicts that as filking grows as a cultural activity, it may subdivide into more specialized subfandoms and the diversity which characterizes the contemporary filk sing may give way to the gender or program-specific nature of the fanzine publishing community. For the moment, filk still represents a microcosm of the larger fan community and the many different types of interests that cluster around science fiction and fantasy.

By far, however, the largest class of songs concerned not media or literary texts but rather fan culture itself, with songs commemorating or commiserating about previous cons, fanzine publications, costume competitions and the problems of maintaining ties to a mobile community. If the other songs reflect special interests, albeit those shared by large numbers of fans, it is this last group of songs which most persistently articulates the groups' collective identity and points towards their common interests. Often, these songs acted as triggers for discussion as fans exchanged memories of experiences shared in the past. Some of the most powerful of these songs are anthems (Julia Ecklar's 'Born Again Trek,' [1982]; L.A. Filkharmonic's 'Science Wonks, Wimps and Nerds' [Fletcher *et al.* 1985]); others are thoughtful explorations of childhood memories or celebrations of the fan's deeply felt commitments to media products, to the space program, to various other causes. Yet, perhaps most frequently, filk songs offer representations of fandom which are comic and playful, that depend upon broad exaggeration. The use of humor contributes actively to the articulation of a group identity, the invocation of shared experiences, and the creation of common feelings. As filker Meg Garrett explains, 'If you "get" the joke, punchline or reference and laugh when the rest of the fan audience laughs, it reinforces the sense of belonging, of "family", of shared culture' (personal correspondence 1990). Such songs are sung loudly and boisterously, and often end upon moments of communal laughter – a laughter born of warm

recognition or playful transgression, of loving parody or biting satire, but a laughter whose primary function is that of creating fellowship.

Filk songs often evoke the negative stereotypes of fans circulated by the mass media or by cultural critics, yet inflect them in directions more sympathetic to the community's own interests – pushing them to absurd extremes, celebrating their transgressiveness rather than accepting them as rebuking, redefining them in terms which proclaim the pleasures and idealism of fandom. The LA Filkharmonic's 'Science Wonks, Wimps, and Nerds,' written in response to a 1982 *Los Angeles Herald* review of *Star Trek II*, challenges the categories thrust upon fans by the 'stereotypical minds' of 'all the mundane and Philistine herds,' evoking instead an image of fans as 'prophets, inventors, and movers.' The song conceives of fans not as passive consumers of the 'vicarious thrills' offered by media texts but as active participants in society, dreamers who are finding ways to translate their dreams into 'accomplishments [that] speak much louder than words.' Fans are linked to 'physicists, researchers, astronauts, programers,' professionals who are often themselves science fiction fans and who share in the fans' attempts at 'grasping the future, making it ours,' and are contrasted to those outsiders who lack the imagination to grasp the true significance of fan culture.

This song adopts a position of militant resistance to media stereotypes, yet others embrace those stereotypes only to push them to absurd extremes, relishing precisely the fan's self-proclaimed rejection of emotional restraint or social propriety. Fan songs often speak with guiltless pleasure about the erotic fantasies ('Video Lust' [Davis and Garrett 1989]) and loss of bodily and emotional control ('The Ultimate Avon Drool Song' [Lacey 1989]; 'Revenge of The Harrison Ford Slobber Song' [Trimble 1985]). Fans sing with ironic glee of lives ruined and pocketbooks emptied by obsessive collecting of media-related products, of houses overrun with fanzines. The Great Broads of the Galaxy's 'Trekker' (no date) awakens one morning to discover that her husband, thoroughly disgusted with her endless expenditures of time and money on her fandom, has 'taken the kids and moved to Delaware/ Bye, Bye,Bye.' The protagonist of Roberta Rogow's 'I've Got Fanzines' (no date) has a collection of

fan-produced works that has expanded until she has 'no room . . . to live in' and has been forced to sleep in her garage. Still other songs evoke media creators as deities, appealing to them to complete their unfinished sagas ('Dear Mr. Lucas' [Christy 1985]), to resolve displeasing elements in the favoured texts ('Roddenberry' [Ross 1988]), or to rescind decisions to cancel popular programs ('An Irate Fan Speaks' [McManus 1989b] and 'Do Not Forsake Me' [McManus, 1989a], both about the final episode of 'Blake's 7,' suggesting the fan's extreme respect for certain textual producers as well as the mix of fascination and frustration which sparks fannish production.

Fannish obsession with media texts need not be viewed entirely in relation to the categories of consumption or adoration proposed by dominant stereotypes, however; filk also offers extreme images of fannish productivity, of editors who become fixated on publishing fanzines, of artists who cannot stop painting, and of fans who choose to spend their lives con-hopping. The protagonist of Sally Childs-Helton's 'Con Man Blues' (1987c), perhaps the ultimate fan hero, was conceived on 'a pile of T-shirts/ in the back of a huckster's van,' the offspring of a fan and a filker, and delivered on stage during a world con-masquerade, destined to spend his life ensnared in con culture.

Other songs articulate a gleeful refusal to embrace media texts which witlessly attempt to exploit the fannish community's commitment to the genre. Dennis Drew's 'Smurf Song' (no date) expresses the singer's violent fantasies of ridding the planet of the little blue cartoon characters. One Chris Weber song (1982) complains that 'All you get is drek' when they put 'sci-fi on TV,' while Duane Elms (1985) tells editors who cynically recycle old ideas to 'Take This Book and Shove It.' Roberta Rogow's 'Lament to the Station Manager' (no date) complains of how local stations constantly replay bad 'Star Trek' episodes, such as 'Spock's Brain,' while systematically excluding the series' best efforts, such as 'Amok Time' and 'City on the Edge of Forever.' The fans' proprietary response not simply to individual media and literary texts but to science fiction as a genre authorizes them to criticize the shoddy products released by the culture industry and marketed in their name.

The bankrupt values and lack of imagination which filkers

recognize in certain media producers and literary hacks often get mapped onto the larger social order through an evocation of a long-standing distinction between fan culture and the mundane world. This distinction is partially one between the fannish and the non-fannish, a contrast which essentially reverses the normal–abnormal dichotomy drawn in journal-istic accounts of fan culture. Fandom becomes the stand-ard against which consumer culture is measured, thereby expressing both the pleasure that fans find within fan culture and the displeasure they feel towards many aspects of their everyday lives. This highly critical stance is clearly expressed in Barry Childs-Helton's 'Mundania'(1987b) (sung to the tune of Leonard Bernstein's 'America' from *West Side Story*):

> I know a place where you can get real.
> Lots of folks think it's a good deal.
> Be just exactly what you seem
> As long as you don't think or daydream.
> Buy what you see in Mundania.
> Don't domesticate me in Mundania.
> Free to agree in Mundania.
> No where to flee in Mundania.

Childs-Helton's biting satire of American consumer society characterizes 'mundanes' as living a 'Barbie and Ken' existence in suburbia, watching soap operas, discussing *Reader's Digest* articles, eating Big Macs, gossiping about the neighbours and engaging in quick sex at singles bars before settling down to raise their 2.3 children: 'A nice padded cell in Mundania/ Boring as hell in Mundania.' It vividly expresses the sense of profound alienation many fans feel in a world whose values are fundamentally at odds with their own and in which they enjoy limited creative freedom within fairly menial jobs. Mundania contrasts sharply with the sense of community, creativity and intensity they find within fandom.

More generally, filk celebrates pleasure over restraint and open-mindedness over imposed moral standards, assigning in each case the negative values to the 'mundanes.' 'Mundania' is perceived not simply as a separate cultural realm but as one dia-metrically opposed to the fan's pursuit of pleasure, one which

is implicitly if not explicitly present in most representations of con culture. The traditional killjoy figure can be found in the dismissive husbands in 'Trekker' and 'I've Got Fanzines' who finally cannot live with the wife's fannish interests, in the press from Lee Gold's 'Reporters Don't Listen to Trufen'(1986) which ignores rational explanations of fan culture to spread exotic stereotypes that titillate mundane readers, in the hotel staff and Amway salesmen who accidentally stumble into a filk sing in Rogow's 'A Use For Argo'(1989). Fans embrace pleasure; mundanes suppress or deny it.

Interestingly, this fan–mundane opposition remains even when the filkers start to describe fictional characters from favored media and literary texts. The Dorsai may be unbeatable and inexhaustible warriors in Gordon R. Dickson's novels, but in Chris Weber's 'What Does a Dorsai Do?'(1985), they conform to a more mundane suburban lifestyle after their workday is done, dancing to the 'Tommy Dorsai Band,' taking their kids to Disneyland, and wearing a 'dorsai gator on his dorsai preppie shirt.' The song involves an ironic reversal of the structure of the fan's own social experience which often involves accepting mundane values at work while enjoying fan culture in their leisure. Conversely, other songs identify favorite characters with fannish excess, casting them into situations which mirror the filkers' representations of con life. Leslie Fish's 'Banned From Argo (1977),' one of the earliest 'Star Trek' songs written and one of the most well-known filks within the fan community, represents the Enterprise crew running amuck on a shore-leave planet for 'three days or more' (the typical length of a con), with disastrous and scandalous results. Kirk engaged in group sex with five different genders of aliens. Chapel used a Vulcan love potion on Spock. Scotty outdrank seven space marines and put a shuttle craft on the city hall roof. Uhura rigged their communication system so that all speakers appear nude. Space pirates stumble upon their recreational activities and are so shocked that they flee in horror, mirroring the response of the mundanes who find themselves at fan cons in other filk songs. The end result is that the program characters, like the proverbial con-goers who are refused booking at hotels, are 'banned from Argo, just for having a little fun.'

If fans in filk songs differ from 'mundanes' in terms of

227

the intensity of their feelings and in their commitment to pleasurable pursuits, they are also contrasted in terms of the shallowness and short-sightedness of mundane thinking. Fans see themselves as people who dream, who use imagination and creativity both in constructing their culture and in making sense of their social experience; they are technological utopians who see possibilities for human progress to which many of their contemporaries remain blind.[7] In that sense, they are different from 'mundanes,' yet they are like children in their innocent hopes and imaginative fantasy lives. A fair percentage of filk songs involve idealized representations of childhood, representations which may be read as reflections of the fan's own self image.

These autobiographical tendencies are highly visible in Bill Roper's 'Wind From Rainbow's End' (1986), which begins with a description of a lonely schoolboy, picked upon by his classmates because of his difference from other children, who found an escape through reading fantasy and science fiction. These childhood fantasies provide a 'mighty shield . . . for the schoolyard battlefield,' a place to escape from an unsympathetic environment. The song ends with the boy grown, yet still finding fantasy a way to deal with his adult-world problems. The child has become a fan while his mundane schoolmates have moved from 'Sally, Dick and Jane' books to equally 'mundane' adult reading. Roper's song ends with a warning, however, suggesting the danger of becoming so identified with the fantasy that one can't find a way back to reality again. As this example suggests, fan songs of childhood retain the opposition between fan and 'mundane,' often transforming it into an opposition between child and adult (or here, the opposition between bookworm and bully).

A more complex play between adult and child characterizes T. J. Burnside's 'Robin Hood' (no date). While the song several times asserts the impossibility of adults remembering or re-experiencing the vividness of children's imagination, of admitting to a time when their play could 'turn a backyard garden/into twelfth century England,' the songwriter proceeds to recount her own childhood experiences, assuming in the process the role of children at play: 'I'm Robin Hood/I'm Marian/Let's fall in love.' Adults may, as the song asserts, 'lose

228

their fantasies,' but the songwriter casts herself in a role which is neither child nor adult, but that of fan who maintains close ties to the imaginary even as she moves into maturity, so that by the final line she can sing: 'They'll never see how we feel.'

Fans, the filkers claim, are not simply dreamers who maintain the imagination and idealism of their childhood; they are also 'doers' who envision a better world and are working to transform those dreams into a reality: 'Look where hopes and fantasies lead us,/Making life better, our efforts do aim' (as 'Science Wonks, Wimps and Nerds' proclaims). It is this willingness to act upon their fantasies, these songwriters suggest, which links the fans to a larger group of technological utopians, a group which also includes scientists and astronauts. Fans display a proprietary interest in the space program much like that exhibited towards favorite media and literary texts. The *Challenger* might have been 'carrying Humanity's dreams,' as one Doris Robin song (1985) claims, but the fans hold a special claim on those dreams, since they have maintained faith in NASA's goals even when the 'mundanes' have lost the ability to imagine their fulfillment. This closeness is suggested by the proprietary 'we' which runs through so many of the songs ('We will reach the stars'; 'All my dreams are coming true.') It is also suggested by the frequency with which fan songs center on characters who are neither fan nor astronaut but share traits of both groups. Like the astronauts, these characters are actively involved with the mission, but, like the fans, they must be witnesses rather than participants in the actual space flights. Mike Stein's poignant 'The Final Lesson' (1989) describes the thoughts of Christa McAuliffe's son watching with his class as his mother blasts into space only to explode, while William Warren Jr's 'Ballad of *Apollo XIII*' (1983) describes the experience of mission control as it waits to see if the damaged ship will be able to regain contact with them. Leslie Fish's 'Toast For Unknown Heroes' (1983) celebrates the everyday workers whose efforts enable the astronauts to soar, yet who can only watch the spacemen gather the glory. Such figures serve to bridge the gap between the historical reality of the astronaut and the fantasy participation of the fans.

A number of different yet interrelated conceptions of fans

run through the filk-song repertoire. Fans are represented as both passionate lovers and harsh critics of media culture. Fans are defined in opposition to the values and norms of everyday life, as people who live more richly, feel more intensely, play more freely, and think more deeply than the 'mundanes' who constantly surround them. Fans are seen as people who carry the dreams and fantasies of childhood into their adult life. Fans are represented as technological utopians who maintain an active commitment to humanity's future in space. The communal quality of the filk sing allows such claims to be made not *for* or *to* but *by* the fan community itself, enabling them to be read as reflexive artifacts that collectively shed light on the ideals, values, and lifestyle of the group which produced them. Such songs play a pivotal role in articulating and maintaining a common identity for fans which reflects and integrates the group's own diverse interests and which challenges the dominant negative stereotyping of fans.

However, filk's relationship to the fan community is currently undergoing a fairly dramatic transition, one brought about by the emergence of semi-professional companies which are recording the works of individual filk 'artists' and attempting to circulate them to a larger listening audience.[8] Personal tape recorders have long been a fixture at filk sings and some filk clubs barter for recordings of some of their sessions. Individual fan musicians have sometimes recorded their own music and circulated it on tapes. Roberta Rogow, who currently has five different tapes of media related filk songs in circulation, characterizes her tapes as 'electronic fanzines.' But, if Rogow's tapes, which have a first run of 200–300 copies and are marketed personally by the musician, maintain the same cottage industry status as other types of fan publishing, the recording of filk has increasingly become concentrated in the hands of two semi-professional manufacturers, Firebird Arts and Wail Songs, which sell recordings for a limited profit, contract for exclusive rights to certain fan musicians and market tapes with print runs which may reach 2,000 copies. Each company currently offers roughly 50 different tapes either recorded live at filk conventions or increasingly, recorded under studio conditions and offering the music of a single 'star' performer.

Such a development has the potential of bringing filk into

contact with a broader audience and thus expanding its power as a response to the cultural environment. A few filk songs are starting to receive limited radio play. Firebird recently linked its release of a new tape, *Carmen Miranda's Ghost*, with the commercial publication of a science fiction anthology of the same name, and the book's introduction included a description of filk tapes and an address where they may be purchased. People can buy and enjoy filk tapes who have never attended a filk sing at a con and be drawn into the fan community.

Yet, most of my informants suggest that the semi-professional tape producers and distributors are already having some impact on the nature of filk as a musical tradition. A star system has started to emerge as individual performers are drawn from the community and featured on their own tapes. A form of music founded on ideals of musical democracy, an acceptance of various competencies, has become more hierarchical due to the push towards professional standards of perfection. The result has been an increased complexity of song lyrics, a movement away from songs which can be quickly learned and sung by the fan community to those which require greater practice and showcase the particular vocal abilities of their performers. A number of the recorded filk songs also depend upon mixing and sampling techniques only possible under studio conditions. The semi-professional concerns have been far less willing than the original fan producers to risk violations of copyright law, refusing to allow direct references to media characters or the use of songs not in the public domain. Some filkers have reworded their original media-related songs to give them a more generic quality. Others have written new songs, songs which borrow generic features from science fiction without directly evoking specific copyrighted texts. Filk, built from fragments borrowed nomadically from other media commodities, now runs the risk of itself becoming another commodity as the filk community is increasingly divided in feuds over the proprietorship of songs and the percentage of return each artist will receive.

Filk, then, offers us a particularly vivid illustration of the various dimensions of fan cultural production. Filk songs may, like fan writing, serve as a vehicle for interpreting and commenting upon media texts, a way of opening favorite texts to new interests and making them produce new meanings; filk is

231

indeed a form of textual 'poaching.' Yet filk also plays a vital role in the construction and maintenance of the fan community, as a means of articulating a group identity and expressing collective ideals. Finally, filk is becoming one of the aesthetic commodities which circulate within the fan Art World, becoming the basis for the creation of institutionalized systems of artistic creation and distribution, and offering a new arena within which fan artists may build their reputations.

Filk songs are far more than simply the material trace of individual fans' reception and interpretation of media texts. To read them in such a fashion is to offer an impoverished account of fan cultural production. The significance of fan cultural production must necessarily be understood in relation to the larger social and cultural institutions of the fan community and understood in terms of its aesthetic norms and generic conventions. Such communities draw upon media materials as an important resource, one which forms the basis for interpretive debates, one which provides the raw materials for aesthetic creation, one which facilitates social interaction with people who otherwise might not have a common frame of reference.

Yet it is important to see these communities not as constituted by single media texts, but rather as constituting themselves from a multitude of borrowed materials. Fandom is a 'scavenger' culture built from poached fragments of many different media products, woven together into a coherent whole through the meanings the fans bring to those fragments and the uses they make of them, rather than by meanings generated from the primary texts. Any understanding of fan cultural productions, then, requires not simply sensitivity to the relationship of those products to their media origins but also their particular function within the larger cultural logic of fandom.

Author's note: I am indebted to Cindy Jenkins, Signe Hovde, Lynn Spigel, Meg Garrett, Lisa Lewis, Roberta Rogow, Barbara Tennison, Spencer Love, Duane Elms, Mark Blackman, Robert Laurent and Gail Barton for help in researching and writing this essay. This essay grows from my own discovery and pleasure in filk as well as from my ongoing research on fan culture. As with my other work, I see this paper as a collaboration with the fan

community. I have shared drafts of this essay with fans and have incorporated their comments into the revision process. I have made an effort to contact every fan mentioned or discussed in this essay and to gain their thoughts on its progress. In a few cases, I was unable to do this and/or did not receive response from my inquiries. I apologize for any misunderstandings which might result from this regrettable situation.

Notes

1 For a fuller discussion of the traditional representation of the fan, see Jenkins (forthcoming a).
2 My discussion of fandom as an interpretive institution draws inspiration from Bordwell (1989) and from extensive conversations with its author.
3 According to Jackson (1986), the term filk is the result of a typo on a conference program which turned 'folk music' into 'filk music.' The word was retained out of a certain perverse pleasure, but it functions nicely to show both the continuity and discontinuity between fan music and traditional folk music. Filk adopts many folk music practices and often bases its songs on tunes from the folk repertoire, but borrows its contents from mass media and popular culture. As a result, the form, like most fan culture, mediates between folk culture and mass culture, suggesting an intermediate form wherein mass culture can be turned back into something akin to folk culture.
4 'Ose' is a slang term used in filking to refer to songs which are highly angst-ridden and tragic. It is derived from the pun, 'Ose, Ose, and Mor-ose,' though sometimes it is associated with 'Verb-ose.'
5 Anne Prather (undated) summarizes the position of many filkers when she celebrates the 'anti-elitist' nature of the filk sing which provides space for 'a wide variety of all kinds of voices' and where 'technical expertise was nice but lack of it didn't matter too much.'
6 Cherryh's writings enjoy a particular prominence within the filk community. Cherryh is herself an active filker and has helped several filkers – Leslie Fish, Roberta Rogow, and others – to gain professional publications through her collectively-written *Merivingen Nights* novels. A tape of songs based on her writings, *Finity's End*, features many of the best-known filk performers and is currently available from Firebird.
7 The term 'technological utopianism' is derived from Segal (1984) and refers to 'the belief in technology . . . as the means of achieving a "perfect" society in the near future.' Technological utopianism

is an important tradition within American science fiction and
one which has been embraced by many fans as a means of
understanding contemporary social experience.

8 For more information, write to:

Firebird Arts and Music Inc. Wail Songs
P.O. Box 14785 PO Box 29888
Portland, OR 97214–9998 Oakland, CA 94604

Other World Books
PO Box 1124
Fair Lawn, NJ 07410
Roberta Rogow, Publisher

Off Centaur Productions, one of the first companies to distribute filk
tapes commercially, is now defunct, though many of its titles are
available through Firebird Arts and Music.

References

Amsley, Cassandra. 1989. How to Watch *Star Trek*. *Cultural Studies*
Fall: 323–39.
Ang, Ien. 1985. *Watching Dallas*. London: Methuen.
Becker, Howard. 1982. *Art Worlds*. Berkeley: University of California
Press.
Bordwell, David. 1989. *Making Meanings*. Boston: Harvard University
Press.
Bradley, Marion Zimmer. 1985. Fandom: Its Value to the Professional.
In *Inside Outer Space: Science Fiction Professionals Look at Their Craft*,
ed. Sharon Jarvis. New York: Frederick Ungar.
Brunsdon, Charlotte. 1981. *Crossroads*. Notes on Soap Opera. *Screen*
22(4): 32–7.
Burnside, T. J. (no date). Robin Hood. *Station Break*. Wakefield, MA:
Fesarius Publications. (Available through Wail Songs)
Carter, Paul A. 1978. *The Creation of Tomorrow: Fifty Years of Magazine
Science Fiction*. New York: Columbia University Press.
Childs-Helton, Barry. 1987a. 'Flying Island Farewell.' *Escape From
Mundania!* Indianapolis: Space Opera House. (Available through
Wail Songs.)
———. 1987b. 'Mundania.' *Escape Fom Mundania!* Indianapolis: Space
Opera House. (Available through Wail Songs)
Childs-Helton, Sally. 1987c. Con Man Blues. *Escape From Mundania!*
Indianapolis: Space Opera House. (Available through Wail Songs)
Christy, Jo Ann. 1985. Dear Mr Lucas. In *Return of Massterial!: Star
Wars and Other Filk Songs*. Los Angeles: L.A. Filkharmonics.
Davis, Anne and Meg Garrett. 1989. Video Lust. In *Hip Deep in*

Heroes: A Blake's 7 Filk Song Book, ed. Meg Garrett. Los Angeles: Meg Garrett.

de Certeau, Michel. 1984. *The Practice of Everyday Life*. Berkeley: University of California Press.

Drew, Dennis. (no date). Smurf Song. *The Final Reality*. Joplin, MO: Self-Recorded, distributed by Wail Songs.

Elms, Duane. 1985. Take This Book and Shove It. *Mister Author*. Oakland, CA: Wail Songs.

Finity's End: Songs of the Station Trade. 1985. El Cerrito, CA: Off-Centaur, available from Firebird.

Fish, Leslie and the DeHorn Crew. 1977. Banned From Argo. *Solar Sailors*. El Cerrito, CA: Firebird Arts and Music.

Fish, Leslie. 1983. Toast for Unknown Heroes. *Minus Ten and Counting*. El Cerrito, CA: Off-Centaur.

Fiske, John. 1987. *Television Culture*. London: Methuen.

———.1989. *Understanding Popular Culture*. Boston: Unwin Hyman.

Fletcher, Robin, Doris Robin and Karen Trimble. 1985. Science Wonks, Wimps and Nerds. In *Return to Massterial! Star Wars and Other Filksongs*. Los Angeles: L.A. Filkharmonics.

Gallagher, Diana. 1984. Monsters in the Night. *Bayfilk II Concert 1*. El Cerrito, CA: Off-Centaur.

Garrett, Meg. 1985. VCR Song. In *Return to Massterial! Star Wars and Other Filksongs*. Los Angeles: L.A. Filkharmonics.

Gold, Lee. 1986. Reporters Don't Listen to Trufen. *Filker Up*. Oakland: Wail Songs.

Great Broads of the Galaxy. (no date). Trekker. *The Cosmic Connection*. Lawrence, Kansas: Audio House, currently distributed by Wail Songs.

Jackson, Sourdough. 1986. *Starship Troupers: A Filkzine*. Denver: Virtuous Particle Press.

———.1987. *Filk Index*. Fairlawn, N J: Other World Books.

Jenkins, Henry. 1988. Star Trek Rerun, Reread, Rewritten: Fan Writing as Textual Poaching. *Critical Studies in Mass Communication* 5(2): 85–107.

———.1989. Going Bonkers!: Children, Play and Pee Wee. *Camera Obscura* 18.

———.1990. 'If I Could Speak With Your Sound': Textual Proximity, Liminal Identification and the Music of the Science Fiction Fan Community. *Camera Obscura*, 23.

———.1991. *Textual Poachers: Television Fans and Participatory Culture*. London: Routledge.

Lacey, Jenny. 1989. The Ultimate Avon Drool Song. In *Hip Deep in Heroes: A Blake's 7 Filk Song Book*, ed. Meg Garrett. Los Angeles: Meg Garrett.

Lipsitz, George. 1988. Mardi Gras Indians: Carnival and Counter Narrative in Black New Orleans. *Cultural Critique*, Fall: 99–122.

McManus, Vickie. 1989a. An Irate Fan Speaks. In *Hip Deep in Heroes*.

————.1989b. Do Not Forsake Me. In *Hip Deep in Heroes*.

Morley, David. 1986. *Family Television*. London: Comedia.

Palmer, Patricia. 1986. *The Lively Audience: A Study of Children Around the TV Set*. Sydney: Unwin Hyman.

Prather, Anne. (no date). Editorial Soapbox. *Denver Filk Anon-y-mous* No. 2: 4–5.

Radway, Janice. 1988. Reception Study: Ethnography and the Problem of Dispersed Audiences and Nomadic Subjects. *Cultural Studies* 2(3): 359–76.

Robin, Doris. 1985. Rise Up, You Challenger. In *Return to Massterial! Star Wars and Other Filksongs*. Los Angeles: L.A. Filkharmonics.

Rogow, Roberta. (no date). I've Got Fanzines. *Rogow and Company* (self-published, currently available through Wail Songs and New World Books).

————.(no date). Lament to the Station Manager. *Rogow and Company* (self-published, currently available through Wail Songs and New World Books).

————.1987. 'A Use for Argo.' *Rec-Room Rhymes* No. 5: 39.

Roper, Bill. 1986. Wind From Rainbow's End. *Liftoff to Landing*. Milwaukee, WI: STI Studios, currently distributed by Wail Songs.

Ross, Jessica. 1988. Roddenberry. *Rec-Room Rhymes*. No. 6: 7.

Segal, Howard P. 1984. The Technological Utopians. In *Imagining Tomorrow*, ed. Joseph E. Corn. Cambridge: MIT.

Stein, Mike. 1989. The Final Lesson. As performed at Philcon, 1989.

Sutton, Brenda Sinclair. 1989. Strangers No More. *Strangers No More*. Santa Monica, CA.: DAG. Available through Wail Songs.

Trimble, Karen. 1985. Harrison, Harrison or Revenge of the Harrison Ford Slobber Song. In *Return to Massterial! Star Wars and Other Filksongs*. Los Angeles: L.A. Filkharmonics.

Warren, Jr, William. 1983. Ballad of Apollo XIII. *Minus Ten and Counting*. El Cerriot, CA: Off-Centaur.

Weber, Chris. 1982. All You Get Is Drek. *Fan-Tastic: Filk Songs and Other Fannish Delights* 1(1).

————.1985. What Does a Dorsai Do? *I Filk: The Science Fiction Folk Music of Chris Weber*. Santa Monica, CA: DAG.

Index



INDEX